THE JOY OF WATERCOLOR

BY DAVID MILLARD

WATSON-GUPTILL PUBLICATIONS/NEW YORK

Warning

Many of the paintings reproduced here are on loan from private and corporate collections or the collections of the artist and his wife. Therefore, these paintings and drawings are meant for you to copy in practice exercises only. You are forbidden to exhibit your copies publicly or to enter them into an art competition of any sort. Making prints or reproduction copies in any form is also prohibited. These paintings are for instruction purposes only!

Watson-Guptill Publications

Paperback Edition
First Printing 1992

First published in 1983 by Watson-Guptill Publications,
a division of BPI Communications, Inc.,
1515 Broadway, New York, N.Y. 10036

Library of Congress Catalog Card Number: 83-14538

ISBN 0-8230-5680-5
ISBN 0-8230-2566-7 (pbk.)

Manufactured in Singapore

3 4 5 6 / 97 96 95 94 93

THE JOY OF
WATERCOLOR

Barbara Thomson
1993

This book is dedicated to my wife Edith Carol Millard,
who nurtured a creative climate with enthusiasm and
encouragement for these thirty years.

Acknowledgments

I want to thank:

. . . My mother who started me at Montclair Art Museum in sixth grade.

. . . My many artist friends for their warmth and exchange of knowledge over the years.

. . . My editors, David Lewis for his sound advice and guidance and Bonnie Silverstein for her astounding ability in assembling this vehicle.

. . . My art director, Jay Anning.

PREFACE

This book is based on two very important experiences in my life: painting with the use of a sketchbook on trips around the world and teaching watercolor workshops from coast to coast in the United States for over nine years.

In the first instance, these various travels made working with compact materials a necessity. As a traveling artist working with sketchbook and camera, I evolved two essential techniques: on-the-site speed sketching (backed up when necessary with photographs to record details) and memory sketching (used when a camera was not allowed). These two basic techniques—speed sketching and memory sketching—will be treated in depth in this book. If you practice them regularly (I advocate a minimum of fifteen minutes per day), they will lead you to a more creative process of painting as you learn to extract just the essence from the subject at hand.

I also advocate a second approach to the material in this book, one that has proven highly successful in my workshops, and that is—regardless of your experience—that you start at the beginning of the book and speed-read the information and visual material before re-reading the book and concentrating on the material in greater depth. For advanced artists, this will provide a review of classic material and perhaps an insight into how these basic areas relate to more complex work. For the novice, it means that you are not left to dawdle with elementary problems but are "force fed" more advanced material right away. As you are swept up in the emotion of daring and risking new things, with so many visual experiences and so much material to absorb, a crescendo of excitement will develop that will keep building to the very end of the lessons.

General Objectives

Before we start our drawing and painting lessons, let's talk about the general objectives of this book.

You, as an individual, will be seeking to paint subjects that appeal to you. Have the courage to seek out your own subject matter, things that you wish to capture in a drawing or painting. I just hope, through this book, to help you see better.

Shapes, colors, patterns of dark accents, groups of people, the way the light strikes a field, a house, some flowers—all are qualities that may appeal to you as an artist. This is where you will find your own way. There are many paths to art and you will be trying a number of them before you select a general direction. Just leave yourself room to grow—always. Your selections of subjects will become *your* own voice in drawing and painting. This voice will become very personal . . . ultimately to the point where no one else will draw like you or paint like you. Have the courage to believe this.

Over the years you will develop your own style. It has to grow from your own feelings and your own motivations. No one can really give it to you. But the purpose of this book is to try to show you some of the many paths. You will also learn from other artists, from seeing paintings in galleries and museums, and from reading many more books. And perhaps the exercises that follow will entice you into a direction.

A word of advice before you start work. Don't just copy carelessly, either from these pages or from nature. Stop, look, think, plan your page . . . then draw!

Good luck . . . and best wishes on your journey.

CONTENTS

WHY KEEP A SKETCHBOOK?

Keeping a sketchbook will prove to be a valuable learning experience. It will provide:

1. A record of progress of how you grow through the years in the way you see as an artist. Your work in drawing, composition, color, and general creativity are all bound and stored for ready reference as an inspiration for future paintings in watercolor. Over the years ahead, the accumulation of sketching and painting ideas will eventually become your own private gold mine.

2. A portable laboratory that will travel with you wherever you go. This means that you'll always be ready when that unexpected "winner" pops up in front of you, when the light is just right and that group of figures is perfectly placed, and the colors are just perfect. At times like this, a fragment, a note or two of what you saw at a glance, jotted down quickly on a page is all you need to prompt your mind to experiment with making this sketch into a painting . . . first on your sketchbook page, then on your watercolor paper.

3. A place in which to develop your creative flow and evolve your own individual painting style. The creative flow is developed by rapid and frequent sketching. Expressing what you feel and see becomes an intuitive process.

4. A place for practice and experimentation. When you experiment, you dare new things. And when you try noting four different versions of a subject on a single sketch page, you will be growing in your own individual manner. Isn't this what the masters did throughout the centuries?

5. An opportunity to develop your pencil-sketching abilities. The pencil is a primitive tool. It flows right from your arm and body, directly and without interference in the action. There's no dipping involved, as there is with ink; no mixing problems, as with a brush in watercolor. Just an easy, gliding, versatile motion that allows you to make a delicate, searching line. And when needed, the carbon pencil can also give you the most extremely rich darks—and just a rub of a finger will produce a tone of velvet. You'll find that your sketchbook page will respond eagerly to the range of values a carbon pencil provides.

6. A casual, informal place in which to work. You won't find an easier, more comfortable method of creating than drawing with a pencil in your own sketchbook as it rests on your lap.

7. An inconspicuous mobile recording device. Because a sketchbook is easily hand-held, with no easel required, you can move in and out of situations with little attention attracted to your efforts. This means a comfortable, private sketching situation, with the added advantage of mobility.

8. A cure for "white fright." Many novices are intimidated when faced with an expensive sheet of watercolor paper. Working out your ideas in a sketchbook first gives you a chance to practice on inexpensive paper, saving you a lot of bad guesswork and letting you do your experimenting and weeding out before you paint on good paper. The sketchbook is also a great builder of confidence when you're finally ready for that high-quality watercolor paper.

What sketchbook should I get?

The Super Aquabee-brand sketchbook, size 9″×12″ (229×305 mm) with the burgundy-colored cover has been my favorite for years. It has a nicely textured, laid-grain paper that is heavy enough to take all kinds of watercolor washes applied over your carbon sketches. In fact, the paper takes washes so well that you will frequently find it hard to duplicate the beauty of your sketchbook watercolors on other paper!

Caution! Use only the page on the right-hand side when the book is open. It is the correct side of the paper, where the tooth or grain will do the best service to your carbon drawings. Never use both sides of a sheet in your sketchbook or the pencil will ghost or offset onto the facing page and spoil your sketch there. Since the Super Aquabee is spiral-bound, it always closes in the same precise position. Therefore it travels well, usually discouraging smudging in transit. Just don't put a heavy weight on it. Heavy pressure might cause your pencil drawings to smear.

What kind of sketching materials will I need?

You will need a carbon pencil. I recommend any of the following types:

Conté Extra Fine Drawing Pencil, no. 2
Hardtmuth Carbon Pencil 190A, no. 3
Rowney Carbon Pencil, BBB

Since carbon is soluble in watercolor to some degree, it can contribute rich darks in your washes in the form of a modest granular deposit. Your carbon sketches will also hold strongly to the paper and will take a lot of abuse when watercolor is combined with it. But if you use your fingers rather than a tortillon (a rolled piece of pencil-shaped paper available in art supply stores) for smudging dark tones, be sure to wash your hands well with soap and water before eating.

How do I use the sketchbook?

Draw or paint in your sketchbook at least fifteen minutes every day. Try to set aside a specific time of your day to do this.

Get into the habit of the daily schedule of sketching. If you put it off one day, you'll put off the next day and, perhaps, the next. The greatest gift an artist has is not talent, it is self-motivation! Talent is developed by working . . . by sketching . . . by the continual use of your watercolors throughout the years.

If you plan ahead the day before and set up a project to be captured in carbon in your sketchbook the next day, then you are starting your self-motivation program and you will begin to get a volume of good painting material accumulating for future watercolors. Your projects should vary so as to include landscapes, still lifes, groups of figures . . . just the variety you are going to find in this book, which is a planned program of many subjects. I carry a sketchbook everywhere. In fact, I'm seldom seen without one, and by doing the same, you will find material wherever you go.

The more you use your sketchbook, the better you'll get. If you practice regularly and faithfully, your facility with the medium will increase, and so will your speed. As the speed and volume of your work increase, the stiffness in your sketching will disappear and *you will begin to acquire a creative flow* in your work and your own style will develop from this flow.

As you move up the plateaus of ability, you will be inspired and encouraged to increase the amount of time you are putting into your sketching and watercoloring. You will have a record of progress growing in your sketchbooks. Proof of your ability . . . proof that you are making it as an artist.

By working every day you become a doer and not a doodler.

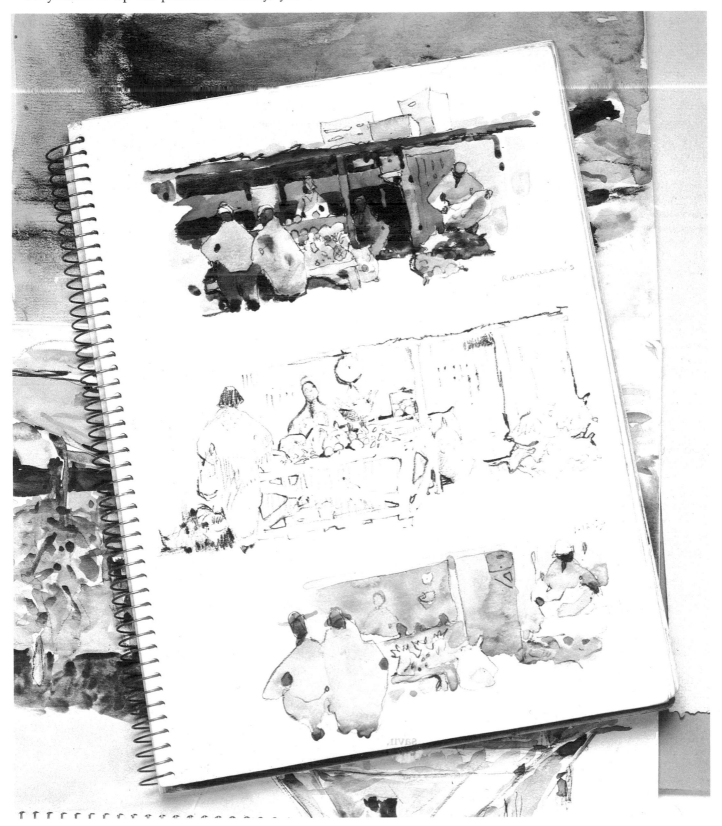

CONTOUR SKETCHING

The 5-Minute Sketch: Lines and Shapes Only

Plan your drawing this way: Think about your subject and study it carefully before you dive into your sketch. Begin by putting in the curve of the street.

Next, as you draw the rooftops, start at the left and shape and design them so that you are creating an exciting abstract "sky piece."

Continue by designing each house in relation to its neighboring shapes. Look carefully . . . each piece of each house is different from any other piece. The bases of the buildings become the top of the sidewalks . . . roughly, but not exactly, repeating the curve of the street. These curves are very flattering to the angular pieces of the houses.

Carefully place the figures . . . a shadow on a shoulder, a darker figure, and there is your center of interest.

Block out the figures with your fingertip and see how the mood of this scene changes.

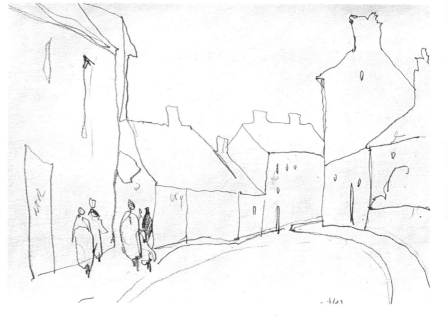

Assignment: Color the "sky piece" with a midtone wash of cobalt blue and raw umber. (You will find a detailed discussion of your palette in a later chapter.) Remember this abstract quality of the shape.

The 15-Minute Contour Sketch

This is an "earth piece" consisting of a compact grouping of buildings. It has a good feeling of solidity. There is a good sky shape here also, but the emphasis is on the earth piece.

Start drawing the main house (left center) and complete it with windows and the one large figure.

Next draw toward you, in contour lines, the sidewalk and the two houses to complete the bottom left-hand corner.

Move over to the top right-hand corner and in contour lines draw the building down to the street.

Continue working . . . up the hill . . . up the street, designing each piece of house in relation to its neighboring pieces.

Place the remaining figures across and up the street from the first figure. Notice how this leads the eye back into the painting and creates a concentrated area of interest.

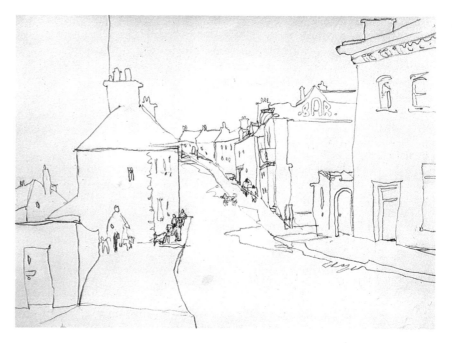

Assignment: Color the buildings with a midtone wash of Davy's gray and yellow ochre. Leave the one large figure as the white of the paper and also leave the color off of the street and the sky. Notice how this separates the painting into several well-controlled shapes or abstract pieces.

Build Up Your Memory

In this problem we will be spotting in the darks after leaving the site. This will be the third quick contour sketch, limit five minutes, in the same simple, single-weight lines. This is to help you see the basic design of the composition in two dimensions while on the site. You're in a restaurant, watching the people around you.

Get a nice flow in movement of your figures just by the change in size relationships. This carries the eye up the left and across the street . . . to the open doorway.

Assignment: Later, you will remember that when the door opened a figure appeared, silhouetted by the dark in the doorway. Put in this dark first. Then stop and think where you want to take the viewer's glance. . . . You can lead the eye by just putting in the two dark pairs of pants. The figures are your center of interest.

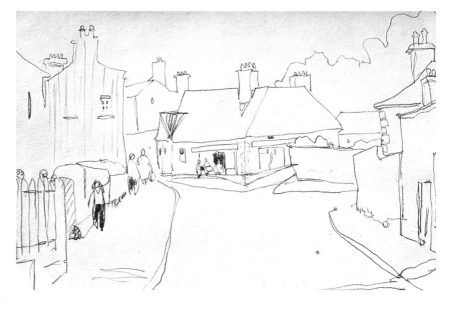

5-Minute Contour Lines

Working from the center out, sketching outlines and shapes only, pick a spot for the dark window and place it there. Then draw the front of the square house around it. Draw the right side going back in perspective. Don't fuss with careful vanishing points and stuff . . . just whack it in as an educated guess!

Next, draw in the little figure with the bucket alongside the bottom of the house.

Then contour your way down into the group of three figures to the lower left . . . thinking all the time how you can best design them.

Go back up to the top and look at what you have on your paper. See how the lower figures and the one at the house corner are in line with each other? See the beginning of the X form? You are now leading the eye of the viewer into the painting.

With the X composition in mind, carefully design your way up to the right and then down toward the "earth line," which is the line at the base of the buildings where it meets the sidewalk. See the figures aligned along one axis of the X?

The second axis is completed by aligning the dropping right edge of the roof with the sidewalk earth line. The spot where the X crosses is where the last figure should be placed.

We are now talking about some of the old masters' use of *composition,* and we will be getting into some of the classical shapes they used from time to time in the pages ahead . . . without putting you to sleep. Incidentally, this drawing is a vignette, one that leaves the edges unsquared.

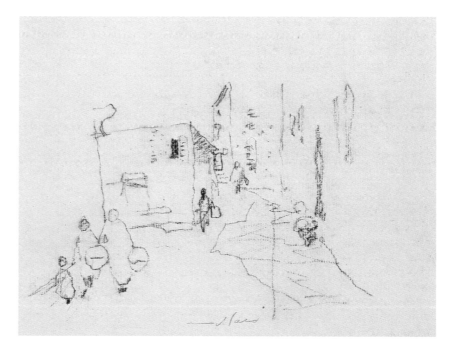

Assignment: Color this entire page with a warm midtone wash of cadmium orange and a little Davy's gray . . . with the exception of the largest of the foreground figures. Leave the paper white here. This is your center of interest, placed in a classic location . . . a comfortable spot near the "golden section"—about two thirds of the distance from one side or the other in a horizontal format, and similarly from top or bottom in a vertical format. Although it is a choice spot for a figure placement, it may give your work a slight stiffness if you were to use it in every painting.

FREEHAND SKETCHING

The 5-Minute Freehand Sketch

You're in a French cafe, looking up at these figures and down at the sketchbook in your lap (so as not to attract attention and "lose" your subject), your eyes moving up and down a great many times as you're picking out a piece of the scene at a time, composing from a somewhat moving target. This time, you're sketching outlines and shapes only—but your drawing is freehand, not contour. In contour drawing, you look for the basic outlines of your subject. In freehand drawing, you also try to reproduce (with line) the feeling, movement, and emotions the subject evokes. The outside line is not an end in itself.

Now is the time for me to remind you to throw away your eraser! Look at drawings by Degas or Cézanne. These great Frenchmen described the edge of an arm or a mountain with several lines—they never erased their first impressions. And the many lines, side-by-side, create a shimmer, a feeling of movement. Had they erased them and left merely one line they would have lost the excitement.

Begin with the breezy umbrellas and quickly move down to position the two central figures, catching them in an attitude that you feel is attractive as a shape. Again move quickly to include the table, glasses, and foreground chairs.

Now draw in the figures to the left . . . and to the right, the lady standing under the overhead lamp. Their smaller size moves them automatically into the background to middle distance and makes the central couple the center of interest. Then draw in the smallest group of tiny people in the cafe across the street.

Hatch in some fairly open diagonal lines across the distant group of figures only. This really seems to push them away!

Remember the colors! This is the beginning of memory painting. As an artist, you can train your mind to remember color just by wishing not to forget an outstanding "painting" that you're in the process of sketching. You can also assist your memory by noting details and colors in "call-out" notes to yourself.

Assignment: Color a pale wash of cobalt blue and raw umber over the entire background. Include all the figures except the two central figures and the tabletop. While the wash is still wet, drop in a tiny bit of cobalt violet where the little group of people are sitting in the cafe across the street. Let it dry.

Place a second wash over your dry first wash. Color your umbrellas ultramarine blue . . . make the tablecloth a pale permanent rose . . . and the foreground, all chairs, a midtone wash of cadmium red light with a touch of cadmium orange on the backpiece of "her" chair.

Leave this watercolor unfinished, as an investment to be completed at a further date. Learn to stop before you are finished. It leaves food for thought and dreaming.

Plan Your Lines and Darks

In this busy outdoor market scene there is a consistent, planned repetition of curved lines and straight lines. This makes for a well-knitted, tapestry-like, overall pattern. All the shapes and pieces seem interwoven.

The curves of the umbrellas, arched palm fronds, and hurricane doors relate well to the *straight lines* of the architecture and tabletops and table legs.

Your darks control the eye movement from one side of the painting to the other side (push-pull). Also, the darks take your vision up into the tree, which is made up of curves and "straights." The upper right branch of the tree brings your eye down to the figures at the upper right and then past the umbrellas and figures to the lower left, where the table is covered with exotic-colored fruits. This is your center of interest.

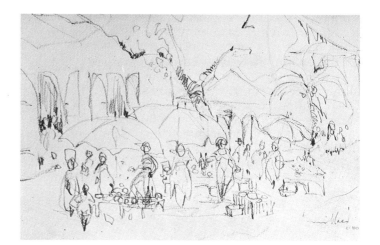

ADD FIGURES

How to Place Figures

You will now draw the scene in a combined technique of part contour and part free-hand. Imagine that you are creating a stage setting. Then wait and watch for the figures to move out "on stage." There will be a feeling of excitement when the figures hit the right "spot" . . . and you'll know it!

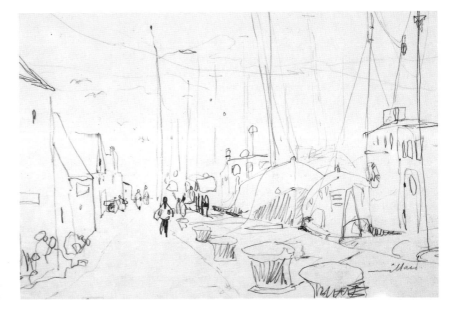

You'll have to invent the positions when your landscape has been "staged" and no one shows up for the party. If there's no one around to sketch, study your drawing and decide where it needs interest and place your figure(s) there. Don't worry about making mistakes. Your instinct for placing figures in the right spots will develop over the years. Just practice and it will come easily to you.

The figure in the center was placed well down the dock to give a good entrance into the painting between the boats, bollards, and buildings. Smaller figures are moving off to his left onto one of the boats. There is a lifting fog and the last group is down the dock in the mist. The center of interest gets the dark pants!

Cover these figures with your fingertip and see how dis-organized the composition becomes. It is just set up to make all these little people look like they "belonged" on the quay. That's where part of the magic of painting occurs.

Make Figures Part of the Dark Pattern

Draw all the buildings you want to make up your composition. Use a cardboard viewer if you need it to help you define your limits. This is your stage setting. You're drawing *freehand* now, with a very free use of lots of sensitive lines. This is quite different in interpretation from the simple, single-weight contour lines with which we started.

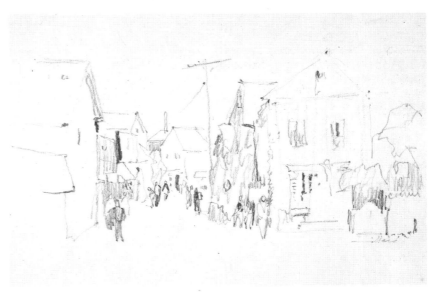

Imagine two arrowheads leading the eye from each side of the street toward the center. Work up your darks within this area, putting in the shadows and texture tones on the buildings. Work your dark figures into this dark pattern . . . keeping them along the base of the two imaginary arrows. Don't make all the figures dark. Let some figures be "out in the sunlight." But keep the center of the road uncluttered and without people.

This drawing is quite poetic. The more you approach photographic reality, the more you will lose the poetry. Remember this!

Add Figures and Darks to Direct the Eye

This is another freehand drawing, rather than a contour sketch. The lines here are freer, more sketchy. There is less of the solid linear quality of the contour sketch, though you can see some of that, too. *Although the perspective* moves to a vanishing point, the roof and road lines do not run from corner to corner as in the first diagram, but avoid the corners, as in the second diagram.

By putting darks behind the figures (to push them "out") and by aligning the figures along a line perpendicular to the base of the buildings and parallel to the bottom of the picture, you can draw attention to a cluster of people who seem to be gathered very naturally on the sidewalk. You will see later how this is used as a painterly device in a street scene.

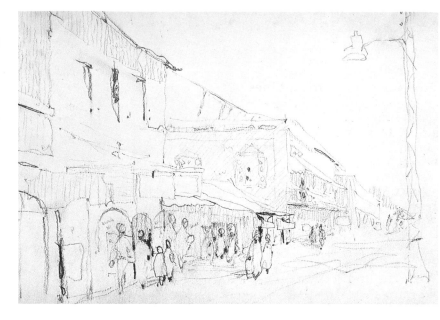

Place Figures and Darks Along a Single Plane

In this case only the *faces* of the buildings catch the morning sun. The sharp shadows of the people are cast perpendicular to the buildings and show that the sun is in the east. The horizontal line also serves to move the figures onto "the stage." The darks in the doorways, under the balcony, along the street curb, and on the trunk of the palm tree all guide the eye from one spot to the next.

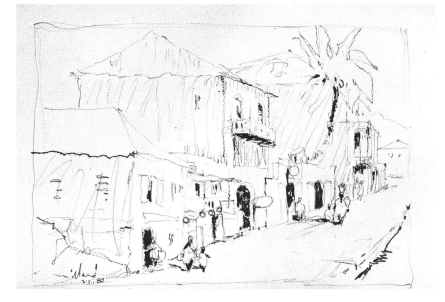

ADD TONE AND ACCENTS

Add Tone with Vertical Lines

Create your outline drawing of the buildings, keeping the single weight of the contour-line technique, but look up frequently to orient yourself in your drawing, as in freehand drawing.

The light is higher in the east now than in the preceding sketch, so plan in your mind where you want shadow patterns to fall.

Keep your vertical toning lines open . . . not too close together. Starting at top left, hatch in the tone on all the roofs and their shadows all the way across to the right.

Next . . . drop down at the left and work your way across all the balconies and awnings with your shadow hatching.

Finally, drop down to street level and work across, putting in the well-designed arrangement of figures. Behind them hatch in all the dark door recesses. Notice that several diagonal lines are used to make the street rather than a single line as in the first three drawings in this chapter. That's because this drawing is freehand while the others were contours.

The effect of atmosphere has been created by the use of these vertical hatched lines. Again, this freehand drawing has a painterly quality and differs greatly from a tight photographic rendering.

Use Darks for Design and Contrast (5-minute sketch)

Sometimes darks are used not to guide the eye, but to enrich the painting. The detail sketch of the young girl eating her meringue shows the placement of darks behind the food on the table *in a stripe.* The dark backdrop exists only to enhance the items in front of it. The still life and girl are set forward "on the stage" by this use of *chiaroscuro* (literally, *chiaro*-clear; *oscuro*-dark)—the arrangement of the lights and darks in this drawing.

Use Darks to Organize and Enhance a Drawing (5-minute contour)

This is similar to the sketch above, but the darks are placed *in a wedge shape* here in order to organize this handsome but scattered group of farm buildings. Whereas the preceding sketch had a flat band of darks, this drawing shows an interchange of darks on roofs, doors, sides of houses, and windows. In other words, these darks are moving from behind the buildings to the front and sides.

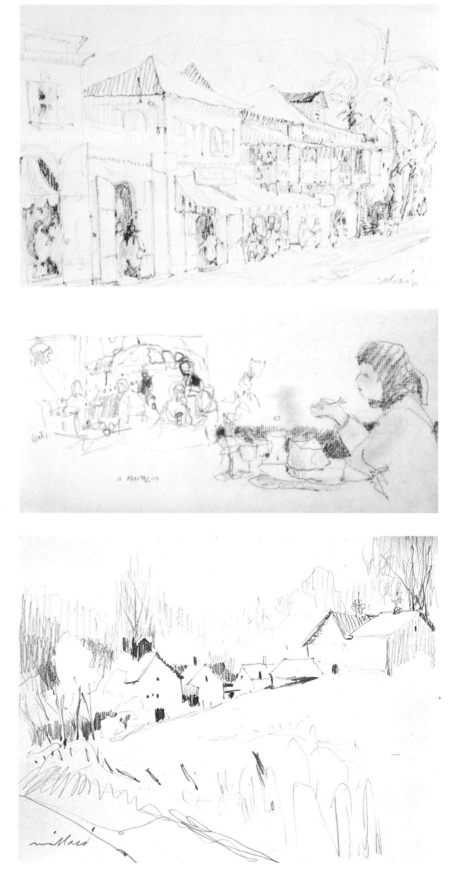

SPEED SKETCHING

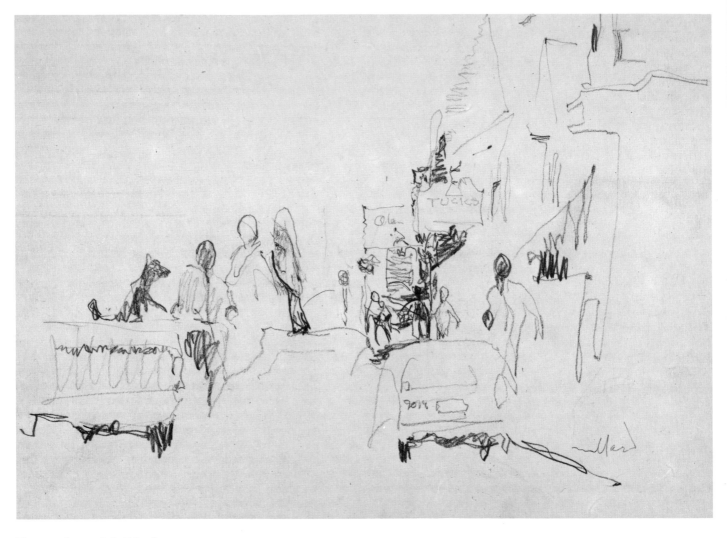

Patterning with Blacks

This drawing shows the outline forms in contour line of all the buildings, cars and people. But it is the patterning of black bits and pieces that really forms the structure here. This speed sketch has a good, fluid line which has produced a complementary vertical foil for the angle of direction of the darks.

When I set out to do a street scene, I usually have no preconceived idea as to composition. But as I was sketching, a pickup truck arrived with a black dog in the back. Then friends began to come over to greet the owner and the dog and suddenly patterns and pieces of darks began to stand out where none were noticed before. In drawing such a scene, this is how you would proceed:

First . . . draw the black dog . . . get the gesture!

Next put in the dark underpinnings of the two vehicles and the curb to form a base. Then add the figures by the truck—quickly or they'll move. Then work your way across the sidewalk and up into the lines and black pieces in the buildings, adding the little dark triangles of awnings and bits of signs.

This is all done so quickly that I call it "speed sketching." A great deal of emotion went into these fluid lines. But I had to work quickly because within five minutes, it was all over. The truck had pulled away and the figures were gone. This is one of the reasons why it's so essential to practice your 5-minute contour drawings.

Hint: Capture this spirit by drawing more rapidly than you think possible for *your* ability level! Just try copying this drawing over and over until you can catch the emotion of this incident. And as you draw, be aware that there is a very definite pattern happening with these black pieces. Notice how they interlock and relate to guide the eye. You will find other such examples of emotionally charged sketches in future chapters.

CROP YOUR DRAWINGS

Crop by Design

You are looking at a busy harbor scene, trying to get a good composition. If you need to, look through your cardboard viewer. Otherwise, decide how much of the scene you will include, and where you'll crop it. This scene has the makings of an important painting. So plan to include not only the central core of the composition, but also a generous border at all four sides. Include all the ships and some water below them and also extra buildings at top and sides. Make a 30-minute contour drawing. This can be the preparatory study for a painting.

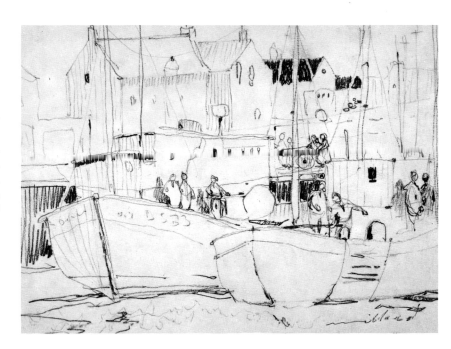

Crop by Intuition

After you have completed the drawing, take another look at it. Study it. What do you think of it?

If you have the curiosity to explore a bit further, hold up your cardboard viewer or make a box with your fingers and move it back and forth like a zoom lens, each time showing larger and smaller segments of your drawing. (See diagram and instructions on making a viewfinder.) If you like the strength of this area "where the action is," then redraw just this section. You are cropping by instinct!

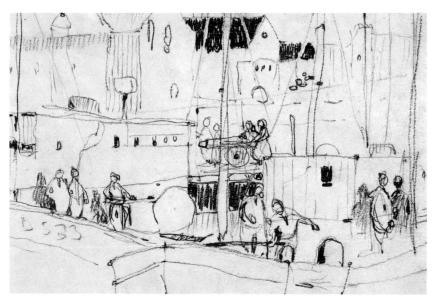

After you have finished this second drawing, place the two sketches side by side and—again by instinct—choose the one you prefer. This is where I will almost always paint a watercolor sketch of each and then choose the one that will become the final painting.

To make a cardboard viewfinder, take mat board or strong cardboard and cut out a piece 5½″ × 2¾″ (140mm × 69mm). Fold it in the center vertically, scoring the fold with a knife. Tape the fold on the underside. The left hole is 1¾″ × 1⅜″ (44mm × 34mm) and the right hole is ⅝″ × 1⅜″ (15mm × 34mm). This bottom half folds back to 1⅛″ × 1⅜″ (28mm × 34mm). Keep 4″ (10cm) all around the 8″ × ½″ (203mm × 12mm) "value checking slit," a separate unit from the viewer.

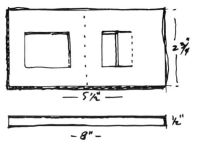

LANDSCAPES

Add Tone to a Contour Drawing

You want to capture the radiant light of these pastel houses by the sea. This is St. Tropez—but it could be anywhere!

Begin with a 5-minute contour drawing—keep your contour linework light, and throw away your eraser to reclaim errors.

Now add tone. Apply a pale, soft smudge over all the shadowed areas, saving your lights (just leave them white). Then rub in some deeper tones and add a few dark accents to the doorways and on parts of the three figures to attract the eye.

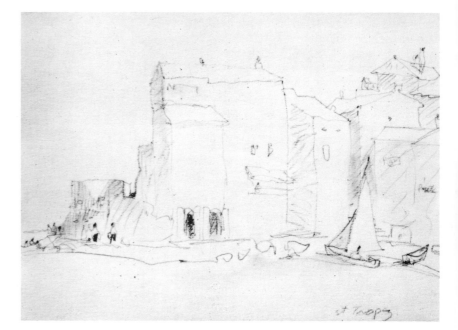

Add Tone with a Carbon Pencil

You are looking down from the cathedral grounds into the warm and cool mixture of earth tones in the old city of Cannes. You only have time for a 5-minute freehand drawing, and you choose a carbon pencil because it provides a range of tones from soft velvety grays to jet black.

There are many tones here, and each building and roof texture is handled separately. Some tones are made by rubbing, then hatching lines over the smudged tone. Others are indicated with vertical lines only. The deepest accents are solid blocks of carbon tones—first smudged, then restated.

Note the cleavage, the way the dark vertical pattern splits the paper. The left foreground is kept white to balance the white side of the building on the right. The uneven quality of the edges makes this drawing a *vignette*.

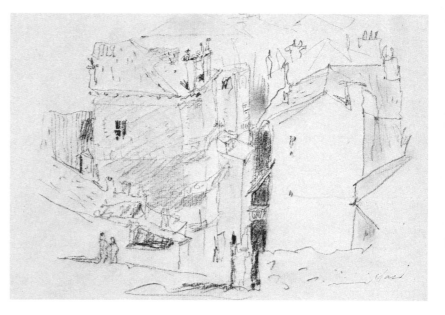

Smudge to Make Edges Soft

With a mixture of contour drawing and freehand sketching, make a 30-minute drawing of these buildings. Carefully position your figures, then hatch lines in some shadow areas for "mid-dark" tones.

On a separate piece of scrap paper, rub some carbon from your pencil (hold the pencil sideways as though you're sharpening it) to create a dry "smudgepot." Rub into this carbon supply with a finger or tortillon.

Apply soft, pale smudges to the foreground figures. Work right over the first figure. Rub alongside the second figure to soften the edge toward the shadow of the doorway. Smudge a tone over the roofs and sides of the houses, then over the third figure from the left to move it back into the interior. Leave the next group white so they appear to be standing out in the sunshine. *Wash your hands after smudging.*

Smudge to Suggest Lighting on Figures

This is another 30-minute contour and freehand drawing. First prepare your stage set. Draw the buildings, and place some figures on the street and some on the balconies. Now you are ready to suggest the lighting.

Begin by smudging the shadows. First put in the roof shadow, working around the figures on the balcony on the left. Then work on the second balcony, but this time bring the roof shadow down over the heads of the figures there. The result? The first group of figures are frontlit, while the second group is in the sun from the waist down. They seem to recede into the distance.

Now work on the figures in the street. The figures on the left are mostly frontlit, though a few are in the shadow of the doorway. The woman with the basket on her head is partly in the shadow of the overhead sign. This is the center of interest. *The figures on the right* are backlit. Throw shadows over their bodies to show this.

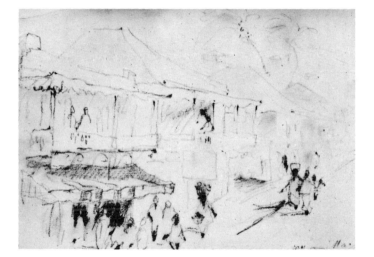

Create Tone with Directional Lines

Study this 30-minute freehand drawing. Notice the variety of directions the lines take, in individual segments. For example, the edge of the rooftop on the left is created by lines that come from the branches of the tree *behind* the roof. An eave is formed where a series of horizontal lines end. A middle tone connects all these buildings, creating a unity of pattern. Each building or part of it is treated with care and affection. Learn to love your drawings!

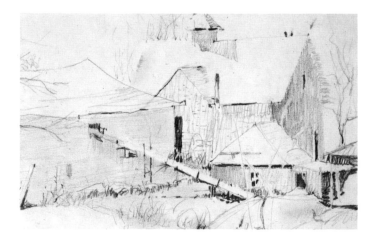

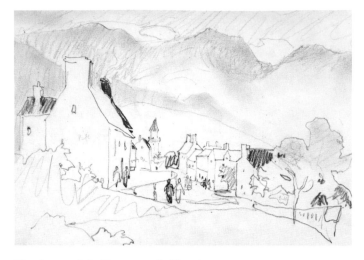

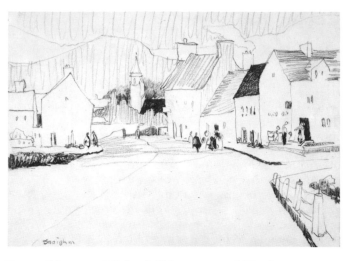

Design with Tone and Contrast

First draw a 5-minute contour drawing. Put in just the major shapes—the houses and distant mountains—then decide where you want tone.

Select a few very dark spots to lead the eye across the picture plane, back into the distance. Then smudge a light tone over the rolling mountains. Notice how the soft, gray tone of the mountains contrasts with the sharp, white shapes of the sunlit houses. Look closely. There are many contour lines, smudges, and lines over smudges here.

Draw Lines to Make Midtones and Darks

This is a 30-minute contour and freehand drawing. There are a variety of tones here. The sky has the lightest tone because the lines there are furthest apart. The mountain behind the village is a bit darker because the lines there are closer together. Repeat this variety of lines in your own drawing.

The blacks in the drawing have been carefully designed and placed. The figures were also carefully positioned in the scene, and each has an individual "look." Can you see how the figures and darks help the overall design of the picture?

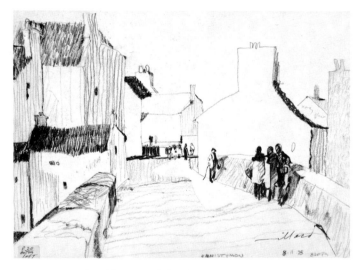

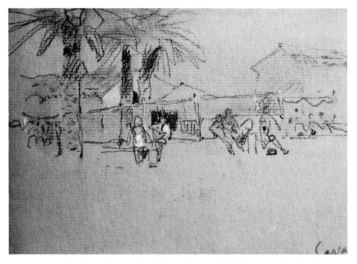

Get Special Effects with Line

If you draw a group of buildings and make them all look alike, your drawing will be dull. Treat them as individuals, each with its own personality, as in this drawing.

In this medieval town in Ireland, each building had a special quality . . . a certain character, and so each was treated in its own specific manner, through line. Look at the variety of textures here, and the way each is described: a thatch roof . . . a slate roof . . . stone buildings . . . plastered dwellings . . . the bridge to the village . . . the dirt road . . . the chimneys . . . all centuries old. And look at the villagers, each drawn with affection. Is there any question that they are the center of attention? Turn this drawing upside down to better abstract the blacks. Darks serve a dual purpose—as part of the abstract pattern and as a descriptive element.

Try Another Sketching Medium

Copy this scene of French Riviera bathers in black Conté crayon. Conté crayon is a dry, compressed drawing stick having the same texture as carbon, and resembles the chalk of the old masters. It is used here, in this 5-minute contour drawing, along with white and red (or sanguine) chalk on gray drawing paper.

Carefully study your composition for the white accents: a sunlit house siding, two bathers, and a series of white sticks . . . your center of interest. This time you are adding your whites to the surface of the paper rather than leaving white areas blank . . . and it is the *white*, not the darks, that is leading the eye.

You are also adding color through your spots of sanguine chalk . . . on the roof tiles, palm trunks, and on two of the bathers.

STILL LIFES

Sketch Still Lifes to Learn Composition

There are two typical 5-minute contour drawings on this sketchbook page. The drawings show the outside shapes and lines of the setup, and there are value smudges (done with the side of a finger or a small piece of chamois), along with some rapidly drawn blacks. The vitality and freedom of these black lines maintain the loose, sketchy quality of the drawings. Both still lifes have a different shape.

Trapezoid shape (top): The shape of the draped fabric under the still life gives a direction and orderliness to the composition. The garlic, fruit, and pineapple-shaped sugar bowl follow this line of direction. The best place to put the vase of flowers is behind and to the right (see diagram).

Parallelogram shape (bottom): The grid behind this still life comes from the base line of the sketch and helps you orient the directions coming off the mustard tin. The end and top of the tin creates two of the angles and influenced my decision to work on a frame of a parallelogram. There is a robust, deep quality to the lines and tones that should indicate that when you paint it, the colors will be richer and the values darker than the top sketch. (The upper sketch is higher in key and suggests lemon, orange, lime, and pink colors.)

Assignment: Whether you are a novice or an advanced artist, you should do at least one still life.

1. Begin with two or three 5-minute contour drawings of your subject.
2. Pick one of these quickies and do a 20-minute value study of it.
3. Now draw the outline on your watercolor paper and paint it, working directly from your *study* of it—not from the still life itself. Why? Because you have already made your intuitive interpretation of it. Just refer to the original setup for minor details and color (later, you'll learn how to invent your own colors) or to see how a shadow or edge looks. This is memory painting, and we will go into this in detail later.

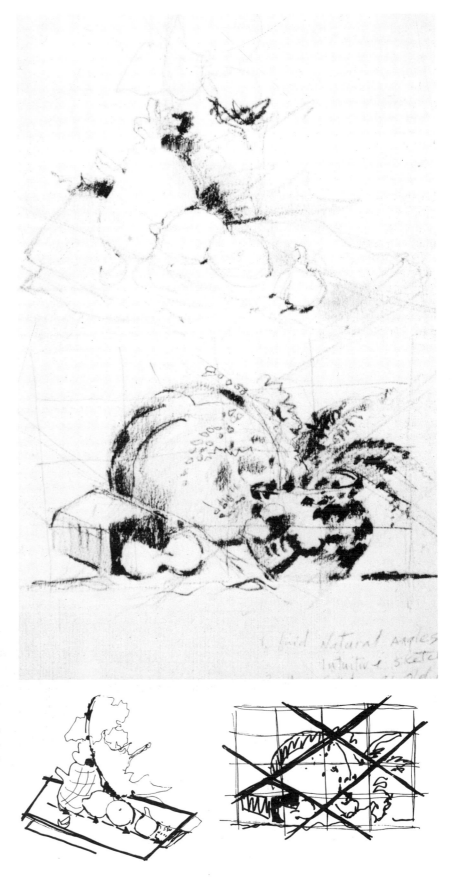

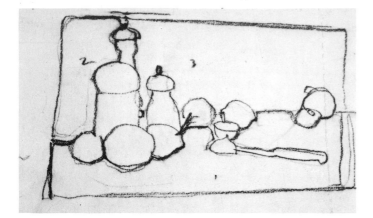
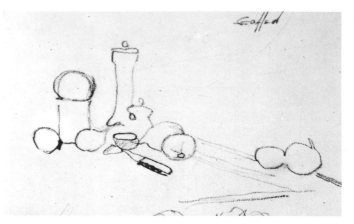

Select a Good Vantage Point

This still life is composed to please your mind's eye. When setting up an arrangement like this group of fruits and vegetables, salt and pepper grinders . . . move the objects around until you have a satisfied feeling about their relationships with each other. Make your unshaded contour drawing "frontal position," as in the first illustration. Box it in so that you can see the negative shapes as the objects relate to the four sides . . . and look for good shapes!

Move to the right around your first setup until you have an equally exciting new composition. You haven't moved a single item and yet you have discovered a new setup for the next painting. Orient yourself by the angle of the knife and the cut onion . . . "⅝ position."

This is like landscape painting. You encircle a still life setup just as you would walk around the barn to see what is on the other side. One painting does not exhaust all the potential compositions. Painting still lifes is where you learn to compose. You could make six or a dozen sketches from different angles of the same setup. You can do the same thing in life class . . . move around the model.

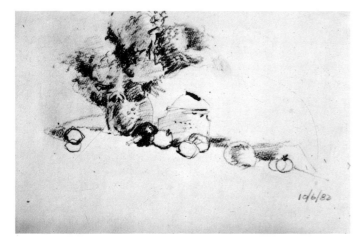
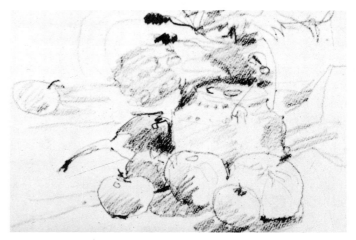

Let's Take Another Example

This time the angle is running slightly diagonal. Draw your contour in a flat frontal view as in the first setup. Next draw in some simple shading as illustrated to get the feeling of some depth. Concentrate your darks in the handle and in the eggplant. This is all you need to trigger a good painting from memory. Try it!

Now go around it and look at the end view. Same setup . . . nothing moved except you . . . but you have a new composition . . . a new painting! Follow the illustration for shading. Note the vertical alignment of the darks to accent the side of the earthenware pickle crock.

Assignment: Now try a new memory painting from your carbon drawing . . . this time without a black-and-white drawing to "guide" yourself. Paint direct!

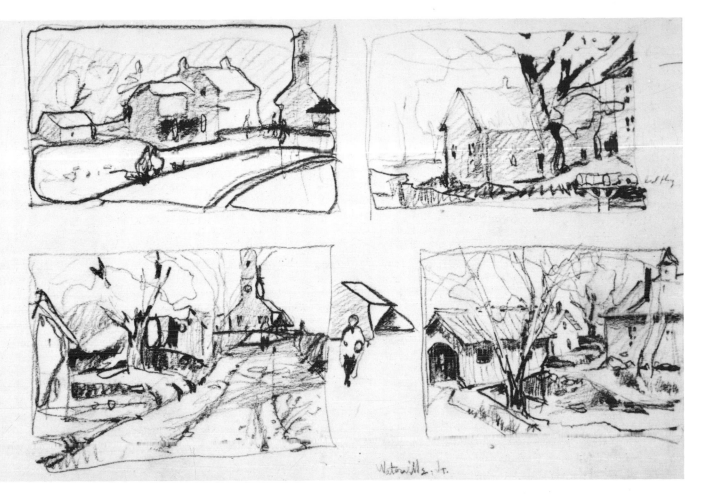

Earth and Ground Lines

Always be alert to interesting shapes and patterns. This little Vermont town offered so much rich material that rather than select a single viewpoint, I instinctively based four different segments on the area around the church and bridge on a single sketchbook page. Putting several drawings on a single sketchbook page is a technique that lets you collect a lot of good material in a hurry.

Earth lines are very prominent in Vermont. It is easy to see these curved lines at the bottom of the stone walls, barns, and country houses. These ground lines help you divide the composition into several abstract pieces of design. Let's look at each of these sketches individually:

Sketch 1 (top left): There are five major abstract shapes in this 5-minute contour sketch (see diagram). Notice how the edge of one object forms the boundary of another. For example, the outline of the buildings also forms the lower boundary of the sky piece. Try to be aware of this as you're drawing. Notice also that smaller abstract bits and pieces have been outlined as a reminder of where the sunlight is hitting.

Sketch 2 (lower left): This is the same scene, but from a different angle. We are looking uphill toward the church, and the earth lines are on both sides of the road. I did a small drawing of the figure to clarify how it breaks the

ground line in front of the church. This pushes the figure toward the viewer. Don't hesitate to make marginal notes like this to yourself to clarify information, report greater detail, or provide a visual explanation.

Sketch 3 (top right): The earth line here is very uneven and rough. It runs along the base of the house on the extreme right, and continues under the barn and manure pile. Notice the way these abstract bits and pieces fit.

Sketch 4 (lower right): The earth line here runs along the edge of the river (across the base of the sketch) and goes under the covered bridge and along the barn on the right. The center of interest is now the white house behind the covered bridge. When you work this sketch into a large watercolor, put a figure or two in front of this white spot. Other abstract pieces are here, too. These shapes are attractive and add design interest. The sky is also a good shape and acts as a foil to all this tracery of branches.

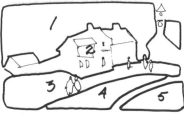

ADD SKYLINES

"In-lines" versus Outlines

You are looking at a sky and I want you to have "double vision." Let me explain:

First, look at the sky piece. It is resting on top of the mountains and is a placid shape (that's polite for "boring"). The base of the sky also forms the outline of the land mass.

Now look at the in-line. It is well below the outline of the mountaintops, which forms the border of the landscape mass, and it runs along the tops of the barns, silos, and outbuildings.

This in-line is too good to waste. If you were to draw the scene as you saw it, this in-line shape would be lost against the mountains. But you can turn an everyday landscape into an exceptional one. By sacrificing the pale mountains and little puffy trees to the larger shape of the sky, making the skyline border the same as the in-line, you now have a fabulous abstract shape for the sky! Turn the sketch upside down to better see it.

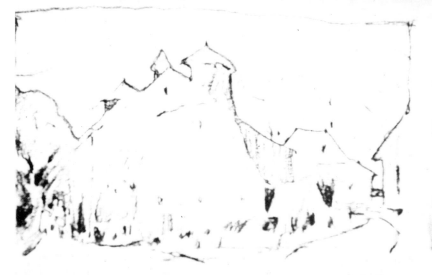

Accentuate Negative Shapes

Always be on the lookout for good shapes when you're out on your sketchbook rambles. Here are two of several sketches from a page from my sketchbook on several subjects within the same location. Each sketch has a very stimulating skyline or sky piece—in fact, that is what prompted the sketches.

In the first sketch, the land mass is unified and simplified by the shape of the sky piece. The land mass also includes the little man in the skiff and several rocks to the left. Why? So the shape of the sea piece (the third abstract piece) has a more interesting shape.

The second sketch contains two negative and two positive shapes. The two negatives are the two sky pieces and the two water pieces (fore and aft the boats). The two positive areas are the single land mass with the buildings, and the dinghy and the lobster boat. Get used to seeing large areas in terms of the shapes and patterns they form.

EMPHASIZE DARK NEGATIVE SHAPES

Mass Details into Basic Shapes

A sky or land shape is easy to design when you have the strong abstract silhouettes of the preceding landscapes and seascapes to inspire you. But suppose your subject is just a mass of bushes. How in the world can you abstract them into shapes? How can you design negative shapes within a solid mass? You will need patience and a seeing eye to impose a structure on these trees. You will also need a bit of imagination, to shut off the reality and look at this group of foliage as design pieces . . . as abstract bits. Then you will break this mass into four values—a white, a light gray, a midtone, and a very dark gray.

Plan your whites first. These will be your tree trunks (you say they're black? Don't worry about the reality. You're designing it). Note how the diagonal chunk of white at the lower left fills the corner and supports the midtone diagonal band above it and provides a base for the white trees.

Then start by massing your light gray tones with your carbon pencil held lightly, as if to scrub it on. Be careful not to smudge these tones with your hand or cuff. If you're right-handed, start at the top left and carefully work your way across and down. Select part of a negative shape and render it . . . then another and another until you've covered all but a few little sky peek holes.

Now add the midtone. Squint! Do you see the midtone band running from the top left diagonally down to the lower right-hand corner? Render this darker midtone just within the envisioned band. Now this band didn't exist until I drew it—and this is an important lesson, one I'll be teaching you again and again in this book. You must always think in terms of design . . . of poetry . . . as you draw. Use your wits . . . dream it up . . . be original!

Put in the deepest gray tones last—but only within this midtone band. Then look at nature—it's right in front of you, though you must design it—and decide where you want the blacks. Remember, you're leading the viewer's eye. But don't overdo it. Don't overdesign your picture. Understate.

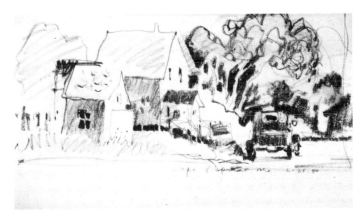

Design Landscapes with Darks, Vignettes, and Shapes

This attractive clutch of buildings made a natural subject for a painting. In fact, it was almost too pretty, too like a postcard. And so it had to be redesigned.

First decision: Elongate the composition to get rid of the postcard shape.

Second decision: Design a "cascading" row of black fingerlike shapes above the bushes at the entrance to the house. The truck drove into the scene just in the nick of time (this was no fake prop). It is a dark gray, with black underpinnings, tires, and differential. These horizontal darks are just enough to stop the cascade of blacks around the birches from running the eye out of the picture at the bottom. Since the eye is still being pulled to the right, put in a jet black shape on the shack roof for balance.

Observations: Can you see how important the shape of the sky piece is to the sketch? Notice the soft, round shapes of the trees and the complementary angular shapes of the roofs. Do you see why the chimney was *not* placed in the center? The decision to leave the ground line soft and unemphasized helps to give a vignetted feeling to the bottom of this drawing. After a while, if you sketch enough, you will begin to "see" paintings when you spot a subject. Even before you sketch it, you will feel a tingle . . . and it will "fall right off your brush" when you come to paint it.

Design Figures with Darks, Vignettes, and Shapes

Whether you're drawing landscapes, still lifes, or people—and I will make this point again and again—the same design principles hold true. This picture is very much like the preceding one. Again, carefully selected black negative shapes concentrate attention—this time on the legs—as the center of design interest.

Add two wedge-shaped pieces to define the back edges of the table the model is seated on. Then smudge the tones with your finger. As you smudge, the soft shapes of the shadow sides of the rest of the furniture appear in quite an abstract fashion—and you decide to keep this vignetted shape on the top and two sides. Finally, add the two upper darks. The one on the left pushes the shoulder out toward the viewer and is a negative shape. The other dark is just there for balance.

And Have You Considered . . . Would you have put darks only around the legs and tabletop? Turn the sketch upside down and see how well they relate to the composition as a whole.

Would you title this sketch *Legs?*

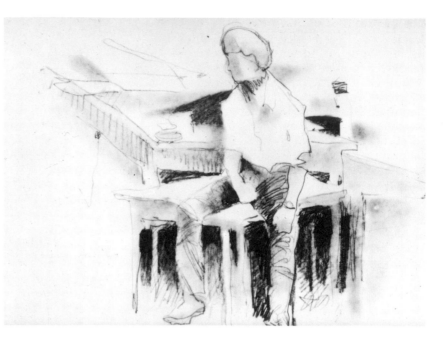

USE YOUR SKETCHBOOK . . .

Work Out a Composition

Again, working out ideas for a composition is also an important use of your sketchbook. Sure, you can sit down with your watercolor paper and do a beauty of a painting . . . but this way you have captured seven possible compositions, you have expanded your feeling for the place, you have gained intimacy with your subject, and you have learned a lot more about composition, too.

Now when you sit down and do your watercolor, you not only have that to take home with you . . . but you also have enough material to inspire several more paintings. And the experience of working out these compositions will help you to learn to "see" what you want to paint, too.

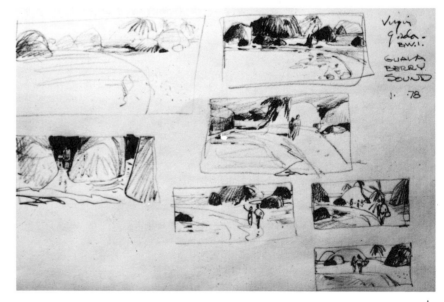

Design the Sketchbook Page

Besides being a great place to practice drawing, test your memory, and record ideas, the sketchbook is also a place to practice design. Of course, you are designing each sketch as you draw . . . but what about the planning that goes into placing two or more sketches on a single page?

You have just finished the top sketch of the beautiful terra rosa-colored church and its surrounding filigree of houses, choosing a square format to reinforce the feeling of the huge church. But it is not the only drawing you will do today. You have left space for another.

You walk to the waterfront and watch the workers load a boat. You also want this drawing, *Loading for Tortola*, on the page, but you don't want it to interfere with the visual flow of the street above . . . so you box it. It solves the problem of keeping the drawings separate . . . and it makes an attractive page.

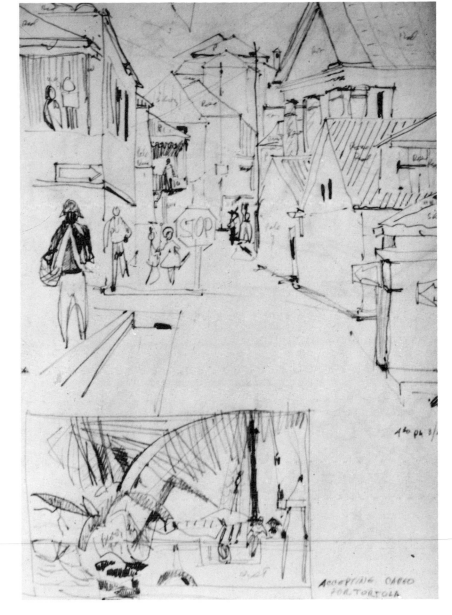

Before we start painting, I'd like to say a word about brushes. I swear by the Winsor & Newton Series 7 sable brushes (sizes 1 to 14). The size you need depends on the size of your watercolor sheet. For full sheets (22″ × 30″/56 × 76 cm), you'll need brush nos. 9, 10, 12, and 14, as well as nos. 3 and 8. Smaller sheets require smaller brushes—like nos. 5 or 7. I also use very inexpensive Japanese bamboo brushes. They come in a variety of sizes and hair such as fox, squirrel, bear, wolf, etc. Try

painting with them and see how they suit you. Try a set of ⅛″, ¼″, ½″ (3mm, 6mm, and 12mm) diameter to start, and if you like them, then get a more expensive 1″ (25mm) diameter "horse." It can hold "a cup of water" in its hairs and is marvelous on a full-sheet floral. I also recommend a no. 8 Delta Finest Selected "natural" curved French bristle oil brush for special edges. (See page 69 for a photograph of my brushes and palette.)

Determine the Light Direction

Select a composition for your first color wash based not on round forms, but on the *cube*, where the light direction is more obvious. By adding a wash to the shadows, you can show form, change your sketch from flat to three-dimensional form, and practice laying washes. Always study your drawing to see which way the light should come before you add shadows. Perhaps you may find a better design of light than one you see.

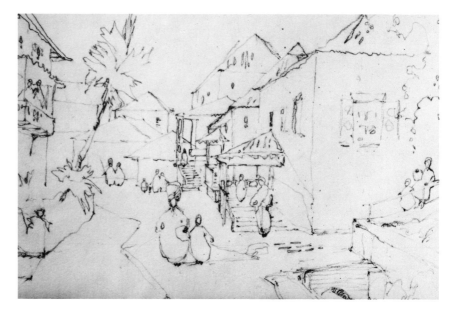

Add Shadow Washes

Mix up a puddle of shadow color, more than you think you'll need. Use a combination of cobalt blue and raw umber.

The sun is coming from the left in a morning side light. Paint a red dot in the upper left-hand margin of this painting as a constant reminder of the light direction. It may look strange, but this little red dot has prevented many a spoiled watercolor.

Hold your work at a 5-degree angle. (Always do this when laying a wash.) Starting at the upper left (if you're right-handed), paint the face of the backlit houses. Then, on the right-hand side of the painting, paint the area facing you. Leave the space between these houses blank, saving the whites. Remember, you are designing as you paint.

Complete your washes, carefully checking the illustration each step of the way.

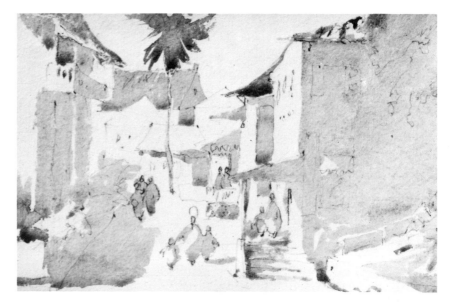

Prepare a Drawing for Front Lighting

You can suggest shadow on the drawing itself to help you place your washes. For example, the shadow between the two left-hand houses is noted with continuous lines. Another shadow further down the street is indicated with darker lines, with open spaces in-between. And there are dark accents—like the ones under the balcony and behind the figures—to describe the deepest values.

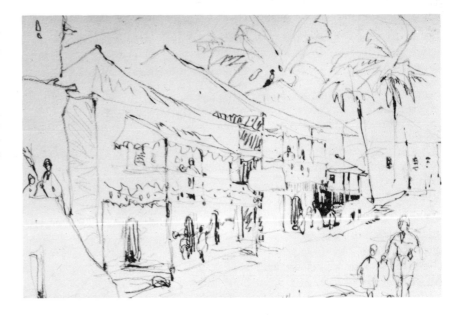

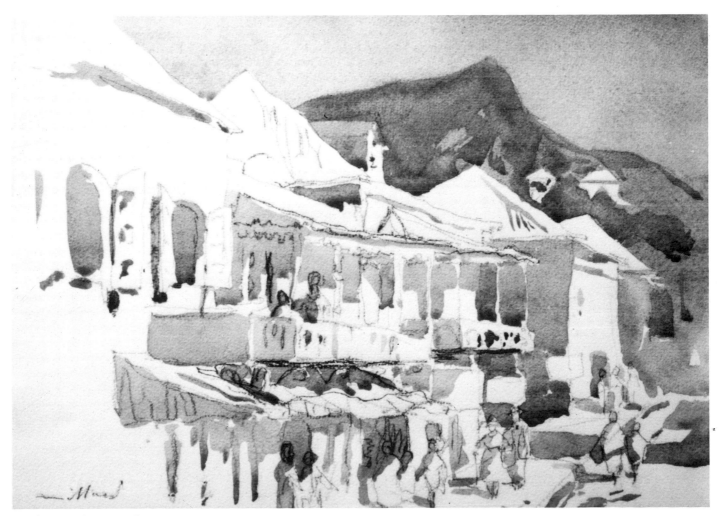

Add a Darker Wash

Here's a similar scene with the shadows painted in over a 20-minute contour sketch. Again, begin with a big puddle of shadow wash (the same colors as before) and paint left to right across the sky, around the rooftops, down to the upper windows and balconies. Then work at street level, cutting around the posts. Remember, you're de-signing every inch of the way. Then let everything dry.

Now for the dark wash. To your first puddle, add a bit of ultramarine blue with a touch of ivory black . . . this gives you a darker, richer tone. Apply this second wash to the mountaintop and to a few selected dark spots around some balconies, an awning, and the heads of the two figures.

29

Design with Just One Color

You don't have to paint only landscapes. There are subjects around you everywhere, paintings to be made from everything you see. This one was in the life class.

After about half a dozen five-minute poses, I noticed the patterns occurring in the group of fellow artists on my right. So next pose, I sketched them instead of the model. And during the next pose, I laid in a fast bistre wash around the pieces of white that were happening in a good design, with perfect positioning.

Assignment: First copy this sketch. Then make a second copy and fill in the brown tone to square off the bottom. Which do you prefer? As you approach photo-realism, do you see how you lose the magic?

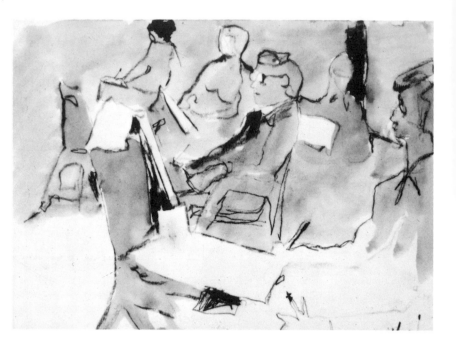

Design with Two Colors

Sometimes you can find interesting new subjects right in your own kitchen! Here's a batch of kitchen knives, along with some spoons in a jar, with mortar and pestle resting against a wooden panel. A "piece of white" was designed as a rectangle, to complement these three forms. The wash was simple . . . just varying amounts of yellow ochre and Davy's gray. Note the spotting of the darks.

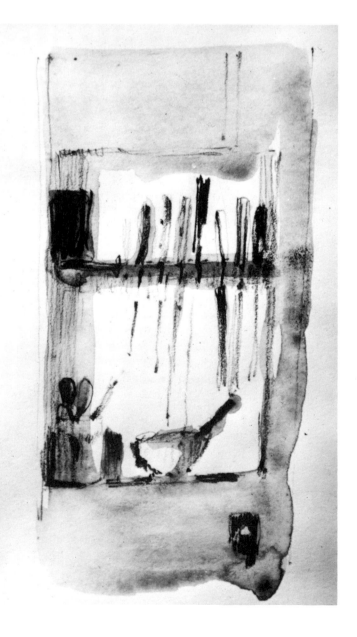

Design Color Shapes Carefully

Even a simple subject, like a game of checkers, makes a good painting—if you design it well. I happened to walk by as my wife, Edie, was playing with two boys we were babysitting for and . . . wow! This sketch fell onto the paper in a flash!

Look at the design patterns—then turn it upside down and look again. Many of the smaller pieces contain tones hatched in with lines. Can you see how they relate to each other and to the picture as a whole? The color here is just raw umber, painted over the finished sketch.

Assignment: Make a second copy, this time filling in all the whites except the window. Compare it with your first copy. Do you see how you lose the poetry as you near realism? Remember this!

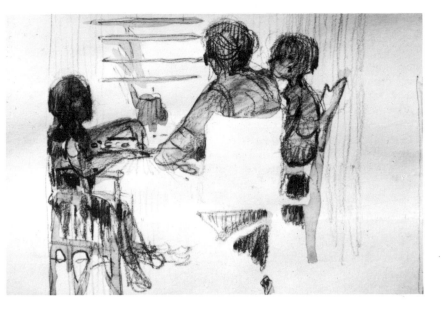

Play "Design Games" with Positive-Negative Shapes

This looks like a sketch of a ship . . . but it's actually an excuse for a "design game" with a one-color wash. Notice how the shapes of the ship—flag, antenna, and street signs—are breaking out into the white area in the upper half of the sketch. While, in the lower half, just the opposite is happening: The carefully designed white pieces are *fitting into* the toned wash, a combination of permanent rose and lamp black. The top is a lesson in vignetting; the bottom, practice in reserving whites.

This is also a lesson in composition. Notice how the sketches on these two pages fit their prescribed perimeters. For example, look at how the diagonals in the diagram run from left to right and follow the angle of the boom.

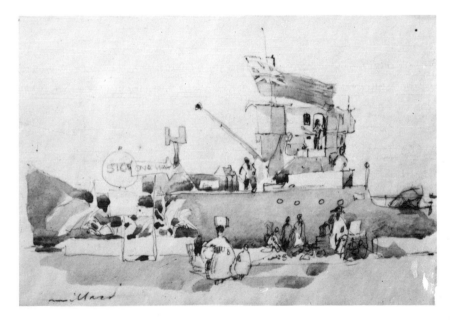

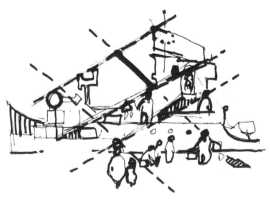

ADD WASHES FROM MEMORY

Tone Your Sketches from Memory

I remember driving past this great sugar maple in front of a farmhouse in Vermont. I couldn't stop, but I had seen it . . . and one glance is all you need. This is where your sketchbook—and your memory training—comes in handy. Observe, then record your memories in the sketchbook. Get the facts . . . get the shapes . . . get the values. Simplify your sketch—and also your colors. It's easy. Start cultivating the sketchbook habit. It has been used throughout art history. This is toned from memory in just three colors: mauve, burnt umber, raw umber.

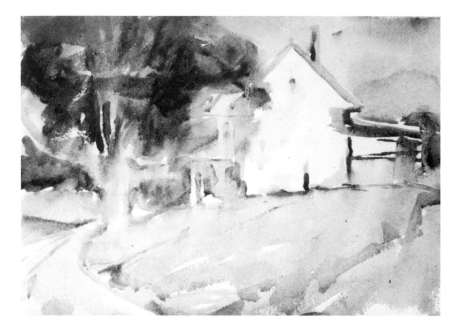

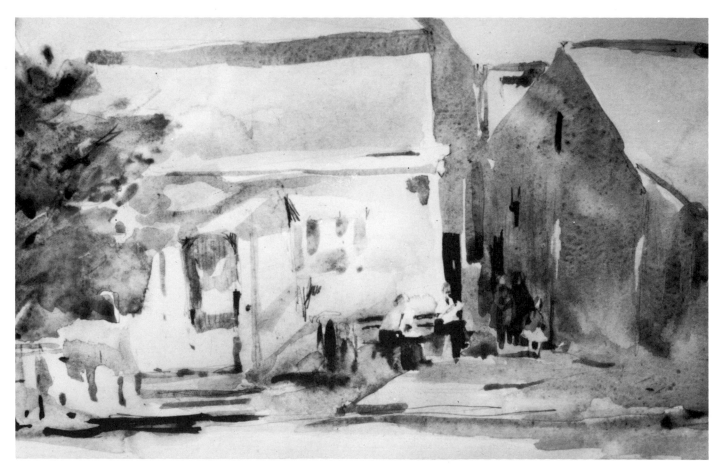

Try Another Memory Sketch

This is a scene I'm sure you've also observed many times early in the morning . . . someone reading the morning paper. Now we're moving away from black and white tones into a controlled atmosphere of restrained color.

The figures are the feature here . . . some in sun, some in shadow. The little girl in white and pink, along with her mother and sister, is almost lost in the deep shadow tone of ultramarine blue, burnt umber, and cobalt violet. Try it . . . these are your colors.

Gradually Deepen Your Colors
(Work into the Picture Plane)

You will work in just two colors, ultramarine blue and permanent rose, each with a touch of ivory black, and build them up one wash at a time, letting each one dry in between.

Start by deciding where you want your white areas saved for a design pattern (I chose the sunlit foreground), and apply your first wash to kill the light everywhere else. Gradually build up your darks by glazing one wash over another after it has dried. Note that the blacks occur along a planned, designed strip that runs behind a few of the heads and necks of the people and on the center of interest . . . the little tot in red.

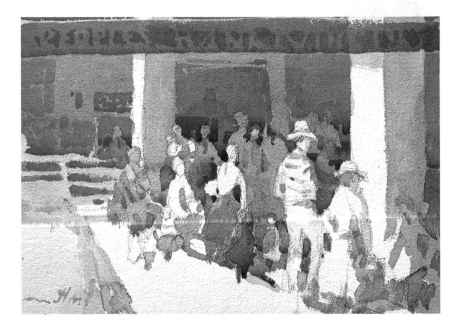

Use Deep-toned Primary Colors
(Move Further into the Picture Plane)

This is a study in perspective and in ways of moving the eye back into the picture plane. You are using the primary triad, cobalt blue, Venetian red, and yellow ochre. The success of this sketch depends on your getting these colors and values right on the nose.

Mix each color in your tray as three separate puddles and apply them in a series of glazes, letting each wash dry in-between applications. The center of interest is the figures under the awning . . . those out in the sun. The sky is a mixture of blue and red with a touch of yellow if it gets too purple.

Let's review the ways you can move the eye into the picture plane:

1. By breaking into flat washes of neutral color with a few dark accents.
2. By glazing colors in layers, deepening and darkening them as you approach the foreground.
3. By receding the lines of the drawing to the horizon and making objects get smaller as you go back.
4. By diminishing the value of your colors as they recede.
5. By making your figures get smaller in the distance.
6. By losing the figures in tone and light.
7. By placing the cloud at a contrasting angle to the roofs so it seems as though it's breaking through a veil of focus . . . another layer.

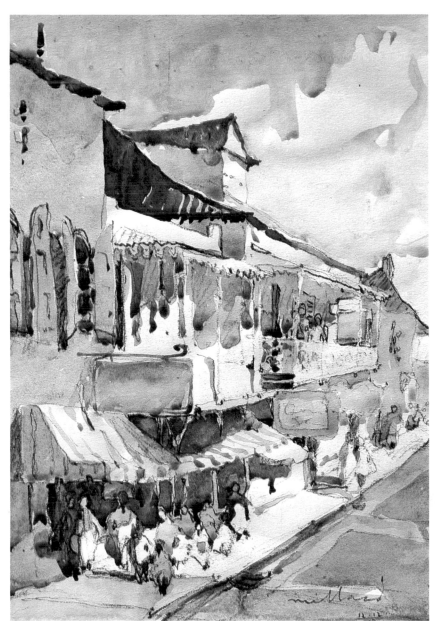

USE THE PRIMARIES

Look for Simple, but Dramatic, Subjects

The search for new subjects is a never-ending process for the artist. I was in Ireland, on my way to a pub, when I ran across this handsome group of buildings. The scene looked like a painting the minute I spotted it . . . even the figures appeared at the right time. But I had forgotten my sketchbook, and so I did this 5-minute contour drawing on the back of an envelope I luckily found in my pocket.

After a while, you will acquire the knack of seeing subjects as finished paintings. I think it has to do with the light . . . or the way one color is reacting with the others . . . or with just having plenty of practice in spotting one.

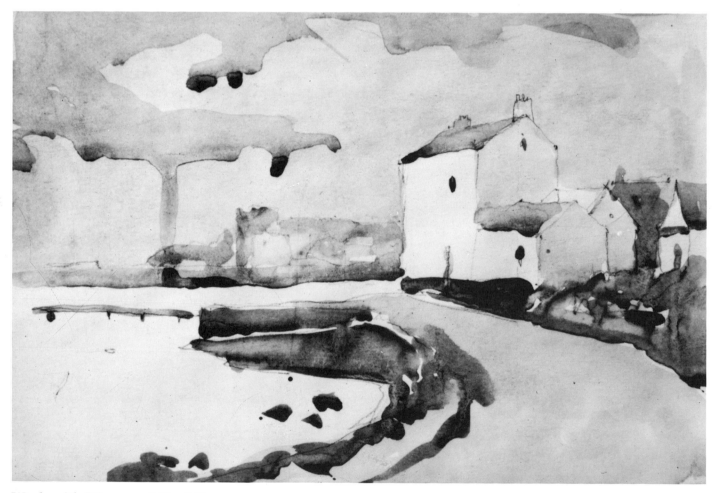

Work with Warm and Cool Tones

I returned to the scene at 8 PM and had until 10 to carefully plan and enter a drawing in my sketchbook (a 20-minute contour), and lay in a cool wash over the sky, road, and shadow sides of the houses. The cloud structure, shadowed roadside, and three roofs were well thought out and quickly designed in the darker second wash. The small amount of warm tones were carefully planned to make the late eventide seem cooler. See how the water and side of the house have a bright glow? (The colors are ultramarine blue, Davy's gray, and raw sienna.)

Make a Value Study of Cubes and Curves

At 6 AM (when I did this sketch) there was a very dramatic light. I made this contour study in only ten minutes. As you copy it, pay close attention to the values. There is a rich range of tones from black to white, with six midtones and two negative accents. These two black areas recess deeply into the picture plane and are drawn on either side of the pilings and mast as negative shapes.

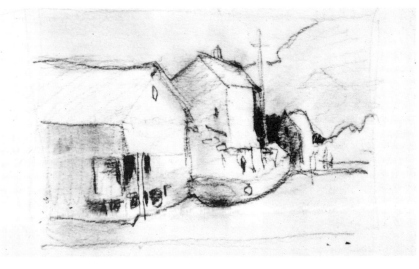

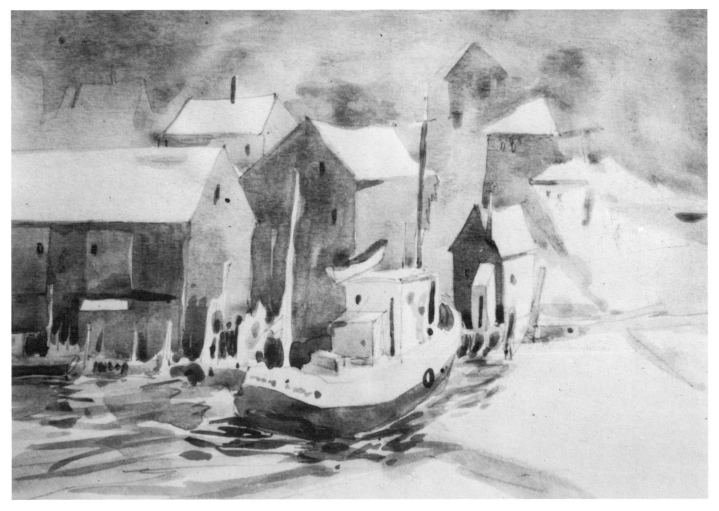

Add a Third Color (The Primary Palette)

There is a lot you can do using just the primary colors (red, yellow, and blue), as you can see in this seascape. Begin with a single, big puddle of fog color . . . light red and cerulean blue together (don't forget to mix more than you'll need). Then, angling your sketchbook, wash in the fog everywhere, except where you want the whites. Then drop in a little of your third color, yellow ochre, working wet-in-wet. Gradually build up the values until they look the same as they are here.

I also used two more colors as accents. A touch of cobalt violet was added to the light red at the trawler's bow and as negative shapes on both sides of the stern mast. And when the watercolor was dry, I added a touch of cadmium orange to the foremast to make the fog look foggier. (There is an extensive discussion of the palette later in the book.)

I am going to illustrate the many ways of working in watercolor, not by the usual step-by-step method at first, but by a very deliberate sequence of *finished* watercolors. The first series of paintings, a group of street scenes, will show you how to apply your color in layers and gradually work up to an intensity of color. The second series, a group of still lifes, will describe how to make your washes darker and more dramatic. This time, value rather than color is the subject. And you will learn a calculated and controlled method of holding back your explosive desire to shovel on the color!

The third and fourth groups of paintings are actual step-by-steps, but this time there is a change in the physi-

cal appearance of the watercolor. Instead of casual (or seemingly casual) washes, we have the deliberate, careful, hard-edged look of a Japanese woodblock print. As always, the choice is yours. There are many ways to paint.

The fifth, sixth, and seventh series of demonstrations also describe the working process—but now the emphasis is on perception . . . ways to see . . . ways to *describe* what you see . . . to convey a mood . . . the quality of the light . . . to emphasize a positive shape . . . or a negative one. In this series, you will be working from the reality—what was actually seen—and painting your artistic response (or responses) to it.

TUCK'S CANDY STORE SERIES:
Layer colors from light to bright

Light Washes over a Freehand Sketch

Make your speed sketches freehand and free thinking. Let your pencil fly over the storefronts just as it would over apples and wine bottles in a still life. Don't get lost in the architectural rendering. No one is going to grade your drawing. Speed sketching should give you a free feeling . . . like running barefoot through the fields. This sketch should take only five minutes to do—ten if you're a novice.

Select and plan your whites first. These little pieces of white will lead the eye and please the viewer. I have also planned to leave a little "escape route" at the end of the street on the left.

Mix a big puddle of gray using cerulean blue and light (or English) red and lay it, from the top left, across and down—and around the whites—in one big, soupy wash. Look at the result: There's a subtle movement pulling the eye toward the right . . . created by the figures and the pinkish wash.

Assignment: After you've copied this, make a second copy—but this time fill in the lower left-hand corner. Compare the two sketches. Can you see that by filling in the corner you've lost the support for the white verticals on the last building? Do you notice how the white figures "pop" too much when everything is filled in?

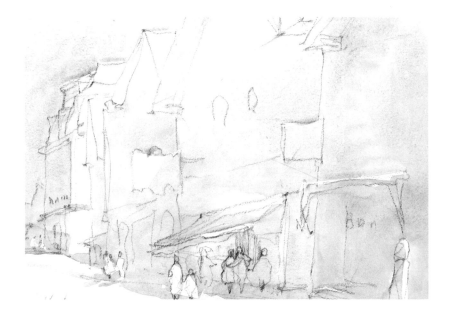

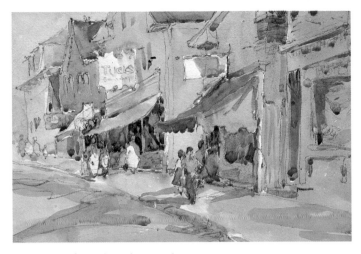

Layer Colors in Flat, Pale Tones

Sketch the storefronts again (in carbon pencil, as always), but this time slow down to "contour-drawing" speed (novice, 45 minutes; intermediates, 30 minutes; and advanced, 20 minutes). These are the drawing times for all of this series. Try to cut your time down (over a period of years), and you'll move up automatically in ability. Speed is as important as volume . . . in watercolor, at any rate.

Run your first wash—very pale—over everything except your white pattern, using the same mix as before . . . that is, cerulean blue and light red. (If you're a novice, and you find it too hard to work around your whites, you can use Winsor & Newton's art masking fluid, washing your brush immediately afterward in soapy water.

Next, lay in tinted washes, building one at a time, palest tones first, over the initial dry tones. The center of interest, a store called "Tuck's," gets a tone of raw sienna right over the first gray wash. Try to match the other colors in the picture using this palette: cerulean blue, light red, rose madder, burnt sienna, raw sienna, mauve, raw umber, and sap green. After you paint the shadow washes and buildings, work on the awnings, and then the roofs. Remember to hold your watercolor at a 5-degree angle for clear washes.

Put your people in last. Now that the stage is set in full color, you can gauge where you want to put the accents and where you want to lose them. For example, the front group blends into the pink, gray, and mauve store with the rust awning, while the second group is silhouetted against the darkened interior of Tuck's.

Quality of the day: This sketch was done several days after Mt. St. Helens erupted and, although the sun was out, there was so much fine ash in the air that it diffused the shadows and gave this strange, flat light. Remember, always paint the light of the day . . . *that* day!

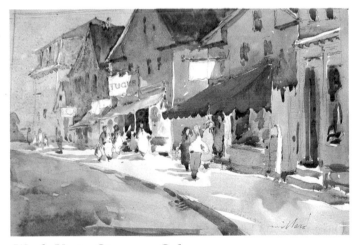

Work Up to Stronger Colors

Same composition? No! Study it closely and see where it's different. For example, the sidewalk has been raised, the building on the right is eliminated, and the roofs are lower . . . and much darker. We've also zoomed in for a closer view of the figures, and they're brighter. Also, the sidewalk is whiter, and the stores still run across the picture plane as an almost flat backdrop.

This is a bright summer morning, and the stronger tones on the stores and the rust awning make for greater contrast with the whites . . . the radiant, luminous center of interest.

New colors are added to the palette: manganese blue for the sky and last building, and cobalt green for the last awning. The transparent dark in Tuck's window is burnt sienna and mauve.

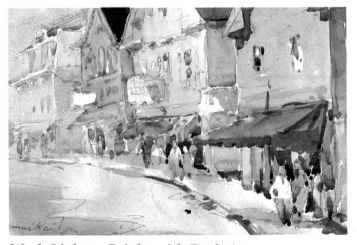

Work Light to Bright with Dark Accents

This is a brilliant summer noon . . . there's almost a glare in the sea air. The buildings recede rapidly in color, as do the figures, giving a powerful feeling of perspective. The street is also curved for even greater perspective (and interest). Notice the carefully balanced, extremely dark accents here—used sparingly. One roof looks almost black . . . but it's really made of two more new colors, ultramarine blue and alizarin crimson. There's a lot of pigment here—this is not tinted water!

Assignment: Do sketches like this of your own hometown. This series is of Tuck's, a store in Rockport, Massachusetts . . . and one of my pet subjects to paint and sketch over and over again. But your subject will be just as much fun, and just as challenging to paint. And there will be an intimate quality that you will gain using *your* street, with your neighbors. They'll stop and chat, but you can politely explain that you have work to do . . . and get on with it.

Layer to Get Deep, Clear Tones

This is Tuck's in winter. There's a low afternoon light . . . patches of snow . . . everybody is bundled up. There aren't very many people on the street It's almost too cold to draw. Get your sketch of the stage setting done and go have a cup of tea.

Watching the gestures of people walking and gossiping is very much like watching the waves. This is also *"memory painting"* . . . in the sense that you're sitting and watching the actors come on stage. All the buildings have a tone of color dark enough to give a snap to the two touches of white where the sun is striking just the edge of a skirt and a pair of pants. Here is your center of interest.

You can have these deep tones and still have clear washes if you work with your sketchbook at an angle, so the washes run *down*. I can't say this often enough! I discovered this secret quite by accident. The only photographs I ever saw of John Singer Sargent doing a watercolor showed him with his painting at an angle . . . so I thought I'd give it a try . . . and it worked. But you must also let the page dry at an angle or you'll spoil it.

Look at the changes in the colors here, and the difference in the quality of the tones. The rust awning was wet with clear water and burnt sienna was applied to it . . . right from the tube. Rich!

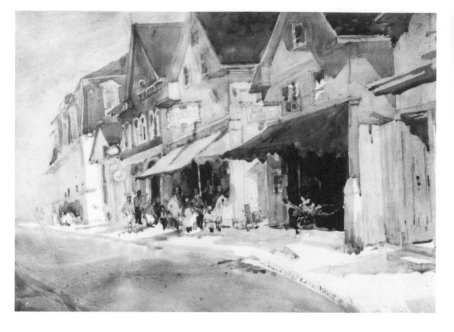

"Lost and Found" People (Detail)

Study this enlarged detail of the preceding painting with a magnifying glass, looking for lost edges and hidden figures. You can't be sure you've seen them all until you've looked closely. That's what you should be doing to your viewers . . . inviting their attention . . . making them probe visually.

Create excitement! Bring a figure or two out into the sun . . . add just a touch of scarlet. Barely discernible in the snowdust of the larger painting, you will find a couple of figures in the distance. "Lost and found" is a term generally applied to edges of objects—but you can use it for people, too!

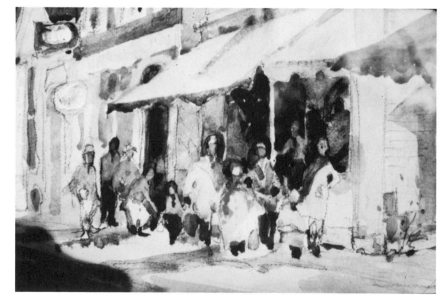

STILL LIFES: Work up to darker tones

Arrange a Setup

Painting still lifes is an excellent way to learn how to paint. You are working with a very controlled subject—no flies, no wind, no curious tourists to break your train of thought, no hot sun to dry your washes too quickly . . . just your own private battle! You owe it to yourself, as an artist in the learning process, to become familiar with the still lifes of Bonnard, Cézanne, Chardin, Braque, Matisse and Renoir . . . to name a few French masters. (You'll find more of these artists listed at the end of the book.) Also look at the great 17th century Dutch painters, with their extremely dark backgrounds and complex selection of subject matter.

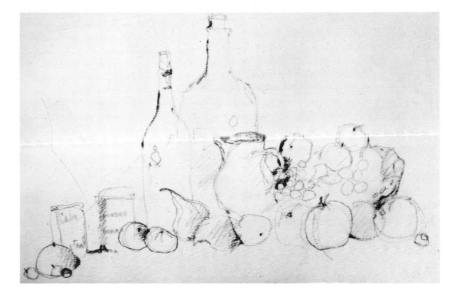

There is a *majestic quality* that comes "into" a still life, and when you learn the feel of this bit of creative magic, it is not so difficult to transfer it to other subjects. You can do this through the medium of the carbon pencil drawing in your sketchbook. Let's take a look at this sketch.

The setup should consist of things you like, objects that are part of your everyday life: fruits and vegetables you like to eat (no spinach!) . . . your Grandmother's pitcher . . . an empty bottle of Chivas Regal, etc.

Eye exercises: Now let's study the composition. Close one eye, hold out your thumb and move it back and forth. Block out the two condiment cans. . . . Do you see how much these little square boxes flatter (complement) the round shapes? Now block out the two bottles. . . . Do you see how much you miss the "triangle apex"? The composition falls fast asleep. Next block out the basket and all the fruit to the right of the pitcher . . . and you've lost your balance.

Color the Contour Drawing

Make a contour drawing of the setup in your sketchbook and look at it . . . think about it. Where do you want the light to fall? Light it from the front left! You are indoors and using the drama of a controlled spotlight. You are staging this as though you were in the theater . . . your theater! *You* control the mood. You are the director. What colors will *you use* to interpret how you feel about these beautiful shapes . . . yes, that's what they are! *Keep the light simple* . . . let's just wash it over all the tops of the objects with a brilliant glare. How do we create this feeling?

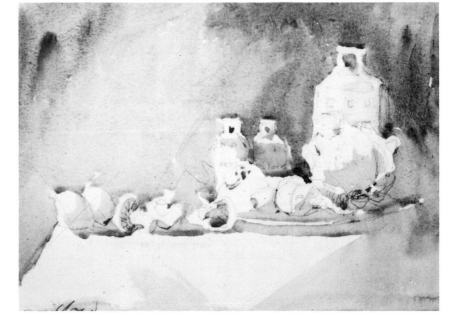

Flood your paper with a big, soupy wash of cobalt blue and raw umber. While it is soaking wet, drop in a wet-in-wet lacing of analogous colors . . . from the left, sap green, then manganese blue . . . then as we move past the cannisters, go a little darker and warmer using cobalt violet and raw umber. Get excited about how you trail the big puddle around the handsome and intricate shapes of the top edge of your still life!

A huge negative shape of colors in motion now sits at the top of the painting . . . and yet it appears to be the background of your objects.

Carefully work out your shadow shapes. Many a painting is ruined at this point—you must put in your shadow washes *quickly* and leave them alone. Don't go back and try to "fix" something up. Stay out of it! Just let the watercolor dry at the 5-degree angle and *quit!* No more color. This is a finished painting.

A Review of Procedure

Let's go over the basic procedure. You are building up to your darks with layered washes . . . tone on tone, wet over dry . . . just as in the *Tuck's* street scenes. (Still life is very similar to landscape.) Begin with a rapid contour drawing, setting your stage. Then stop and study it. Think first about the light direction. Then decide how you're going to build from light, pale tones of color to darker tones and much richer color. You must also decide what "color mood" you're going to create. Then put in your background first, leaving the white areas along the tops of your objects.

After your first wash is bone dry, lay in your shadows. This time add a modest amount of local color (the actual color before you) to the shadow wash. Then let it dry! I mean *dry!* If it is nearly dry, you'll blow it! If you go into a wash too soon it will get creepy and crawly—you will have backruns. (This is not to be confused with wet-in-wet . . . where you can drop in color as long as there is a liquid, watery glisten to the paper.) *The greatest fault* I find in the workshops . . . across the nation, in fact . . . is that artists poke into a nearly dry wash to "fix" something. Again, as I've said before, *work at a 5-degree angle* and your deep tones will remain clear as long as you let the colors run to the bottom and *don't lay your paper flat.*

The sequence of washes and colors are as follows:

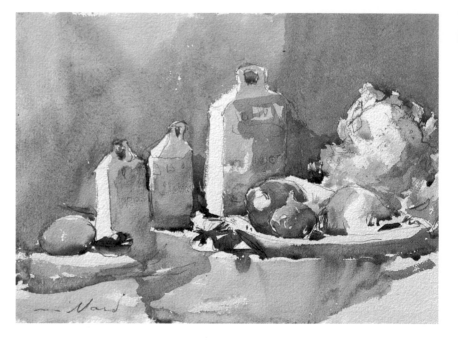

1. Background wash: burnt umber and ultramarine blue.

2. First shadow wash: pale burnt sienna.
3. Second wash—background: burnt umber, ultramarine blue, and cobalt violet.
4. Second wash—object shadows: again, pale burnt sienna.
5. Third wash—local colors: Add the vegetable colors in a very controlled manner.
6. Fourth wash—accents and deep shadows: Add Winsor violet to the burnt umber/ultramarine blue background wash.

Make Clean and Colorful Darks

You can keep your darker washes clear and clean if you put them on the paper with zest and don't work into them. Aim for crisp, clear brushwork. Think of *alla prima* or "one-shot" washes.

You can obtain a tranquil beauty from what appears to the naive viewer to be just two colors. That white tablecloth is just the white of the paper . . . but turn it upside down and look at the excitement in its contortions, leading the eye from one object to another. Color on this white area must remain luminous, not heavy.

The earth tone is really a combination of raw sienna, raw umber, burnt sienna and burnt umber . . . plus a few touches of Winsor violet and Venetian red . . . all analogous or closely related colors. *The blue tone* is actually made up of manganese blue, cerulean blue, cobalt blue, and ultramarine blue, plus some sap green and viridian . . . again analogous colors. Against the tranquility is the constant and carefully planned pattern of chiaroscuro—the light and dark pattern. . . . The dark blue of the pitcher against the light bread and white cloth. . . . The dark negative running down the left side of the big urn, across the top of the bowl and white cloth. . . . And lastly, the very irregular dark under that

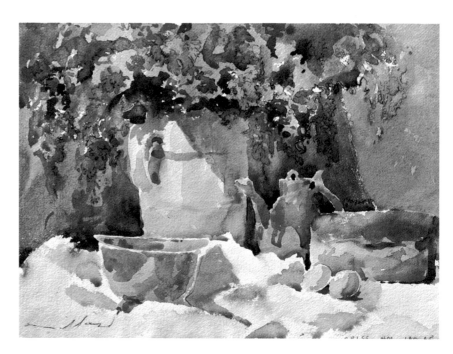

oddly shaped crown of dried weeds, which adds to the simple beauty of the six objects.

That dark wash resting its heavy pigment on top of the blue pitcher and loaf of bread is a negative shape and adds a unique touch to a rather mundane subject.

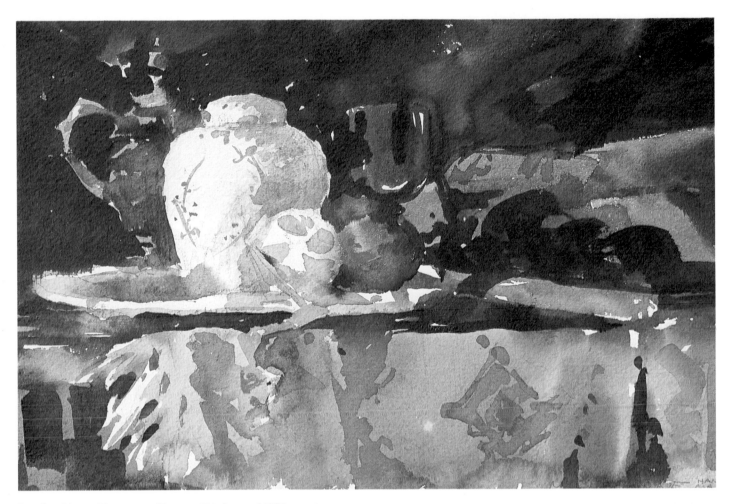

Make Your Deepest Tones Rich and Vibrant

This watercolor, done in the manner of the old Dutch still-life masters, was painted in two sessions. Since the composition was complicated, I felt the need of a very controlled, limited palette. Again, the watercolor appears to be painted in only three colors: orange, blue, and green. But, as in the preceding study, there are *many* blues, oranges, and greens.

All the objects were painted and then put aside to dry at the usual angle. This is the only way to keep the shadows in the background transparent. While it was drying, I tried to resolve how I would execute the deep, rich background . . . a wash of very heavily pigmented sap green and burnt sienna, mixed on the paper. The darkest darks, added wet-in-wet, consisted of alizarin crimson and ultramarine blue, mixed into the wet wash. A slightly diluted wash . . . not too watery . . . was added to the pewter pitcher, since it "popped" forward too much after the extreme deep tones went into the background. This was a correction of a bad guess and I have left the edges to show you that *this was an added wash.*

I deliberately left small specks of white in the background so it wouldn't "go dead" on me. The background wash went right over the glass, except for the carefully placed whites (no masking fluid here).

HARBOR FOLIAGE: The effect of a Japanese woodblock print

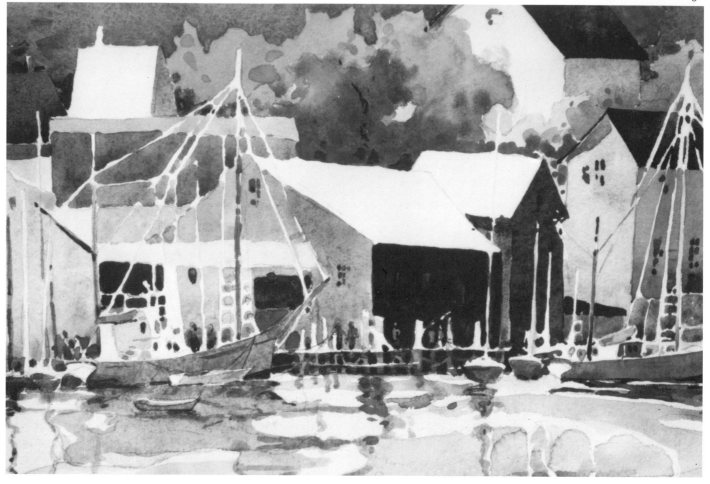

What Is a Woodblock Print?

In our kitchen in Needham, Massachusetts, there is a Japanese woodblock print of twenty-eight colors. Every single color was carved into a woodblock panel, then numbered and printed in register, somewhat like our present-day silk-screen print. The painting *Harbor Foliage* (and the following painting, *Rose Harbor*) was conceived with the idea of approximating the appearance of a Japanese block print. By working step-by-step in this so-called "color-block" technique, even a novice can accomplish a rather complex composition.

The Effect of a Woodblock Print

The look of a woodblock print is unmistakable: the colors are self-contained; the areas are of flat color; the edges, for the most part, are hard. When you are working with a range of colors as extensive as the ones used in this watercolor, the blocks of color become like instruments in an orchestra, and you, the artist, take on the role of a conductor or a composer, interpreting the complexities of a symphonic composition. Each color block has an emotional quality. Some blocks are aggressive and some are supportive. Some are like stringed instruments and some are like brass. Then there are the tympani . . . the deepest tones, the kettle drums . . . the blacks!

How a Woodblock Print Is Made

Let's look at a small section of the finished painting—the rigging of the ship in front of the shed—and see how it would be made had this been a *real* woodblock. Each block is dipped into a color and stamped onto the paper. So if you were to print the red shed, you would have to gouge out everything else from the wood block except the areas that would print red. This would mean that the white rigging would have to be cut out of the wood block first, before the block is dipped in red and stamped (in perfect register) in the spot where the red shed is. Wherever the wood has been gouged out, the white of the paper remains unprinted, creating the rigging.

At the left, there is a black piece above the bridge of the ship. This next block will print everything black, so again the white rigging and ship's details have to be gouged out. Next, as you move up the mast and rigging, you have blue, olive, and tan color blocks. Again, each color block has to be cut out and printed separately, again in perfect register, so that all the ship's lines appear as uninterrupted white and so each color is self-contained. All blocks are cut in reverse and print as a mirror image. Again, so no one is confused, let me repeat that this is a *watercolor* that was conceived to have the *appearance* of a woodblock print technique. It is not a woodblock print!

Preliminary Drawing

This is an imaginary harbor village, a composite of buildings in Gloucester, Massachusetts. I wanted the drawing to have a hand-made quality, so no T-square or ruler was used . . . I just drew it in freehand. But a good deal of thought and affection went into planning the stage setting: the levels of the roofs and their shapes . . . the sizes and positions of the skiffs, boats, and ships, with their rigging patterns. . . . Yet the drawing still seems to have a certain formality, as though it were done in a contour style rather than freehand.

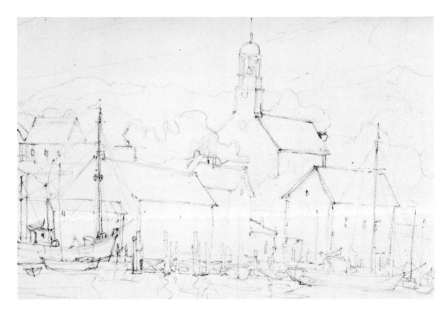

Painting Stages (paintings on page 44)

This time, instead of concentrating on the colors (as I will do in *Rose Harbor*), I will emphasize the process, the order of procedure, of painting *Harbor Foliage*. As the title suggests, the foliage is the key to this watercolor, and all the colors have been selected to harmonize with the trees in shades that relate to orange. If you look carefully, you will see that even the trees are made up of individual blocks of color. The painting steps are as follows:

1. Put the two strips of sky in as a crown or top to establish a color that is unexpected (or unusual as a combination with orange) and will also serve to accent the foliage colors.
2. Put in the block that makes up the hills and trees. This block will be warmer as it comes toward you, and richer in pigment. It rests on top of the trees and roof, leaving an exciting pattern of white as the lower skyline.
3. Now put in the buildings, ships, and skiffs along the waterfront. Work your way along carefully, taking the time to match the colors and values here exactly. (Novices, you can use masking fluid on the rigging and masts, but the rest of you should cut around these spots, leaving the white bits and blocks of white roofs. Look at the detail of the finished painting to help you.)
4. Move on to the water. Study it and duplicate the patterns there with much care. There isn't a sloppy inch in this watercolor, and there is still much to do.
5. Put in the base wash of the tree foliage and when it dries, paint the darker and brighter colors over it, as though they were being printed rather than painted. Work them, one at a time, over the previous, dry layer. This is also the way the darker red siding was painted on the red shed.
6. I have placed two blacks earlier—the horizontal dark below the trees on the right and the black square behind the rigging. These blacks (and the white paper) suggest the extremes of the value range, and I can relate the buildings and ships on the waterfront to these darks as I fill in the other colors. Experiment with the remaining unpainted roofs. Where would *you* have placed the accents?

Notice the motion to the right: the sweep of the sky . . . the swirl of the water . . . the angle of the roofs. Because of it, I chose to lead the eye back into the painting with the ascending, ladderlike quality of the three black roofs on the extreme right . . . moving up and to the left.

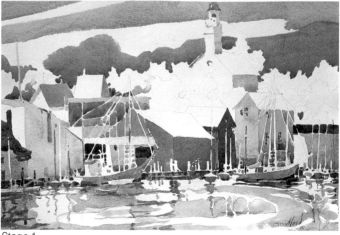

Stage 1.

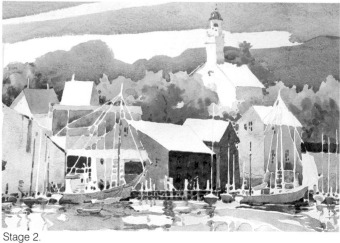

Stage 2.

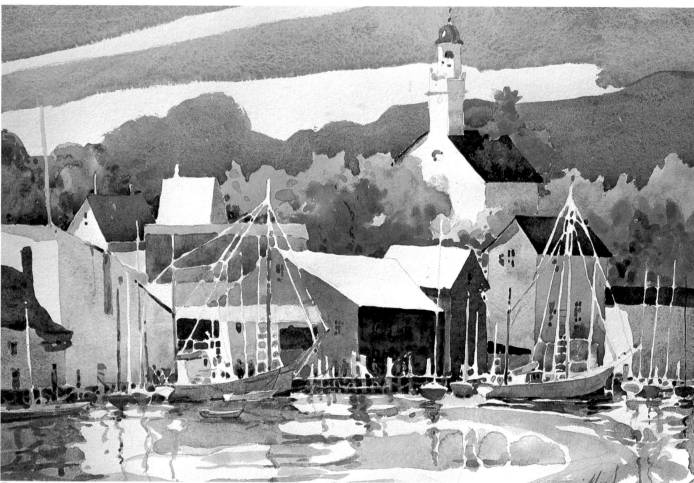

Finished Painting.

Harbor Foliage, 22″ × 30″ (56 × 76 cm). Collection the artist.
Gold Medal of Honor, New England Watercolor Society, 1981.
C. Davies Award for Excellence in Watercolor, Hudson Valley Art Association, 1983.

ROSE HARBOR: A detailed step-by-step

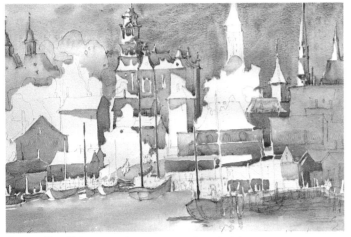

Stage 1 (Detail): Layer washes over a contour sketch.

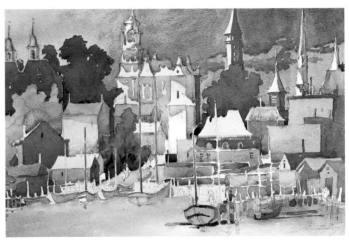

Stage 2: Add deeper tones.

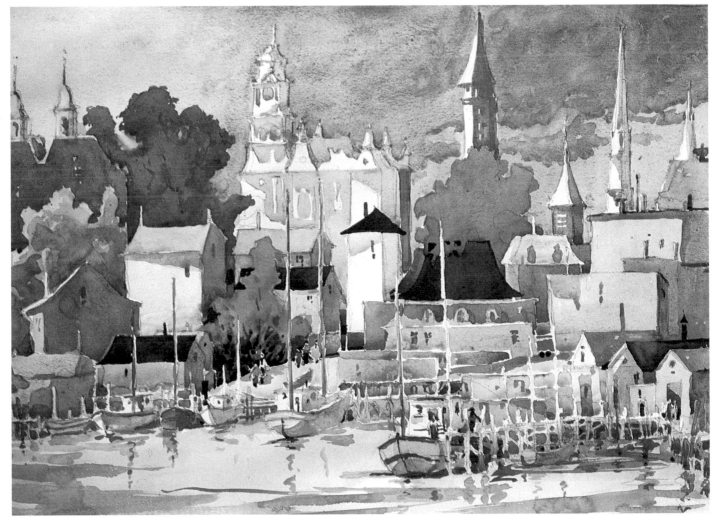

Finished Painting: Add accents.

Rose Harbor, 22" × 30" (56 × 76 cm). Private collection.
Mariboe Award for Excellence in Painting, Rockport Art Association, 1979.

Contour Sketch and Layered Washes
(paintings on page 45)

This is a fairly simple technique used to handle what appears to be a complex subject. The emphasis here is on color, and you will work with a group of warm colors only, handled as flat tones. Notice that there are no rounded forms here, just flat shadow pieces. It's easy!

Contour Drawing: The contour drawing was done on the site. It was sunset and getting dark quickly. The skyline was wide, with many spires and towers, and I gathered them together and concentrated them into this composition. The painting was done from the memory of that sunset. Take as much time as you need to do this contour-style drawing, but don't add any more detail than this.

Shadow Wash: This time we'll begin with the shadows. Mix a wash of ultramarine blue and raw umber for the shadows of the town hall and the steeples. Be careful to work around the whites of the roof and windows. Novices, try to do this without masking fluid—use it only on the ship masts, if you must.

Sky Wash: When the shadow wash dries, lay in the sky (cobalt violet and cadmium orange) in a fast, flat, juicy wash, keeping your work angled. Put the same wash on the center building—the one with three windows—and on the masts, but paint around the dock pilings in the small rectangle. Let it dry.

Add Darks: Use a diluted wash of the same color on the fish house at the right and the piece of road on the left. Work around the figures. Then let it dry.

Yellow Accents: Aside from the white pieces, the brightest area is the small triangle of yellow ochre on the peak of the fish house. A touch of this color can go on the road, too.

Pink and Rose Washes: So far we have put in the gray shadow washes, the orange/pink sky, and the yellow accents. Now we're ready to lay in the rose and pink tones. See how many different tones you can make by mixing Davy's gray with different roses: pale alizarin crimson, rose madder, and permanent rose. Make three different puddles of these grayed roses, matching the values and tints on the painting carefully. Give the blue-gray shadows a pale tint of pink too, but hold off on the shadows of the pink buildings for now.

Notice how many different shapes there are. Turn it upside down and see how they interlock and what an exciting overall abstract design this is.

Add Deeper Tones

Now we will put in slightly darker tones. Notice how they enrich the painting and how they relate these pieces to each other, unifying and accenting them.

Mauve Wash: Now we'll add a new color, mauve, to a strong mixture of Davy's gray and permanent rose and place it on the house at the upper left-hand corner. See the spots of sky wash showing through the windows? Put this same wash on the gutter, a roof and chimney, and in a few small spots on the right.

Red and Orange Washes: Mix cadmium red deep with permanent rose and run it over the two red towers. Then add some burnt umber and cadmium orange to this mixture and tackle the two houses at the lower left. Add yet a bit more cadmium orange to the same mixture and paint the tree under the red tower . . . and directly below on the house, working around the three windows of sky tone. By now the wash is rather orange. Put some of this color on the clouds at the upper right.

Water: The initial wash for the water is a pale pink-gray (Davy's gray and a variety of rose colors—pale alizarin crimson, rose madder, permanent rose—note the variation in hue), along with a touch of cadmium orange . . . just a touch.

Trees: Mix up a puddle of mauve and burnt umber—use lots of pigment, not tinted water, now—and paint the dark tree at the upper left. Then quickly, while it is still wet, drop in some cadmium red deep and cadmium orange . . . plus a little burnt sienna . . . into the wash. Move down between the buildings, carefully, and paint the base of the tree below. Then quickly wash in the top of this second tree with a mixture of cadmium orange and burnt sienna, applied wet-in-wet.

Finishing Touches: The Accents

Now to put the buttons on the suit . . . the blacks. The balance of the blacks must be carefully planned according to where you feel they would best help the design. Spend some time thinking about this. Would you have liked them better somewhere else? Leave yourself some time to daydream . . . this is the alpha state of mind and it has an artistic purpose. Experiment a bit by cutting out some pieces of black paper to match some of the roof shapes and try them out in these new positions. Study the result . . . and make your decision.

Dark Clouds: Prepare the mood for the blacks first. Before you put in the blacks, you still have some deeper colors to add to the clouds on the right. First, wet the sky with clear water, working from the right of the town hall tower to the right edge of the paper. Then, wet-into-wet, put in deeper clouds—almost like a storm brewing—with a mixture of mauve, burnt umber, and cobalt violet. Let some of the first wash show on the bottoms of the new clouds to suggest that they are receding into the distance. (*Caution:* I strongly suggest that you practice this sky first on a separate sheet of paper before you "install" it!)

Harbor Darks: Put the same mixture you used for the clouds in the harbor water, and on the boat hulls and shadows on the ship.

Figures: Now place in the figures where you want to add interest—on the road. These figures will introduce into the painting, in a very restrained manner, the first complementary colors . . . some gray-blue (Davy's gray plus ultramarine blue) and a pale emerald green. Imagine! This entire, elaborate stage setting has been set up to enhance these little characters!

The Blacks: Now, finally, we are ready to place the blacks . . . a mixture of ultramarine blue and alizarin crimson.

HOW TO SEE: Emphasize form and light direction

Analyze the Scene

In landscape painting, it is usually helpful to squint your eyes when looking at a subject in order to simplify the many forms. In this case, at 5 PM, the late, low, raking sunlight is so rich and warm that it is pulling all the dark and midtones together. The twigs and branches are "falling" into the dark gray tones of the house. But the white forms are popping right out at you, and this makes a nice, crisp, juicy watercolor.

Analyze the scene by making a diagram and looking at the parts. The scene is composed of outstanding pieces of white, plus a tree. These are the parts that make this scene, with its dark setting, dramatic.

Contour Drawing and Shadow Washes

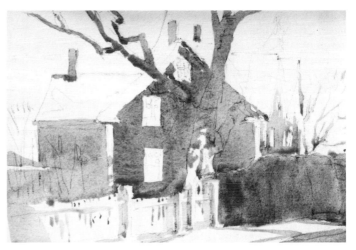

You are shooting for a crisp, simple watercolor . . . the essence of the form . . . so keep your drawing in the same mood . . . a crisp, simple contour (novice, 20 minutes; advanced, 10 minutes). In the photograph you can see hundreds of little twigs and branches, but in your mind's eye you should be able to "imagine away" all these details that are cluttering up the basic form. Don't be literal or unimaginative. Start thinking about how this scene *might* look, not how your camera "sees" it.

Lay in a big, fat, juicy wash of cerulean blue and light red. Start in the tree branches, trail your puddle down into the house forms, and rest it on top of the fence. Then spot in some color between the slats of the fence. As you work, keep your paper slanted. Work out into the hedge and drop in a little viridian. Keep it weak and watery . . . not too strong or it will jump out at you. You want the gray to be *under* the green hedge, not in front of it.

Assignment: Try another version of the wash using viridian and alizarin crimson. Let it dry and put in a weak viridian green glaze. Which effect do you prefer?

Final Washes: Shadows and Details

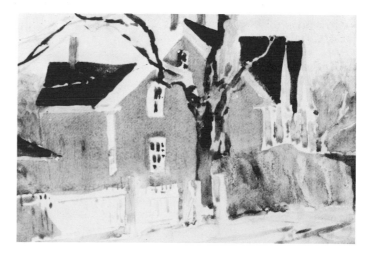

Give the small trees on both sides of the house the same gray wash and let it dry. Then go over the dry area with a light wash of pale alizarin crimson, working around a few tree branches.

Now, emphasize the form with a very dark wash of ultramarine blue and alizarin crimson in four pieces . . . on the roof . . . windowpanes . . . and a touch or two on the big tree. You can see and feel the importance of the darks here. This is a very clear example of how the darks can "make" a watercolor. Remember it!

Light direction is carefully spelled out here by the way the sun is hitting only one eave on the side of the house, yet strikes the entire front of the dormers. The fence is a "personal" matter. If you want to paint in all the pickets, be my guest . . . but I feel that I am getting more glare—more light intensity—by having so much light hitting the fence that the viewer can't "see" all the pickets. Isn't this more brilliant in effect than the photograph?

47

HOW TO SEE: Emphasize positive shapes and mood

Analyze the Scene

This photograph represents my mind's eye—always seeking, looking, searching. Remember: Painting is like hunting. You are always seeing how light is hitting and making form . . . how colors come together in unexpected combinations. This is one of those moments! The weather is cold, the winter sun is low, and I'm prowling around Sturbridge Village. I turn a corner and bang . . . here are two guys sawing away on a huge log. A painting!

The camera is always ready . . . Bang . . . a record. I have the details. But how do these guys balance? How do they hold that big saw? Exactly what does that big maul look like—in detail? I shoot some more pictures to catch the motion . . . the plunge of driving that saw. The crowd is moving around . . . good material, but confusing. I need a sketch for inspiration. These are *The Great Saw Figures*— a painting to do!

Emphasize Positive Shapes

There is a lot of unwanted material in the photograph, so we will do a little photo editing. Here's where you will see the advantage of making a flat, two-dimensional sketch. When you are working with a contour drawing . . . single-weight line . . . unshaded shapes and forms . . . it leaves you *free* to be inventive! The photo, on the other hand, ties you to the reality—and copying it can be deadly. This photo shows a very dark background, but the day I was there, it was *cold!* The contour sketch leaves my mind free to invent . . . there are no tones here. We will do this as a snow scene . . . so white that there is no shed or dirt road.

The next decision is to *silhouette the figures as positive shapes*. The man with the dark hat is our hero, the center of interest. The other four figures are handled in a diluted wash and recede into the snowy glare. All of the characters are *positive* shapes, as are the poles and the maul handle. The foreground figure is mauve and burnt sienna . . . as is the big log and the pole. Use cerulean blue and light red for the others.

Emphasize Mood

It's icy cold outside. The wind is howling . . . the snow is biting . . . we are out of firewood. This is survival! This is mood.

I should say there is a temperature change going on here, but that sounds like a dumb pun! Let's just say that the figures in the distance are bluer and contain just the barest amount of yellow ochre to relieve the gray-blue tones. The hero is closer because he is larger and is done in mauve/burnt sienna washes that come toward the viewer.

The figures were redrawn for story quality . . . the guy with the beard adds character to the casting . . . the beardless man is just another tourist. A few wind streaks are made by wiping out a dark, dry wash with a damp cloth.

The poles repeat the angle of the figures on the saw and, with the log, form a triangle that contains the three men . . . concentrating our attention on them.

HOW TO SEE: Emphasize negative shapes and a different mood

Analyze the Scene

This is a good example of where the eye appeal of a pleasant photograph can be very different from the distilled design that makes a good painting.

Edit out the confusing "cheaters." There are two good-looking figures at the left of the "saw man" with the yellow hat. If you give them the importance that they have in the photo, they will cheat you of the center of attention you should be reserving for the men on the saw. If you copy them as they appear, they will pull your eye away from the man in the checked shirt . . . up the saw . . . past the man in the yellow hat . . . back to them and right out of the picture! The same thing will happen if you put in the lady in the red coat—she will come roaring up to the front of the picture plane and upstage the whole perspective.

Also *edit out* the two light-toned, freshly cut ends of the two logs nearest the viewer. They will only serve to unduly attract the eye.

You should know that copying these three faults will weaken and partially destroy your composition. These two light spots and the red spot will cheat you out of a well-organized center of attention. Think! Don't copy. When you use a camera, use it to back up your sketches . . . to give you needed detail . . . authenticity.

How can you learn more from almost the same photograph? Try doing almost the opposite interpretation of it (as I do here) and compare the results.

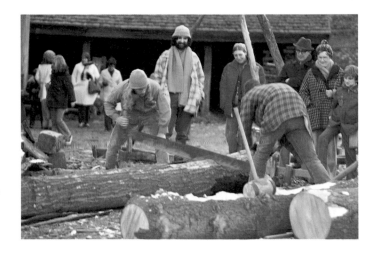

Emphasize Negative Shapes

Start to organize this painting with your flat contour drawing . . . no shading . . . no emphasis by weight of accents. Just state the facts—flat. Now tempt the creative, right side of your brain by putting gray (cobalt blue and raw umber) wash *around* the feature characters, giving their inside shape zero attention, connecting the background "onlookers" into a single shape. Now your "mind" believes that all the colorful characters in the photograph "belong" in this painting. *When your friends tell you* that they saw a painting that was so good that it looked just like a photograph, don't listen to them. Have courage. Do what you want to dare. Experiment, invent, be willing to use your judgment without restriction.

Paint the reverse of what you see! Free yourself as an artist. Your "mind" saw a red coat . . . an orange scarf . . . pink pants . . . black jacket? Forget that! But it's bitter cold, and you can lose all the onlookers in a cold, colorless gray wash (cobalt blue, raw umber, raw sienna). Confuse the left side further by painting in the two foreground logs in strong cobalt blue and raw umber . . . touch the ends of the logs with raw sienna. The third log in gets more vibrant attention than the hero, with a wash of mauve and burnt sienna and a touch of ultramarine blue added wet-in-wet. Look! Not a mark of bright color on the men and the saw! Just the negative shapes.

Emphasize Mood

There is a grim, tense attitude among the three men with the saw. They were redrawn to fortify this feeling. There

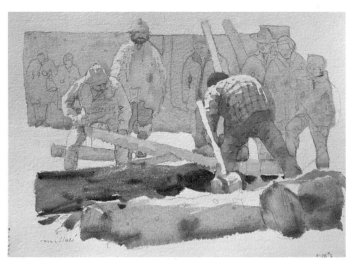

is also a bit of poetry, a bit of magic going on with these men.

Maintain their "white negative shapes" as long as possible as you add the color to them. You must exercise great restraint here in holding back on your color. Remember, *you're holding out for mood!*

Fight yourself to keep these central figures unfinished! Remember, part of the lesson here is the near obliteration of the colorful onlookers. Don't be tempted to add color if it doesn't contribute to the goal you set for yourself in the original sketch, where your mind is free to plan.

Again, be careful as you near reality. The closer you come to the reality of the photograph, the more you'll lose the poetry!

Assignment: Do a second painting—it is part of the learning process. For years, I would do a second painting if it would help me learn. It isn't all that bad either, for it gives me another painting to sell, if I wish. This time, bring the figures up to full reality . . . to full color . . . and see how odd it looks to have the spectators in gray. Now you also will have to put color in the background to balance the painting. And you will find yourself confronting a rather ordinary watercolor. And what happened to the mood? . . . Out the window, my friend.

SUMMARY: A Japanese interlude

These two "great saw" paintings are not ordinary sketches and their colors are not given a typical realistic treatment. The appearance of the two finished paintings is quite unusual, rather poetic, and very simple. Just the essence has been extracted from the subject. The forms we see are reality, but the color is not pure reality. Rather, we are creating an evocative illusion of the biting cold.

> The great saw bites deep.
> . . . in dancing flames the log lives,
> warming little toes.

This is a haiku poem I have written for the great log I saw at Sturbridge Village. Were it not for this log, the series would not have happened.

Reading haiku poetry can open your eyes to a new way of seeing how to paint. The haiku is an expansion of painting. It can invite you to think a little deeper into a subject and it can make you stop and think and study a subject *before you paint it.*

Harbor Foliage was influenced by Japanese block prints. *The Great Saw* series was influenced by haiku.

The Impressionists Degas, Monet, and Cassatt, as well as Whistler, Bonnard, and Vuillard were very much influenced by the Japanese—in their spotting of whites and darks, in their use of negative shapes, and in the unusual cropping of their compositions . . . all shown in Japanese woodblock prints (see the discussion of Utamaro's geisha girl on the following page).

The Importance of Negative Shapes

Look at the shapes in Utamaro's *Geisha* . . . the "movie star" of his day. As you can see from the numbered pieces in my diagram, Utamaro posed and designed his model to get three very different and exciting shapes around her head, hairsticks, neck, and kimono. Now compare this asymmetrical *variety of negative shapes* with my second diagram, which shows the common, "garden species" portrait head stuck in the middle of the painting with the background equal on both sides. Now you have a boring composition, very old hat. Pieces 1 and 2 are much the same shape . . . no excitement . . . no imagination . . . just won't do!

Note, too, the outstanding spotting of blacks and whites in the Utamaro *Geisha*. Although we "see" heads and hands every day, having seen Utamaro's composition, will you now "see" them better in your sketch designs?

Turn my first sketch upside down and see how cunningly Utamaro has designed the forehead, ear, nape of neck—and how he has designed the hand and scroll in the opposing direction—to give his white patterns eye appeal.

The following examples will help you to "see" how to find and select your whites and negatives. Be on the lookout for the uniqueness of white patterns when you approach your subjects. If there don't seem to be any, then learn from these examples how to conjure them up.

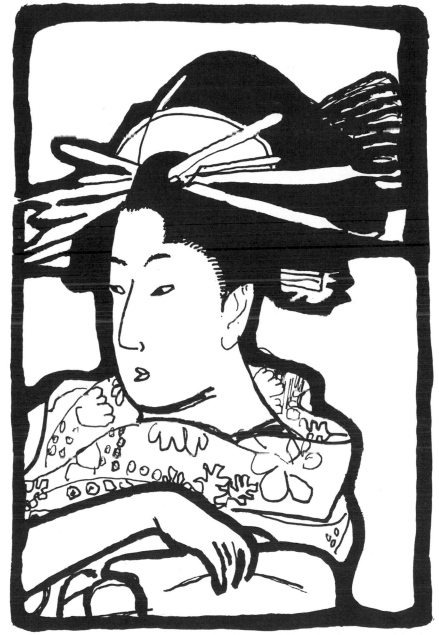

After Utamaro, 18th century Japanese printmaker.

"Dullsville"

51

USE WHITE SHAPES IN LANDSCAPES AND SEASCAPES

A White Painting with Color as Negative Shapes

In planning whites and negative shapes: in a forest scene, I began with a contour drawing of these dark trees. Then, in arbitrary fashion, which is often my custom, I decided to put the color emphasis on the *foliage between the trees* rather than on the trees themselves. The result is quite abstract, if the watercolor is considered complete at this stage. It is a strong example of the negative shapes between the trees, if we imagine that we are looking at a stand of birches.

Recognize a happy accident when it is happening! These white patterns were so visually pleasing, and quite contemporary in feeling, that to have continued painting further would have been no gain. There's another lesson here, too. *Don't always copy what is in front of your nose!* Remember this!

Turn this sketch upside down to better see the shapes of white. There are strong verticals and diagonals evident in these trees. Don't just "see" the trees. . . . *Look for the patterns . . . the pieces in nature*. They are everywhere! It was *imagination* that prevented me from "seeing" these trees as dark oaks. Look! . . . and *see*.

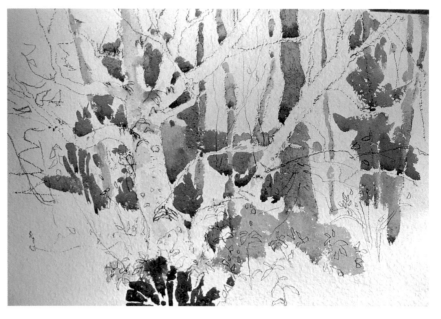

Now copy this painting into your sketchbook. Your colors are raw sienna, Davy's gray, cobalt violet, cobalt blue, burnt sienna, and viridian. Don't mask out your whites . . . paint around them! It's more "painterly" . . . gives better edges . . . is less fussy.

Surround Whites with a Pale Wash

Make two identical contour drawings this time of the trawler, the sailboat, and the houses. Put some fishermen on the deck too, even though you say you "don't *DO*" figures. (I want figures in all of your landscapes, with few exceptions.)

Study the linear patterns in your drawings. Think . . . daydream.

In your first sketch make your dark green trawler—white . . . make your deep blue sailboat—white . . . make your dark, dirty rooftops—white. Now you're being arbitrary, using your own judgment, your own imagination, without restriction. The more you try to dream up stuff . . . the better you'll get! Remember this!

Mix up a big, juicy wash of cerulean blue and light red and lay it on at a slant, working around all the objects you'll leave white. After the first wash is bone dry, put in a few little magic touches of permanent rose (tint) and cadmium orange.

Now do your second sketch in standard fashion: dark green trawler . . . deep blue sailboat . . . dark, dirty rooftops . . . and *yawn!*

With a single "fog" wash, you have been able to create a

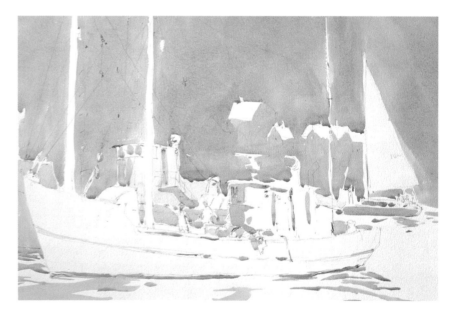

very believable sea mist with its accompanying brilliant glare in your first study. In your second study, notice how your light diminishes in intensity as you add color after color. It is worth doing this second study just to learn how you lose the effect of light by applying washes in this manner.

Use White as Positive and Color as Negative Shapes

Now you will put secondary colors around your whites . . . light tones of cadmium orange, cobalt violet and sap green. (This is much like Exercise 1 in its effect.)

Copy this illustration . . . carefully making your contour drawing. Take as much time as you need if you're a novice, but if you're more experienced, you should really whack your drawings into your sketchbook. . . . You'll get more emotion and "creative flow" into your line if you do.

First Wash: Lay in a big mix of orange and green. Match the colors and values here carefully. There is no time limit on this wash.

Second Wash: Under the awning and behind the figures in the doorway, put in a rich orange with deeper tones of cobalt violet. Drop in a little green to dull the orange, so it's not too sharp.

Third Wash: Start detailing, with the figure in cobalt violet. Then add some grayish greens (orange and green, and when you need it, violet) to the balcony, signs, and arches. You can cheat a bit in the negative shapes under the balcony by using a touch of cobalt blue to cool the mixture of the other three colors. Remember, these four colors will mix and not give you mud if you work on a slant and put the washes in quickly. And don't poke back into them. Put the color on the

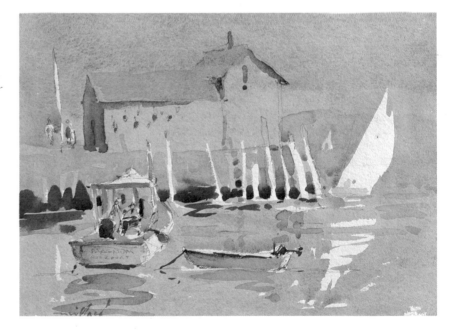

paper once and leave it alone. Right?

Notice how the tones get paler as you approach the outer edges of the vignette shape of this tropical shop. This adds atmosphere—the sensation of bright, white light and heat—and keeps the eye from wandering out of the painting. The bright orange shape also keeps you focused at the center of the painting like a bull's eye.

Tone the Paper and Use the Whites and Colors as Accents

Plan your whites carefully. When you lay in your first wash—a mixture of cobalt violet, cerulean blue, and light red—you will be covering the entire surface of your contour drawing except for the selected pieces you want to leave as white. This is a marine-scape with the famous Rockport subject "Motif no. 1" given a unique treatment. It is very much subdued by the single wash that gives a tranquil mood to sky, sea, and land.

Look at how the whites and bright colors direct the eye. We start with the cerulean blue gunwale at the cadmium red float on the lobster boat . . . travel to the pilings of white that slant left . . . then to the crisp white yawl that is in a counterslant to the right . . . then down and back toward the viewer in the white reflection . . . then across the white gunwale of the dinghy . . . and back to the white siding of the boat to the red lobster float again. There is a secondary interest to the left of the fish house—the two figures and a white mast.

The darks are really spots of color. The fish house roof is Davy's gray and raw umber, with shadows of Davy's gray and pale alizarin crimson. The negative darks along the dock pilings and the seaweed are sap green and burnt sienna. The sky and dock, down to the horizon, are painted with a light wash of cerulean blue and light red.

The dark bait barrel and accent under the boat's transom is sap green with more burnt sienna. These color spots get progressively deeper in color as they approach the foreground.

This same technique, flooding the paper with a single wash except for the whites, then accenting the composition with color spots, works for still-life subjects, too. Let's take a look. . . .

USE WHITE SHAPES IN STILL LIFES

A Minimum of White Will Sparkle

Again you will lay your first wash over everything on your contour sketch, toning the entire paper *except for a few tiny pieces of white* where you want just a hint of glisten or sparkle. Your first wash is airy and feels full of sunlight because of the open, granular quality of the pigments: cobalt violet and raw umber. Mix a big juicy puddle and work across the top, left to right. And each time you reach into the puddle for a new load of color, give the mixture a good stir so it doesn't settle.

After your first wash is bone dry, wet your paper with clear water in the area of the bowl on the plate and the bottom edge of the pomegranate on its plate and put in a second wash, wet-in-wet, with cobalt violet, cobalt blue, and raw umber on the bowl and cobalt violet, alizarin crimson, raw umber, and cadmium orange, as illustrated on the pomegranate.

Apply color over first dry wash for the wine bottle . . . the mix: raw sienna–Davy's gray–olive green applied in a drippy, drooly wash that is mostly "tinted water," not heavy pigment. Put it on quickly, holding your work at an angle, and let it run down. *Remember it also has to dry at this angle!* If you lay the sketchbook flat and leave to answer the phone, by the time you get back your wash will have "clouds" where the last drops have "backed up" into the wet wash.

See the third wash? It is very subtle indeed. Just the darkest bits in the bottle, bowl, and shadows. Notice the see-through quality of the bottle glass . . . the lost and found edges.

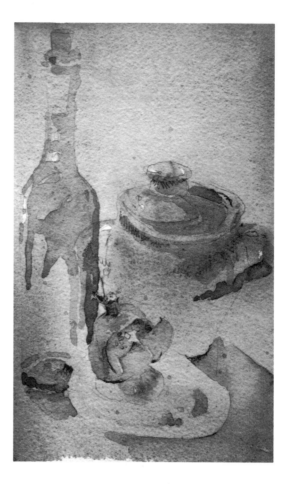

Put Positive and Negative Whites in One Painting

The large curve of white on the papaya, on the tops of three limes and the tiny "flicks" on the wine bottle are *positive patterns*. The one piece of white tucked in behind the lime on the paper plate is a *negative shape*. (Positive and negative shapes will be pointed out to you repeatedly throughout this book until you start to see them automatically and, more important, use them in your compositions. If you want to see examples of effective negative shapes, look at works by Degas.

Foreground, middleground, and distance are quite evident in this grainy watercolor. The eye moves back quickly from the first lime to the front edge of the papaya. From there it drifts back to the wine bottle and sees through the bottle to further depths. There is an illusion of warmth in the center of your big single wash where raw umber has been added wet-in-wet to the background wash. The background is of cobalt violet, ultramarine blue, and raw umber, flooded over the contour drawing, except on the whites. Add more ultramarine blue *to your puddle* as you near the bottom. A little raw sienna has been touched onto the top and neck of the bottle . . . over a dry wash.

Keep the luminous quality in the center of the painting by carefully matching the color and values here.

Now go back and look at the last seascape and see the similarities in technique between these two watercolors. . . . You are painting a still life like a landscape!

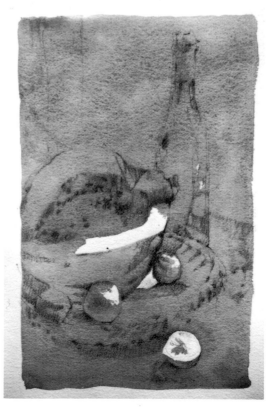

Spot in Color Accents
and Save Whites

This time, using deeper tones and colors, you are going to move almost the same still life still closer to the front of the picture plane. Your first big juicy wash is a bit richer in quantity and intensity of the pigment, plus you're now using a little less water.

This is not a flat wash. You are using the big puddle of cobalt violet–ultramarine blue–raw umber over your contour drawing (except for the whites) in a very wet flood, holding your work at the usual angle. But this time, as soon as you've covered the drawing, drop in a little richer mix of ultramarine blue–cobalt violet, wet-in-wet. A word of caution: Don't put too much water in this second wash or you'll end up with a "river" running down through the middle of the first wash. So go carefully, but with courage.

Practice this type of wash several times over your next half-dozen still lifes and you'll find this uneven wash a good stock-in-trade, a piece of painting ability you'll want to have in your kit bag—and useful in landscapes and portraits as well.

Color the fruit and bottle after your first wash is bone dry: raw sienna for the papaya and basket edge . . . sap green and raw umber for the bottle. Let pieces of background show through the glass. Make these washes juicy but full of pigment so you can create "hanging," rich, dark pieces that give a lot of depth to the wine bottle, while the reserved white spots create a vitreous luster. At the very end, for the last two or three greens, as you build up the bottle color, add burnt sienna to the sap green for clear, deep darks. Then touch the edge of the papaya with just a bit of cadmium orange—not too powerful or it will jump at you! Note all the "lost edges" there.

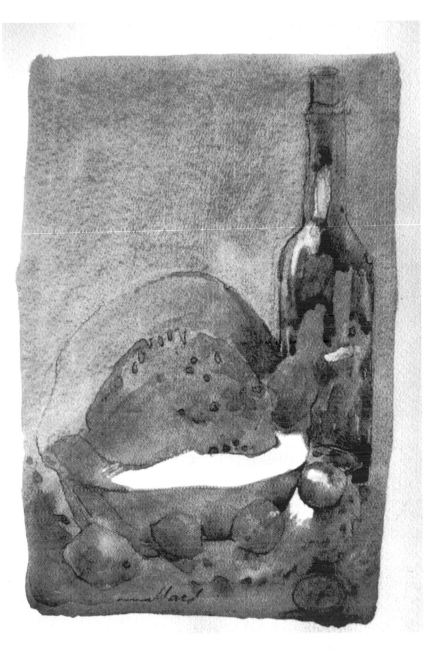

MODEL YOUR WHITES

Make Flat Whites Appear Curved

This time your subject is an earthenware cheese crock in the shape of a cylinder with a flat circular lid. Plan to leave white areas—see their individual shapes as an overall part of your design. By looking down at the crock at an angle, you'll see that its top and lid have become ovals. Arrange your garlic and shallots along an arc that repeats the oval curve of the crock.

Notice the lines with curved rhythms in your contour drawing, lines that carry the arc of the vegetables into your background. Your carbon pencil is *following the forms* on all objects and you are creating a shaded rendering to show volume in *line* only (no smudging).

Take as much care to plan your whites as you did to make your rendering. Study the drawing to see where you can have the whites light. These light-struck areas also follow the form . . . and continue the rhythms you have created.

Flood a big single wash over the entire drawing, taking pains not to obliterate your carefully imagined white curves and working around the interesting shadow at bottom left.

Make a large puddle of raw umber and cobalt violet.

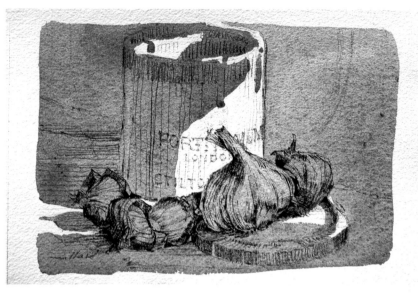

Test your wash on a separate but similar quality piece of paper and *let it dry*. Correct its value and color. Then lay it on quickly (remember to slant it for a clear wash). This mixture—cobalt, violet, raw umber, and ultramarine blue—gives a country look . . . an earthenware look. It's very granular . . . and it must be right or you'll "blow" a beautiful drawing.

A Little Color on White Makes Form

You will find this colored sketch only a little more difficult than the previous one. You are now learning controlled painting, with two washes of color over your first wash. The jar lid is now "stepped" to give a more important stage setting for the garlic, which gets the "spotlight" treatment, and there will be more luster on the porcelain Stilton crock.

The first wash is the same as the one in the last painting. This time you are creating more reality in your white shapes. The highlights along the rim of the crock are calculated bits of design, as are the husks of the garlic and its stem, and just a nip of a shallot. This is a lesson in setting up your still lifes to catch *pieces* of light, rather than full sun. Let the paper dry.

The second application of color involves adding bits and pieces of color. Give the band on the top of the crock and the rim of the lid a modest wash of small strokes of burnt sienna . . . ditto the small bits of shallot husks and the onion at the extreme right. The shallots get a modest touch of cobalt violet with a breath of permanent rose. Keep this wash light and weak. Don't confuse this second application with the final darks. Save your ammunition!

Final touches are just that! A touch of darker burnt sienna on the crock rim . . . right next to the highlight.

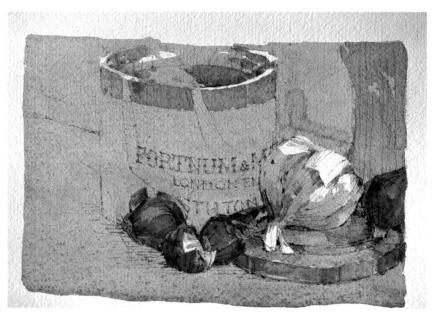

More of the same on the lid and onion. Then a deeper cobalt violet on shallots, crock rim and onion. The second background wash is a bit deeper and follows a curve to lead the eye into the painting.

Model the garlic under the husks and on the stem with a touch of burnt sienna. Follow the form. The edge of your brush describes the edge of an object. You are making edges with color.

Get a Three-Dimensional Effect

You can glaze a good many washes, one over another, as long as each is applied to dry watercolor and you keep your paper slanted to keep the washes clean.

The first wash is the same as the one in the previous two examples. Note how these compositions vary. This is one of the benefits of working in a series. Another advantage is an increasing intimacy with the subject.

The second and third washes over the background follow the same program as before, but there are additional washes now and you will see them best when you scrutinize the background . . . crock and lid . . . garlic and onion. There are two separate mixtures where ultramarine blue, raw umber, and cobalt violet vary in intensity and depth. Don't be too unhappy if you have to redo this color sketch once or twice because the way I see it, the more you paint, the better you'll get! Don't shirk the chance to learn . . . and to improve.

The fourth wash over the background contains considerably more ultramarine blue and cobalt violet, some of which will be added wet-in-wet. Study the illustration.

Because of these deeper washes, your shallots blend into the shadows with "lost edges." Harder edges accent the garlic and onion on the jar lid. Place the onion's shadow

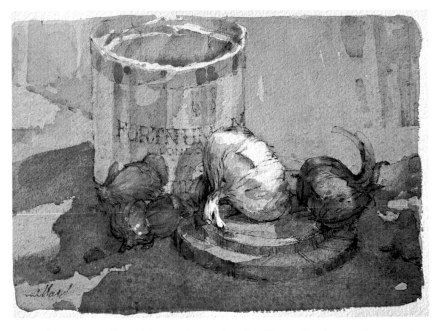

on the white garlic so that it follows the form of the garlic. Likewise the garlic's shadow on the crock. There are very deep shadows under the stem of the garlic that really lift the white out into space. The shadow modeling on the lid makes the light believable. Note how the diagonal axis runs from the background through the garlic top and onion bottom to lead the viewer's eye.

How to Make Whites "Sing"

The vignette of color surrounding the white objects makes them appear brighter . . . whiter . . . and the color is intensified and deepened as it moves from the edges of the painting toward the center. You are taking simple subjects—garlic, limes, and a shallot in front of a small willow basket—and playing with them until you "feel" you have a good composition.

The whites here have impact because of the intensity of the deep, deep viridian green lime, outlining the garlic in a hard, hard edge. The outlining continues in the strange steaks and shadows of darks in the background, fragments from a patterned tablecloth.

The background mixture is cerulean blue and light red in a puddle. Stir it every time you reach in for more color. There are also two broad "spots" where manganese blue went into the background wash wet-in-wet, and wet-in-wet touches of palest Venetian red if you look for them. These red touches relate to the shallot, which is cobalt violet and Venetian red. Touches of cobalt blue, cerulean blue, and cobalt violet are in the limes, along with sap green, then raw sienna going into yellow ochre as you near the center of the limes (not the one in deep viridian).

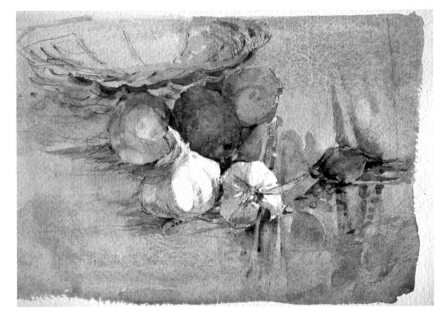

This seems to have a more contemporary or modern composition due to the handling of the background patterns. These unusual shapes contrast nicely with the round shapes of the fruit and vegetables.

Do you see how much you can learn from a simple still life to carry over into your landscapes and portraits, where you want your whites to *sing for you*?

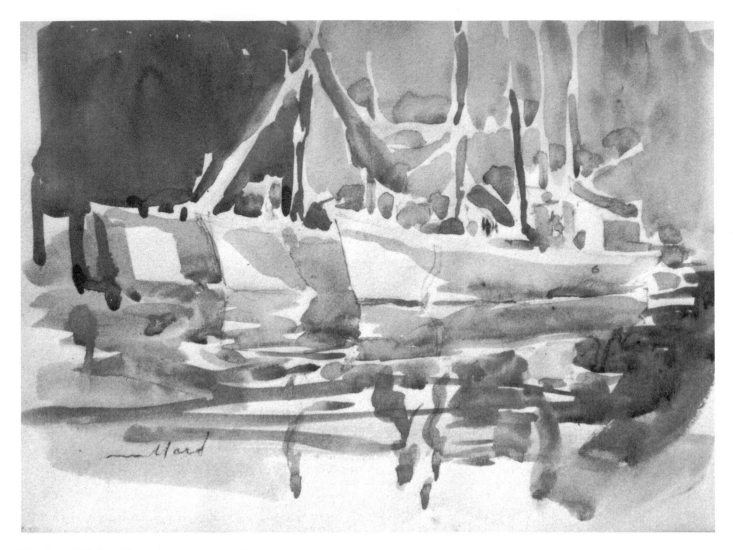

Design White Shapes to Attract the Eye

Very carefully save your white paper to create the white patches on the bows of the three trawlers. Design these pieces as angles so that they lead the eye back into the picture plane and to the left (see diagram). Equally carefully leave your white patch of paper on the mainstay of the second trawler rigging to guide the eye at a counter angle from the bow . . . up and to the right. You are establishing a rhythm in the motion of all these angled white patterns.

You are leading the eye of the viewer with these white shapes in a way that creates a different kind of attraction or appeal for the painting. It sounds a bit complicated, but in reality, it is quite simple, as you can see in the diagram. Always be thinking in terms of shapes as well as color! These accents are out there if you're willing to look for them . . . and if you learn how to "see" them. These

trawlers actually had deep green hulls and the masts were all a deep orange (for visibility in bad weather). The rigging was a confusing array of dark lines. But by changing the hulls, masts, and rigging to white you have made it possible to lift your entire palette to these high-key colors, colors you would sooner find in a flower garden than in a dark, dull harbor scene. Be daring. Be different!

Assignment: Try a second watercolor sketch . . . this time with all masts and dories the same orange color from a single wash. See how "flat" or dull the ships have become? In the illustration, the deep red-orange mast of the first trawler helps to pull it toward the foreground . . . the deep orange-rust dory repeats the angle of the green fish net . . . the deep orange mast near the dark sky section aids the visual transition into the light sky section so it's not as abrupt a change.

And Have You Considered . . . Notice how the dark sky segment and the dark, dull green water at lower right are having a game of "Push-Pull" across the picture plane . . . thus giving a quiet, strong movement to this very still water on a breathless, hot summer's day. That murky sun is created by dropping, wet-in-wet, a thick mass of cadmium orange into a wash of mauve and burnt sienna . . . one shot and don't poke at it to "fix it." *If you miss it, do it better in your next painting.*

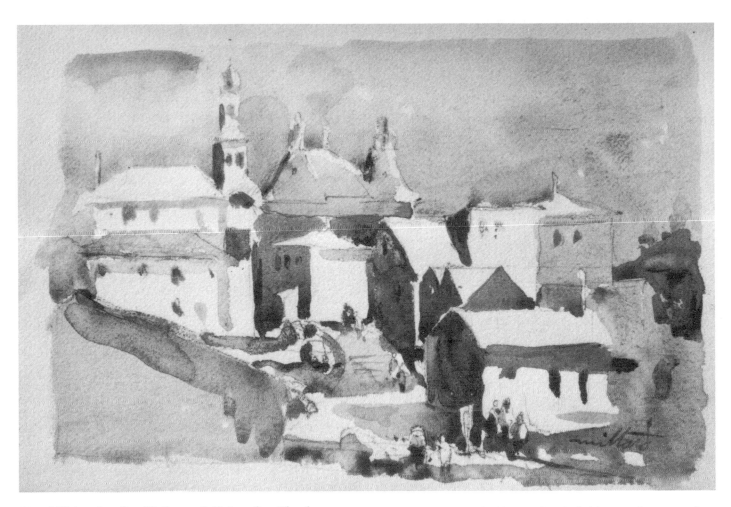

Use White for Sunlight and Color for Shadows

Now we are surrounding sunlit shapes with shadows of deep color. Begin with a contour line drawing of this knot of seaside buildings. As your carbon pencil moves over these sharp, angular, geometric volumes, you should be getting the feeling of power . . . strength . . . hard edges. Your subject should also be saying "deep, rich color" in the dark negatives.

Because there is no shading in your drawing, you are free to play where you want to place your shadow shapes. You are looking at a mass of red, orange, beige, brown, and black forms and it's up to your mind's eye . . . your daydreaming mind . . . and your feeling for this subject, on this day . . . to pick out where you feel the white pattern will flow. And there *is* a flow in this mass of buildings for you to dig out. Can you see it?

Arbitrary light is used here. The sun is actually shining from the left, but you will get a more exciting white pattern by imagining that it's coming from the right. Feel free to choose the light direction. Don't always paint what you're looking at. There are two exceptions to the light pattern: the face of the building at the top right and the dark triangle just below it and to the left. Why? For better design. The first color keeps the eye in the painting and the second breaks up what would otherwise be a dull, square shape.

Put a warm cobalt violet and raw umber wash over all but your carefully chosen whites at the top half of the sketch.

Give the bottom half a cool cobalt blue and raw umber wash, again working around the whites, forming a strong base for the forthcoming deep color pieces. (Note the color and value changes here and match them exactly.) Add more raw umber to the pale cobalt blue in the center of the sketch for a warmer note in the midst of the cool blue areas, and to visually link it to the warmer shadows of the buildings.

When the background washes are dry, mix your deep-toned negatives with Winsor violet and burnt umber; ultramarine blue and burnt umber; and cobalt violet and burnt umber. Then drop some permanent rose wet-in-wet into the middle building and spot a touch of manganese blue and another of cobalt green at the center right.

Observations: There are several granulated washes in this watercolor sketch and they tend to make your whites look even more crisp by contrast. Examples of mixtures that create granulated or sedimentary washes are: cobalt violet with burnt or raw umber; ultramarine blue with burnt umber; manganese blue with raw umber or with cobalt green; and burnt umber with permanent rose.

Turn your sketchbook upside down and look at the sharp-edged, interesting white abstract shapes in the sunlit areas. You need these strong white shapes in order to balance the deep colored shadows.

DESIGN YOUR WHITE SHAPES

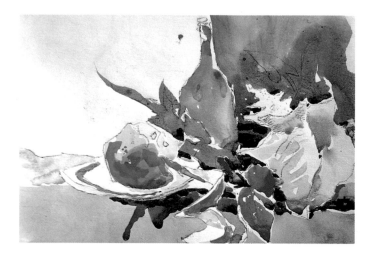

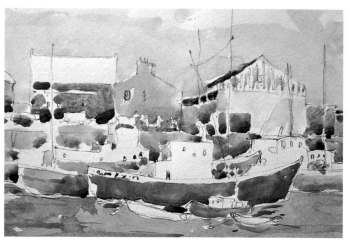

Contrast White Against Dark

You are designing a major abstract pattern in three sections "behind" this still life. The top two-thirds is divided into two pieces: a large white area against a smaller dark one. You have automatically created a dramatic setting for your shell, bottle, and fruit . . . and this is all resting on the third segment of the abstract, which is a middle-toned tabletop and front dropleaf.

The top of the seashell is a very exciting shape, made all the more so by the stark contrast of the white paper against the dark gray-green background piece. As the pink of the shell deepens and you add the poinsettia's red leaves, your background dark gets increasingly deeper in color-value, almost to a black. (Here's where you'd use the dark mixtures of your palette exercises, shown on page 68.)

The green bottle and green-blue leaves also appear very dark against the white paper. This is *the technique of chiaroscuro* . . . the time-tested "tool" of the masters . . . white against dark . . . dark against light. Note how your green bottle becomes a pale blue as it comes against the dark background . . . chiaroscuro again.

Incidentally, the dark background wash for this painting is made up of the pink of the shell and the green of the bottle . . . and the color wash is deepened by strengthening these pigments as you move downward wet-in-wet . . . until *finally* you are adding ultramarine blue with permanent rose and viridian to approximate a black under the red leaves, plate, and shell. To repeat, see shadows as color!

By pitting white against dark, you are creating *power and poetry*. The seashell is dancing . . . the leaves contribute a strong diagonal, repeated in the graceful curve of the orange peel . . . the lavender curve of the plate's border sweeps the eye back into the exciting patch of negatives at the center of this apparently *simple composition*.

Use White Patches as Interesting Shapes

Your basic interest in this composition is the variety of shapes and the way they relate to each other and attract the eye of the viewer to this cluster of harbor buildings and ships. Two white roofs and the white end of a huge fish house are set against a clear, pale, misty sky (Davy's gray and lavender). Use very little value change here. The white and gray sky are quite close in value if you squint your eyes, and yet there is a brilliant quality to this closeness. Look at the work of Turner and you will find more of this type of brilliance, a brilliance that derives from the restrained use of color . . . one next to the other.

The second set of white shapes occurs in the ships' bridges. These are also set against a gray background "piece," except that the gray of the stone dockside is a mite darker than the gray used for the sky. It's also a bit warmer, since you are using Davy's gray and raw umber for your wash.

Note that this warmer gray is pushing your ships closer to the foreground. The spot of orange deck . . . the scarlet floats and the sweeping red hull also serve to set the red ship right up front in your picture plane . . . your center of interest. There is an interesting diagonal "arrangement" of the skiffs and dories. This time these whites are set against the stronger value of the red hull. There is also a progressive movement front to back, and it is created by these three value changes that you have just painted and placed around your whites. Although there is little modeling in your washes of color, this is not a flat, two-dimensional work. There is definite visual movement "into" this painting.

Carefully design your dark shapes and place them in very selective positions. *Here is a good example* of where your drawing line can enhance your painting. This is also an example of where I disagree with Hawthorne (see Bibliography) when he states that drawing and painting are better left separate. Look at how well lines and washes are combined here.

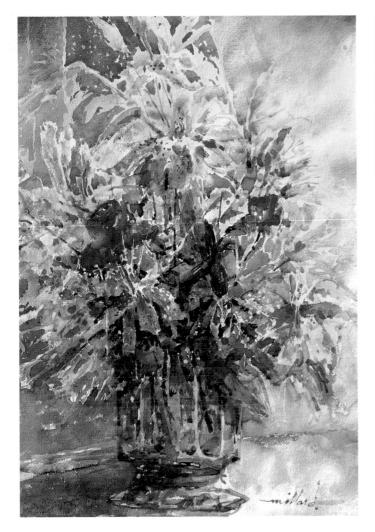

Work Darker Color Shapes Over Dry Washes

Many times, in the throes of excitement, painting away to your heart's content, it will appear that your colors are all correct, the values just what you want, and the tones of color right on the button. Then you'll put the painting aside and work on other paintings. But the next day, when you pull out this first painting, you're disappointed. Yesterday it looked good and now it seems too weak . . . the washes appear faded. What happened?

Watercolorists have always been told to mix their washes deeper and stronger than they think they should . . . richer and heavier with pigment than they almost dare. Why? Because watercolor dries lighter! It is as simple as that. You can also misjudge your colors if you paint in the sun—the strong light blinds you to the true colors. Also, many watercolorists paint with "tinted water," and the colors look perfect when they're wet—but dry they look weak and you wonder why.

Rose and Pink Tigers was painted on a gray day, with the still life set up on a pale pink cloth by the window. There seemed to be enough light at the time, and the washes of color looked all right when they were applied, but the colors of the flowers fooled my eye and the excitement of

painting disarmed my good judgment. The next day, when I propped the floral against the studio wall, I could see that something was wrong.

It was too flat. It needed a single strong source of light coming from one direction (here, from the top right). It also needed a cast shadow. And so I mixed blue, umber, and a touch of black in a large soupy wash and applied it at an angle to keep it clear. I glazed over sections in the lower left, right over previously painted sections of the floral. If a glaze is applied swiftly and without any scrubbing, the undercolors will show through and merely appear darkened.

This bluish shadow is also worked into the center of the flowers on down into the bottom leaves, vase, background, and tablecloth. A very slight amount is also brought over to the right-hand side of the table and placed under the flowers. The reddish brown wall directly above and behind the flowers is also darkened. It strengthens the vertical quality of the floral and adds interest because of the unusual irregularity of its shape (see detail). Notice that a slightly darker wash has been laid over the upper right side of the painting. It is barely perceptible as a pale, warm pink (cadmium orange and cobalt violet with a touch of permanent rose), and yet it is creating new leaves and blossoms out of the previous background where no leaves or blossoms existed.

Detail

Notice that this darker overwash (of cadmium orange, cobalt violet, and a touch of permanent rose) has been applied as a *patch of color* . . . right over the previous wash that seemed too washed out and weak. But be selective as to where you put the wash. You are "cutting" new edges now. Pretend there are some delicate, tiny, pale blossoms, like baby's breath, and "paint around" these blossom bits that *exist only in your mind!* Don't use masking fluid . . . just start your "flood" of the new soupy wash and, as you trail it from across the top and downward . . . let these little pieces remain from your first dry wash. Also create new flower forms. When you bring the "soup" up toward the pink petals, stop before you reach the previous edge and make a new edge out of the first color.

GET TO KNOW YOUR COLORS

I use a twenty-four color palette, but since it is much too difficult to learn how your colors combine when you are starting out with so many different hues, I recommend adding colors gradually, through a series of basic palettes and color exercises that will enable you to work up to the twenty-four color palette at your own speed. Each palette will involve its own set of mixing exercises that will help familiarize you with the colors. I call these mixtures "colored chickens."

Mixing Chickens

The standard way to make color mixtures is to make a vertical stripe of every color on your palette, then cross them horizontally with the same combination of stripes so that every color mixes at some point with every other one, creating a little square where the stripes cross. I personally find this method a bit dull and scientific. Furthermore, it eliminates the exciting quality of working wet-in-wet because the first set of stripes is always dry by the time the second set crosses it. Therefore, I recommend mixing colored chickens instead.

To mix these color chickens, wet-in-wet on dry paper, we will be working with two brushes, one in each hand. I recommend using two bamboo pointed brushes, ½" (13mm) in diameter. Wet both brushes and dip each one into a different color and, working from head or tail of chicken to center, let them meet in the "body" area. For example, you will take a cobalt blue, rich in pigment, and apply it onto the dry paper with your left hand, working from chicken "head" to center, then with your right hand, put a rich glob of cobalt violet on your other brush and with a quick stroke, work from the "tail section" into the center . . . and watch the colors explode!

You can make these chickens look abstract, just simply two strokes of color (more like wings than chickens), or you can experiment with some rather fancy chicken shapes like the ones I've done here. You don't even have to use a Japanese brush (though I think it's fun to experiment with materials). You can use any two medium-sized no. 9 round sable brushes, such as Winsor & Newton's Series 7, or use the new nylon round brushes.

Water and Pigment

Work near a sink so that brushes and mixing bowl are washed clean after each chicken. Or work with two pails . . . a large bucket of tap water for rinsing your dirty brushes, and a smaller bowl of distilled water to mix with your colors. Remember, never mix anything but distilled water with your paints. Many areas have chlorine (a bleach) in their water, and several areas have acid rain, so rainwater is also not safe.

Palette

I use a black tin folding palette manufactured by Morilla. (Other companies, such as Holbein and Winsor & Newton, make similar palettes.) The inside is painted in white enamel, and there are twenty-four small spaces for your colors, plus five large wells in which to mix paints and washes, and a thumbhole so it can be held easily as you paint. The palette and my color arrangement are illustrated here, with the colors numbered according to their location (see "Advanced Palette").

Filling the Wells

Using the large palette chart as a guide for the placement of the hues marked for your specific palette, squeeze about a quarter teaspoon of tubed color into each of the wells you will be using. Let your colors rest for half a day to harden them slightly, then dip your fingertip into a bowl of clean water and make a dent or depression in each color, cleaning your finger after each color. From now on, your colors are to get a drop of distilled water in this dent every night and each morning, without fail, so that your pigments are always gooey or tacky. This will insure a supply of thick, intense color . . . not anemic, tinted water . . . when you mix your hues.

Mixing Area

You can mix your colors in one of the large wells on your palette, butcher's tray, or on a large white dinner plate. If you want to try a dinner plate, choose a plain white one, 6" or 8" (152mm or 203mm) in diameter, with a flat border rim. Squeeze your cool and warm colors on either side of the rim (such as a blue on the left and an earth on the right), or around the rim if there are several hues involved. Your colors can either be mixed directly on the paper, one with the other as previously described, or premixed here in the center of the plate (or on your palette) for a different effect.

If you are mixing two colors together on plate or palette, be careful not to overmix them. Pick up a color on each brush and mix them together in the center well of the plate or palette. Then clean your brushes and pick up a big slurp of the mixture and make a chicken. Finally, rinse your brushes in the bucket of water, wipe them on a clean rag, and wet them again in the smaller bowl of distilled water.

MAKE A COLOR-MIX FILE

You will need a standard three-ring looseleaf notebook, 8½" × 11" (215mm × 279mm), in which to file your mixtures. This will give you a ready reference file so you can see in an instant how each of your colors mixes with the others. The looseleaf format will permit you to remove specific pages for reference to solve a problem or to compare colors. It will also let you lay your pages flat, pull out a page or two to carry with you when sketching outdoors, or bring some blank pages for new mixtures when you're out in the field.

Identify this notebook with your name, address, and a reward for returning it if lost. Keep the notebook in a clear plastic bag to protect it when you travel.

Paper

For your mixtures, you can either purchase a good-quality watercolor paper or use the backs of unsuccessful watercolors done on 140-lb paper or heavier. Choose a paper with some rag content in it . . . you'll want it to last for many years. Wipe off as much color as you can from the watercolor painting with a damp cloth, then turn it over and use the clean side. Cut the paper into 8½" × 11" (215mm × 279mm) or smaller pieces to fit your notebook, and hand-punch holes on the side with an inexpensive hole puncher, available from a stationery store.

Filing the Mixtures

Several mixing combinations are shown here as examples of how to mix colors and combine them on a sheet. Do three rows of two-color mixtures . . . three across and three down . . . for a total of nine per sheet. If you have an orderly mind, you may prefer to keep separate pages for blue mixtures, for yellows, for reds, and so forth, and file them accordingly. But you can also group your mixtures like the examples shown here . . . into primaries, grays, and darks, and general color mixtures. I personally feel that if you have a variety of color combinations on a page, just looking at the page itself can convey a certain exhilaration . . . a stimulation for color. The choice of combining mixtures and filing them is yours to make.

Experimental Mixtures

Don't stop with the mixtures I show here. Experiment, both in your studio and out in the field. Try oranges and yellows mixed with blues and greens when you're out painting foliage. Mix what you see, the local color . . . then try some unusual color combinations, the colors you don't see . . . for that is how you will extend your color capabilities. For example, try cadmium orange and cobalt violet for that strange fall grass color that seems so elusive . . . or try cadmium orange with cadmium red, then cadmium orange with burnt sienna . . . for the effect of leaves turning from sunlight into shadow. Also try some odd-ball combinations . . . like Naples yellow with permanent rose . . . or manganese blue with viridian . . . or pale alizarin crimson with Davy's gray for that old faded burn color. Or mix Grumbacher artist-quality cerulean blue (on the milky side) with permanent rose. (Yes, the brands do make a difference . . . in the colors . . . in the quality . . . in the mixtures with other pigments. Experiment with several brands of the same color for a range of different effects, or to find out which brand of color you prefer.)

When you know how two colors work together, try mixtures of three and four colors. Mixing color is great fun, and when you expand your color range, it is like moving from the subtle tones of a string quartet (working with a palette of four colors) to a full orchestra playing a twenty-four-color Beethoven symphony! Experiment. Practice. Try everything you can. This is how you become a colorist!

BASIC PALETTES AND MIXTURES

Novice Palette
No matter what your level, you will benefit from mixing these chickens and painting with these limited palettes for a while. You will be starting with a cool and a warm version of each of the primaries. The numbers in parentheses refer to their position in the twenty-four color palette (see page 67).

Cool yellow: Winsor Yellow (1A)
Warm yellow: Cadmium Yellow Deep (3)
Cool red: Alizarin Crimson (10)
Warm red: Cadmium Scarlet (6A)
Cool blue: Cerulean Blue (23)
Warm blue: Ultramarine Blue (21).

Primaries and Secondaries, Warms and Cools
By mixing all your cool colors with each other and then with the warm hues, you will get two sets of secondaries, one warm and one cool, for a total of twelve secondary hues. For example, you will mix warm yellow and warm red for a warm orange; cool yellow and cool red for cool orange . . . and continue the process for mixtures of yellow and blue (green) and red and blue (purple). Then you will mix warm yellow with cool red, and cool yellow with warm red and so on. For another set of mixtures . . . this time more grayed, you will also practice neutralizing your colors with their complement by mixing both your reds with the greens, both blues with the oranges, and both yellows with the purples.

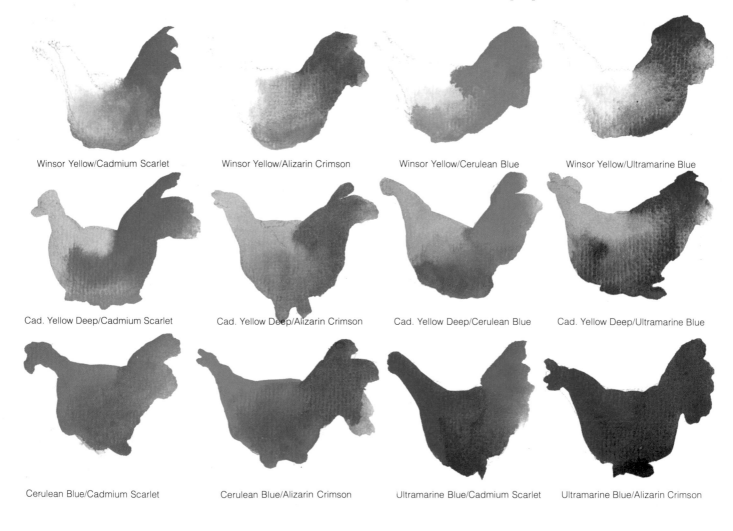

Winsor Yellow/Cadmium Scarlet

Winsor Yellow/Alizarin Crimson

Winsor Yellow/Cerulean Blue

Winsor Yellow/Ultramarine Blue

Cad. Yellow Deep/Cadmium Scarlet

Cad. Yellow Deep/Alizarin Crimson

Cad. Yellow Deep/Cerulean Blue

Cad. Yellow Deep/Ultramarine Blue

Cerulean Blue/Cadmium Scarlet

Cerulean Blue/Alizarin Crimson

Ultramarine Blue/Cadmium Scarlet

Ultramarine Blue/Alizarin Crimson

Intermediate Palette

When you have become completely familiar and feel comfortable using the basic palette of primaries and secondaries, you are ready to add several more colors to your palette—another red, another blue, an orange, four earths, and two greens.

Permanent Rose (9)
Cobalt Blue (21)
Cadmium Orange (5)
Raw Sienna (12)
Raw Umber (13)
Burnt Sienna (14)
Burnt Umber (15)
Viridian (17)
Sap Green (16)

Mixing Grays

Grays form an important part of your repertoire of colors. They can make your more brilliant colors sing in a special way . . . bright colors appear more brilliant when they are surrounded by gray tones. Grays will also tone down some of your brighter mixtures when added to them. But remember to keep your paper on a slant so your colors remain clean . . . and don't poke back into these wet-in- wet mixtures or they'll get muddy.

The set of gray mixtures shown here, of three blues and three earths, will start you on your collection of grays. As you progress, you will be making color-file pages of more grays from new colors and adding them to your palette. But learn these first.

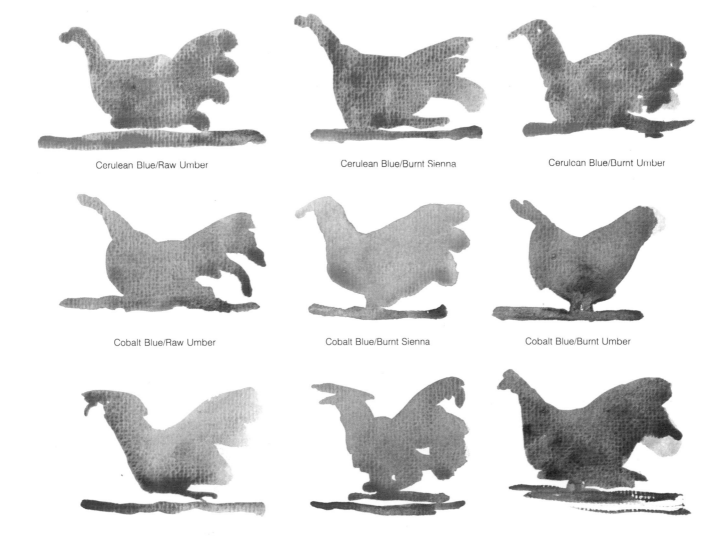

Cerulean Blue/Raw Umber Cerulean Blue/Burnt Sienna Cerulean Blue/Burnt Umber

Cobalt Blue/Raw Umber Cobalt Blue/Burnt Sienna Cobalt Blue/Burnt Umber

Ultramarine Blue/Raw Umber Ultramarine Blue/Burnt Sienna Ultramarine Blue/Burnt Umber

MIXING COLORS 1

Cobalt Green/Winsor Violet

Viridian/Cerulean Blue

Sap Green/Ultramarine Blue

Cobalt Green/Winsor Violet
("plate" mixed)

Cerulean Blue/Light Red

Sap Green/Burnt Sienna

Cadmium Scarlet/Winsor Violet

Cerulean Blue/Light Red
("plate" mixed)

Cerulean Blue/Light Red
and Sap Green/Burnt Sienna*

MIXING COLORS 2

Cerulean Blue/Cadmium Scarlet

Cerulean Blue/Alizarin Crimson (tint)

Cobalt Blue/Winsor Violet (tint)

Cerulean Blue/Winsor Emerald

Manganese Blue/Sap Green

Ultramarine Blue/Venetian Red (tint)

Naples yellow/Permanent Rose

Raw Sienna/Cobalt Violet

Cadmium Orange/Sap Green (tint)

*Here two separate mixtures from Row Two were mixed and combined as a single puddle.

Advanced Palette

When you have mastered the novice and intermediate palettes, you are ready to work with the entire range of twenty-four colors. I have two variations of this palette. Most of the year, when I am working in cooler climates such as northern California, Boston, or Ireland, under more frequent gray skies, I use the palette listed below for my landscapes, seascapes, still lifes, and portraits. But when I am painting under the brighter skies of tropical climates, and when I do florals, where intense and vivid hues are essential, I substitute Winsor yellow (1A), cadmium scarlet (6A), Venetian red (7A), emerald green (15A), and Winsor violet (19A).

Naples Yellow (1) . . . creamy, warm, opaque, unusual mixer

Winsor Yellow (1A) . . . cool, clear, brilliant mixer

New Gamboge (2) . . . cool, clean "cobalt yellow," good basic mixer

Cadmium Yellow Deep (3) . . . warm, hearty, semi-opaque, great strength

Indian Yellow (4) . . . very warm, clear, unusual color combinations

Cadmium Orange (5) . . . a handsome, brilliant, opaque color

Cadmium Red (6) . . . a "basic" mixer, heavy, not clear

Cadmium Scarlet (6A) . . . brilliant, opaque, selected mixer, be careful

Light Red (7) . . . least opaque of the earth reds, good mixer, tone downer

Venetian Red (7A) . . . powerful, opaque, unusual color

Cobalt Violet (8) . . . this one is a sleeper, unusual mixer, granular, poisonous

Permanent Rose (9) . . . hot and sharp

Alizarin Crimson (10) . . . cool red, clear, excellent mixer, rich

Raw Sienna (11) . . . a warm, clear, heavily pigmented earth color

Raw Umber (12) . . . a cool, neutral earth (my most-used color)

Burnt Sienna (13) . . . hot, clear, medium granular, a good mixer

Burnt Umber (14) . . . cool, deep, with heavy granular deposits. Keep the brakes on this one. It can get your colors dirty easily.

Hooker's Green Dark (15) . . . clean, deep, great summer color

Emerald Green (15A) . . . opaque, unusual mixer, poisonous

Cobalt Green (16) . . . rare beauty, delicate, semi clear, pale mixer

Sap Green (17) . . . very clear, warm, stains nicely

Viridian (18) . . . cool, brilliant, mixes well, stays clean

Mauve (19) . . . semi-clear, reddish purple, unusual

Winsor Violet (19A) . . . clear, brilliant, saves mixing a red with a blue

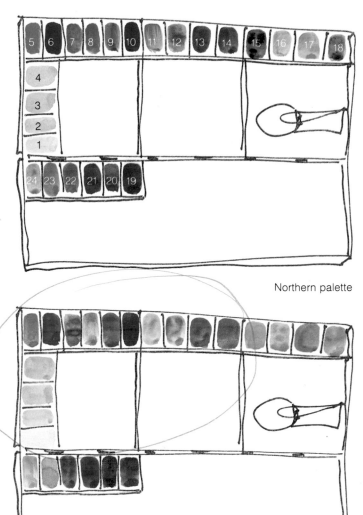

Northern palette

Tropical palette.

Phthalo Blue (20) . . . clear, deep deep cool, use great care

Ultramarine Blue (21) . . . very warm, very granular, mix with other granulars

Cobalt Blue (22) . . . clean and neutral, the key to mixing many of your grays

Cerulean Blue (23) . . . cool, rather opaque, floats well wet into deep colors

Manganese Blue (24) . . . very cool, very granular, unusual mixer, lively.

Notice that the colors are arranged very carefully on the palette, like the keys on a piano, with each note in a predictable order so you can find your colors quickly, without hesitation. Always keep your colors in the same order. It's professional . . . and expedient.

MIXING DARKS

Ultramarine Blue/Alizarin Crimson Ultramarine Blue/Sap Green Ultramarine Blue/Viridian

Viridian/Alizarin Crimson Viridian/Winsor Violet Viridian/Burnt Sienna

Phthalo Blue/Burnt Umber Winsor Violet/Phthalo Blue Winsor Violet/Burnt Umber

COMBINING STRONG AND WEAK HUES

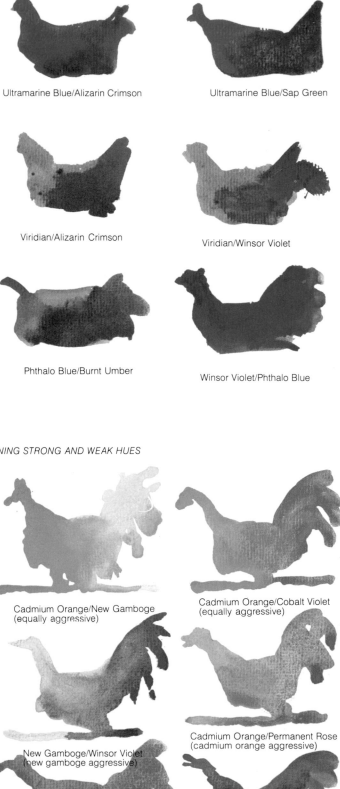
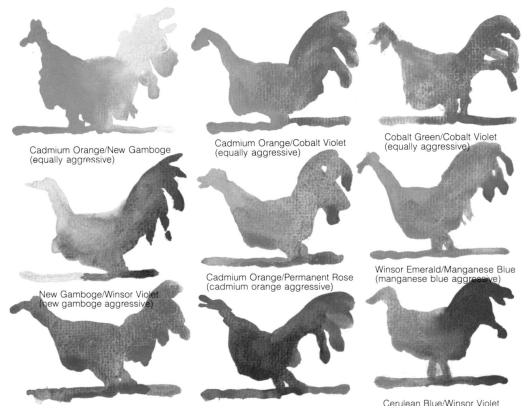

Cadmium Orange/New Gamboge
(equally aggressive)

Cadmium Orange/Cobalt Violet
(equally aggressive)

Cobalt Green/Cobalt Violet
(equally aggressive)

New Gamboge/Winsor Violet
(new gamboge aggressive)

Cadmium Orange/Permanent Rose
(cadmium orange aggressive)

Winsor Emerald/Manganese Blue
(manganese blue aggressive)

Cobalt Blue/Cobalt Violet
(cobalt violet very aggressive)

Ultramarine Blue/Burnt Sienna
(burnt sienna very aggressive)

Cerulean Blue/Winsor Violet
(cerulean blue very aggressive)

Mixing Darks (Advanced)

How often do you hear painters ask, "How do you get really dark colors?" or "How do you keep dark colors clear?" Well, here are some really dark colors for your color file pages, and if you will keep your paper at a slant as you apply them, then your dark colors will remain clear as well as deep.

These colors are all very heavily pigmented (that is, loaded with paint). You might experiment with lesser amounts of pigment to find out just how deep a tone you feel is really required in a painting because these darks are very intense and, seen out of context (that is, apart from a specific painting), it is hard to judge how they would look with the values in a particular painting. Whenever you add an accent to a watercolor, be careful that your color-values work in relation to the other hues.

Too strong a dark will "punch a hole" in your painting. Test the mixture first on the side of your painting or on a piece of scrap paper . . . *before* you commit yourself.

Combining Strong and Weak Hues (Advanced)

As you mix one color with another, you will note that there is sometimes a chemical reaction between them. You might want to make a note as to which of the two colors in a mixture is the more aggressive or overpowering, or observe what happens when both colors of equal strength are mixed.

When two aggressive colors mix wet-in-wet, the result is almost like an explosion . . . a violent reaction. Combine strong colors in your more emotional watercolors, or wherever you want more vitality . . . more exciting brushwork. Your viewer will pick up this quality.

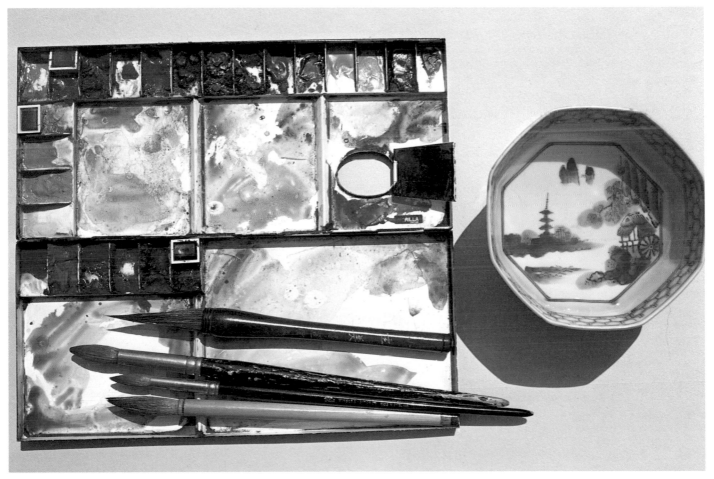

My 24-color palette, with three half-pans of Rowney paints I'm "trying out" placed in appropriate areas over my regular colors. (I'm always experimenting!) There are also two Japanese brushes and some Winsor & Newton red sables here, too. Notice the orderly arrangement of my color mixtures on the palette.

Pattern with Color

Always be on the alert for patterns happening in front of your eyes. The search for the next painting is constant and after a while you will begin to see patterns of color—and if everything is just right . . . light, values, mood . . . *it will look just like a painting.*

These two characters . . . a macho guy in cowboy boots and a big slouch hat, and a long-haired, blonde gal . . . were painting this huge fishing boat. The morning light was very strong and, against the dark hull and white superstructure, their arms, shirts, pants, and legs broke into strange little pieces of color. It was like a vision . . .

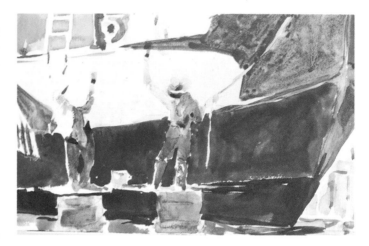

The hull was dark green, but the color wasn't tuned up just right, so I changed it to blue. It looks better now. Their bodies break the hull into three large pieces and two tiny ones between their legs. The shirts and arms of our two ship painters are making unusual pieces out of the white area. *Study these shapes!* Also notice how the paint bucket is enhancing the piece of blue hull between them. And look at the rope in the guy's hand. *Be observant.* Don't leave these little details out of your sketch or run a wash over them in error.

Design Color in Still Lifes

These West Indian eggplants were nestled in their hand-woven basket, sitting on a restaurant windowsill, silhouetted against a midnight-blue tropical sky.

First, bring up the color key of the deep purple-violets to a more brilliant collection of deep rose and violet burgundies. You can also get better contrast of color by putting them against a deep, deep blue sky (ivory black and ultramarine blue, alizarin crimson and ultramarine blue with a touch of cerulean blue, top right). Then, there is an *unusual color vibration* where the scarlet velvet ribbon (cadmium scarlet and permanent rose) rises in a brilliant vertical. You can increase the color's brilliance by leaving tiny white lines on each side of the ribbon.

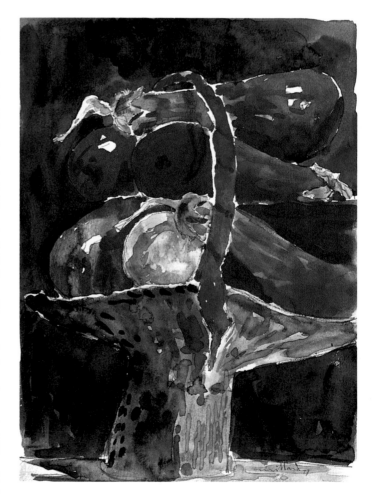

The sap green stems (with a touch of raw umber) complement the many reds of the eggplants. For a severe change of color pattern, repeat the green in two flat strips of windowsill beside the base of the basket . . . This windowsill was in reality a dark brown. Ugh!

The touches of orange on the eggplant add excitement to the color design. First, the orange plays optical "tricks" with reds and rose (see the great still lifes of Bonnard), making the colors appear to vibrate. Second, the interplay of circular shapes makes the basket "nicely awkward" and the eggplants a caprice.

The basket is a variety of mixtures: yellow ochres with raw umber, raw umber alone, raw umber with burnt sienna. The blue of the background is used for the weave marks, and for the reds: permanent rose, permanent magenta, cadmium red, cadmium scarlet, cobalt violet, mauve and Winsor violet . . . wow!

Practice mixing these various reds and purples in your color-mix file, identifying each two-color mixture for future references. When you finish these cross mixes you will better know these seven reds.

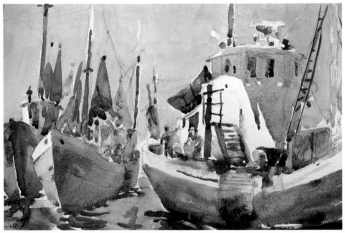

Simplify Color

The conch shell, hibiscus, and mangos are quite varied in shape, as is the shadow pattern on the banana leaf. There is a tranquil quality about this still life by the seashore in spite of the exciting forms . . . and this is due mainly to its simplified color. It also gets a stabilizing quality from the horizontal line of the sea. *Put your watercolor directly onto the sketchbook paper* without a contour drawing to guide you . . . again a technique designed to simplify your painting.

Paint the mangos first so that you have a specific color to judge subsequent colors against . . . to know just what red to use for the hibiscus . . . and just what pink to paint the conch shell. The choice? Grayish pink, now that it can be judged next to that red flower. This gray pink then helps to pick the exact color of the turquoise sea. The mangos are pale washes of Indian yellow, yellow ochre, permanent rose, and a spot of cadmium red . . . no shadow tones in this wash. *Next the hibiscus:* a pale wash of permanent rose and—while it still glistens—add wet-in-wet some heavier pigment of the same color . . . no shadow tones . . . but leave a thin white line of paper separating the mango so the colors don't run into one another. *Next* put in the pale pink and then the pale raw umber of the shell.

The ocean comes next with an overall wash of cerulean blue and light red. Into this, drop, wet-in-wet, some manganese blue as illustrated. Then, *into the wet colors,* drop in a small wash of ultramarine blue with a bit of mauve. This same mix then goes onto the now-dry hibiscus for shadow tones.

Lastly, add the banana leaf, sap green with added touches of viridian on the left side, and with raw sienna and sap green added to the bottom and to the right side, dulled with a bit of the ocean mix. *The shadow mix*—ultramarine blue, mauve and raw umber—goes onto the banana leaf under the fruit and shell. Remember, you are designing all the time you are applying the shadow puddle. Put the same colors on the mango shadows . . . with a touch of sap green in the left-hand side of the shadow to emphasize their form.

Use Analogous Color Creatively

Back to dreamland again for this one! *In the real world* there were only dark green hulls and a red hull on the harbor water this particular morning . . . and you have driven 60 miles to get there. During the trip to sketch the trawlers, you have been thinking about *colors that you like* . . . so you have been putting in 60 minutes of thinking about color combinations. Right?

During the past week you had seen something with orange and lavender and pale greens and soft blues and tints of earth color. It was in a painting you saw at a gallery. . . . or a piece of fabric you saw at a friend's house . . . or in a color movie . . . or a poster. Anyway, you saw it! And you are thinking about it on the way to sketch the trawlers! Put in some time thinking about what you are going to paint before you arrive on the scene. Daydream.

This painting, then, paints itself!

The first sight of the orange masts starts your creative juices flowing. You wonder, "What's nice with orange?" . . . Pink. So in goes a pink sky in a big, fast wash of cobalt violet, Davy's gray, and permanent rose . . . painted around your orange masts. Leave the white around the pieces of the ships where the light is hitting. *Your contour sketch allows you to decide where you want the sun pattern to fall.* Manganese blue and raw umber in the shadows on the bridge housing . . . with just a touch of cobalt violet in the mix. The lavenders and blues and warm earth colors find their way very comfortably into your sketch. Just follow the illustration.

When colors are analogous, they relate to each other in a kinship or close relationship in this sense: orange moves very easily to pink just as they'd normally move around the color wheel. . . . They are very compatible. So this orange dory looks quite exciting sitting in a field of pink sky. For the same reason, the pink sky relates smoothly to the pinkish-lavender of the boat hulls and then goes easily into a more blue-lavender . . . then into the cool manganese blue of the bridge. Touches of burnt umber throughout hold the brighter hues in check, keeping them earthbound.

71

USE COMPLEMENTARY COLOR

Red and Green (top)

As you well know, complementary colors (hues opposite each other on the color wheel) enhance each other. One of the most typical complements is green and red. In this exercise, the reds range into the red-purples: cadmium red, permanent rose, light red, mauve, and Winsor violet. They follow the arc of the lattice porcelain dish, and rest on a violet-pink tablecloth. The greens, also following the arc of the dish, range from sap and cobalt greens with a touch of burnt sienna at the top right to sap green and viridian at the base of this upper green piece. The lower green wash starts with Grumbacher's cerulean blue and cobalt green and goes into a sap green/viridian combination at the darker bottom. Nice, sitting on top of that nifty (complementary) pink. Right? The blue background is a gentle wash of cobalt blue and raw umber and the tone in the dish is raw sienna with a touch of cobalt violet. This is a simple still life, made interesting because of the complementary colors.

Orange and Blue/Violet and Yellow (below)

The flower centers are a complementary orange—cadmium orange with a touch of burnt sienna. The yellow flowers ease into a violet background . . . another set of complements . . . and the blue background (ultramarine blue with a touch of ivory black on the left) blends into the shadow color, with a bit of mauve added against the yellow and Davy's gray blossoms. The ultramarine blue also bleeds a bit into the cerulean blue and light red pitcher and tablecloth. Note the gradual transitions within these colors as you move around the color wheel . . . from purples . . . to red-blues . . . to blue and red mixtures. The tablecloth is wet with clear water and a weak wash of cobalt violet is laid in, wet-in-wet, on the top left of the bouquet. It drizzles down into the tablecloth. Also, stronger dabs of cobalt violet are placed on the extreme right to balance the bright, deep colors. To integrate the yellow flowers, the candlesticks (cadmium orange and burnt sienna) are added. The leaves are cobalt green and sap greens are put on partially wet-in-wet, with sap green spots worked over a dry base of cobalt green.

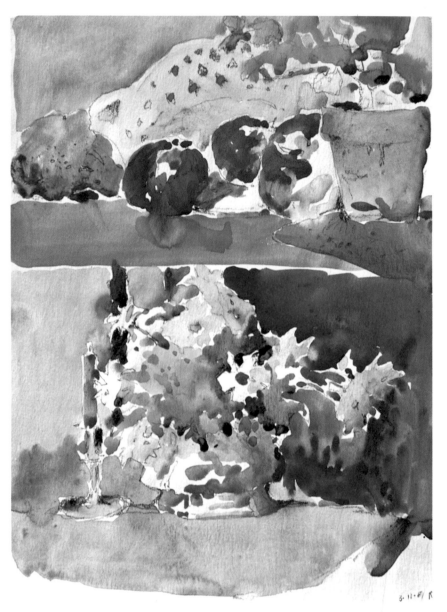

Copy Your Setup as it Appears (top)

This is a simple still life of just a creamy liqueur bottle, a basket of pink flowers, and an orange. In fact that is why I chose an orange instead of an apple . . . to get the right color vibrations for my blue background.

Let's analyze the background. Across the upper half of the sketch, starting at the right, there's manganese blue, moving into cobalt blue, then into ultramarine blue, which is laid over a prior wash of cobalt violet. The tablecloth is a combination of cobalt violet, raw umber, and cadmium orange put on in one fast wash on the upper surface, where the cloth turns down, add a little cobalt blue to the first mixture for a soft, shadowy quality.

Invent New Colors (below)

Now look at the lower half of the sketch-book page and let's shift gears. We're going to try a new color combination with the same still life as before. First redraw your contour lines, this time changing the composition with a simple shift in the line of the basket and of the white cloth.

This time we'll be using a series of reds in the background where you had blue before. Look at what a difference a single change of color makes visually! This is one of many inventive color decisions you will be making as you paint your way through this book. The red background, from the left, is mixed with cadmium red deep with alizarin crimson dropped into it wet-into-wet . . . then cadmium scarlet is added wet-in-wet . . . then a bit of Chinese orange . . . and finally some permanent rose at the lower right above the table.

Change the flowers to cobalt violet with some mauve added wet-in-wet, add more oranges and strengthen their color, and also deepen the basket color. Notice the cropping of the table top and the angle of view of the still life . . . and the fact that we're zooming in for a closer look. More exciting now?

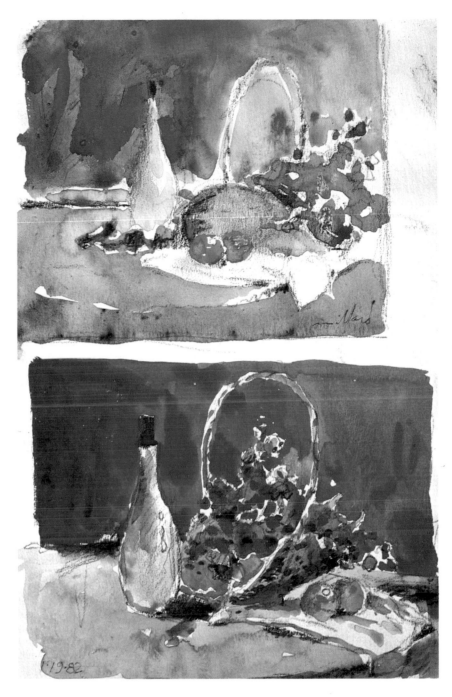

USE CREATIVE COLOR

Easy Color Lessons

Let's spend a morning sketching and painting three trawlers, learning something about color . . . instead of making a single, photographic rendering of a trawler with puffy clouds in a blue sky. By this time you should have picked up enough information on color to work your way through these three paintings using the illustrations as a guide.

First: with a selected arbitrary color, paint each of your three skies . . . one green, another lavender/gray . . . and another pink.

Second: Pick out a "set of colors" that go well together for each of the three skies. Use about six colors for each sketch. *Try to select your own choice* of six colors each time. If you want "outside" help, take the colors from a painting by van Gogh, Corot, Bonnard, or one of *your* favorite artists. If you must borrow from one of these painters . . . then paint them again in colors that you select on your own. Each sky color in this series of three trawlers sets the mood for your creative color . . . helps you to dare, to take a chance, to win! Don't put off making your own color choices or you'll never get the hang of it. And this is what will separate you from all the other artists!

Develop a *witch doctor's kit* from which you can pull out all sorts of creative color potions: cloth cuttings . . . a piece of a necktie . . . clip out with scissors pieces of fine art prints . . . pull off special chips from an Interior Paint Chart (look especially at Martin-Senour's if available) . . . Thai silk threads . . . put them in a tin tea cannister to call on whenever you're stumped.

The message: *Be creative with color from the very beginning.*

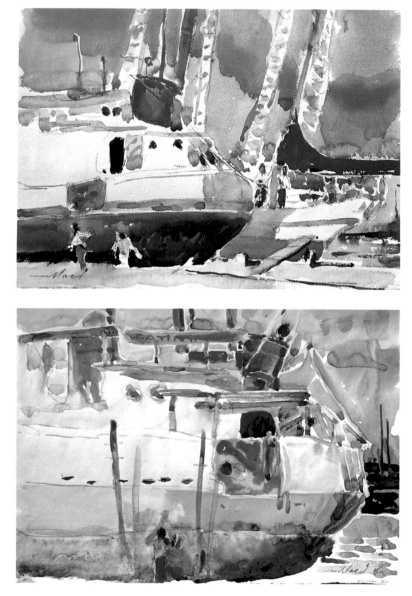

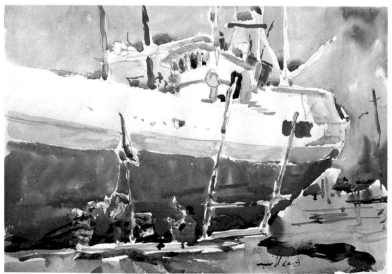

Detail

Your colors, as shown here, are *handled in simple color patterns* in your first washes. Look for big blocky chunks of color: a long strip of green . . . a long strip of grayish rose . . . large chunks of white (paper) . . . rectangles of various blue mixes . . . small verticals of different oranges. *Squint your eyes.* It will help you see less detail. Eliminate smaller color bits and focus on the larger patterns. Try to remember this business of squinting! It is an old and time-tested tradition among artists. Squint to get the basics, the form.

There are many greens within the basic green pieces. Some start with a mix of Winsor yellow and sap green . . . changing as you add manganese blue to the yellow and again as you swing around the stern of the ship and add strips of ultramarine blue with a touch each of raw umber and alizarin crimson . . . just touches, though. *Don't overdo your added colors* as you put them in wet-in-wet or they'll take over the principal color you started with.

There are five greens on your palette: emerald, cobalt, olive, sap, and viridian. These greens will usually suffice to meet your everyday watercolor needs. In addition to them, however, you will be learning all through this book how to mix "special" colors with your greens . . . colors like manganese blue with emerald green . . . sap green with burnt sienna . . . and ultramarine blue with viridian green.

You are being enticed by this detail showing the unusual greens of the trawler and the sky to become a more expansive painter. For instance, in addition to mixing Winsor yellow with sap green (one of the greens from its well on the palette), you are being asked to mix the continuing section of the green stripe, *with manganese blue and Winsor yellow* . . . which brings up the point of *more expansive color use.* This is not a "common" green from a palette well, but rather one that has been mixed in the blue and yellow series (see color-mixing section).

Mix each of the five blues of the advanced palette with each of the five yellow-oranges. Do these color exercises in a separate notebook, your color-mix file.

Study this detail carefully. You are starting each pattern block with a basic wash of color. Then you must decide when to add the next bits and pieces over the primary wash . . . dry or wet-in-wet . . . by knowing (through

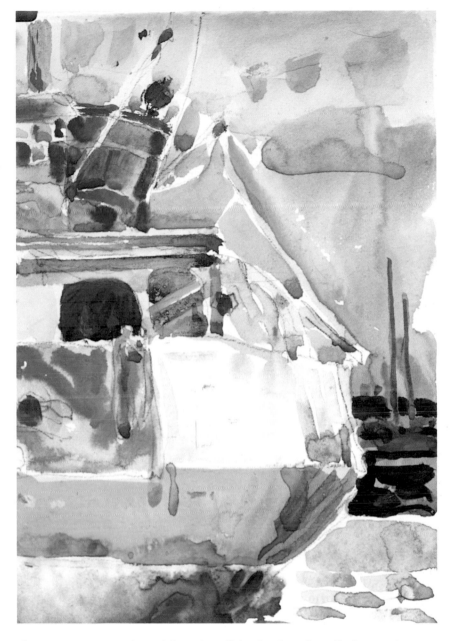

experience) how it will look when handled according to each method.

The blacks are important to the composition to attract the eye and make the other colors seem even more brilliant by contrast. The black here is a mixture of ultramarine blue, alizarin crimson, and mauve, placed in horizontal bars to coax your eye to a little red boat (a thick wash of permanent rose). In turn, the boat's small masts push your eye up into the variegated green sky washes and patches.

USE STRONG COLOR

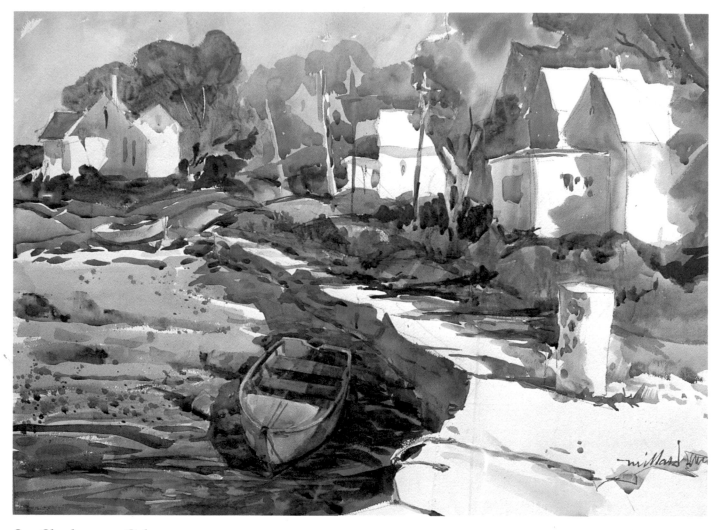

See Shadows as Color

You are sketching and painting on a warm summer day at a handsome place called *Lane's Cove*, a small section of a village consisting mostly of fishermen of Finnish descent. These houses are of a "classical" or typical New England style. You decide to emphasize this feature and in order to do so, you plan a simple color palette, keeping the houses white instead of the yellow, turquoise, and green you actually saw.

You walk around, sketching the various angles that appeal to you. There is one composition that is particularly striking . . . and you sketch it in a rapid contour drawing. Then you rest and watch the scene from the shade of a tree . . . bringing the sketch you just finished in the sun back into the shade with you. Learn to sketch from one position and paint it from another. Stay loose. You are just putting the pieces together, just as hundreds of artists before you have done it.

Start by cutting the green trees around the house at the top left, then paint the tree on the right, cutting around that house too, keeping some edges hard . . . and some edges soft, or lost. Staying with the greens, paint all the

grasses and earth tones . . . cooling your previously painted (and now dry) browns as you do the beach . . . then warming the beach as it comes toward you.

You have been sketching and painting for half an hour and by now your eyes are getting acclimated and sensitive to the colors before you. Your eyes warm up to the task of being creative with color. You actually can "see" color in the shadows by now. When you first sat down to paint, this was not the case. You just saw dark shadows along the stone dock. No thought of being inventive. Now you decide to paint all of your shadows a pale lavender—on the houses, dock, boat, and water, as well as all of the top center background. Then you let it dry.

Paint the upper edges of your dock shadows a cool, strong blue where they meet the sun . . . and with this same blue, cut around the little houses up in the top center background . . . literally creating them out of the first lavender shadow wash. This is similar to the way you created the imaginary flower edges out of your first wash in *Rose and Pink Tigers* (page 61). Landscape can be handled like still life!

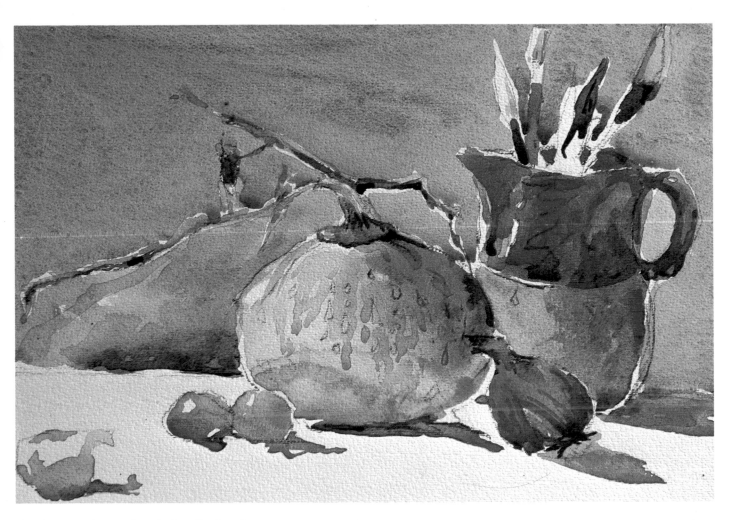

Use Deep Tones for Color Reflections

A simple still life is an excellent subject for some casual experiments. Here we'll be experimenting by making color reflections in deep tones of heavy pigment. Before we begin, let's talk for a moment about color reflections.

Whenever one object is placed close to another, particularly if it is shiny or smooth-surfaced, the colors of both objects are reflected into one another. Reflected color is a great blessing for the artist, since it gives you the opportunity to unify a painting by placing the colors of one object into several other areas. For example, the pumpkin starts as a light creamy ochre . . . changes to cobalt green, and ends in a strong orange tinged with black as it comes against the earthenware pitcher. The same color strength occurs in the pitcher . . . starting with a light warm earth color . . . changing to warmer earth with violet mixed for the reflection, and ending in an intense blue edge . . . rimmed with white.

Use very heavy pigment in your shadows and background and flood it on. Let the white of your sketchbook paper stand for the white tablecloth, which now appears glaring white due to the contrast with these strong hues.

In summary, it is the deep, intense color on your objects that "allows" you the luxury of using these deep-toned reflections. For example, the richness of the pitcher makes it seem very natural to use such a deep reflective orange right next to it on the pumpkin . . . where there is also a spot of pure orange reflecting the onion.

Using the primaries and their complements has added to the feeling of nobility in this simple arrangement. For example, choosing blue for the top of the pitcher prompted the selection of orange for the reflection on the pumpkin. The lavender-violet background wash has certainly enhanced the pale yellow brush. Graying the lavender background wash with Davy's gray has increased the brilliance of all the other colors by contrast . . . and relates in color to the bud of garlic at the lower left. The pale red tomatoes are indeed in good company with the *soft green* freckles on the pumpkin. Maybe the "Old Boys" had something when they used complementary colors!

And Have You Considered . . .

1. The pitcher was black-brown on top . . . would you have made it blue?
2. The yellow brush was a white Chinese calligraphy brush . . . would you have chosen pale yellow?
3. Block out the garlic bud with your finger. Would you have included it in the composition to relate to the background color?
4. The pumpkin was a solid creamy ochre . . . would you have introduced the green . . . or dared to use the deep orange reflection?
5. Would you have plucked the dried vine off the top of this neat little pumpkin? Would you have made part of the vine black?

Assignment: Try a second painting and this time leave out the dried vine branches and drop out the garlic. Do you ever use complementary colors in groups like this?

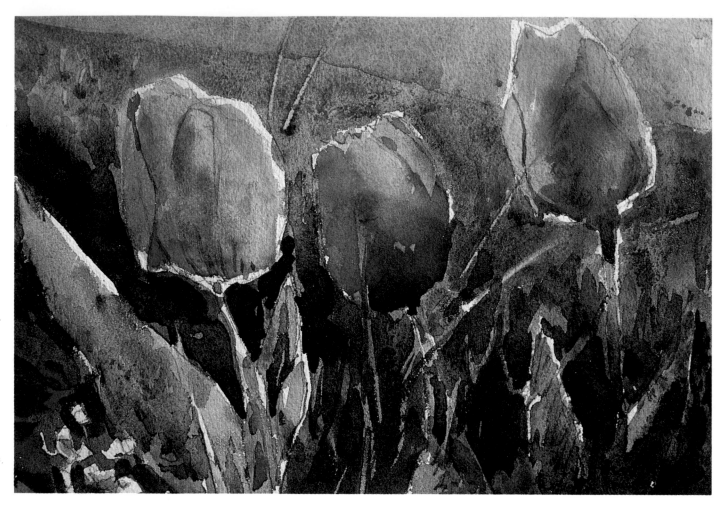

Use Color for Darks

At times you may wish to create a very deep-toned watercolor . . . a quiet mood but not a somber or murky one. Let's say you're out in the field very early to start your painting day and run across this delicate trio of tulips in the early light of dawn. How can you manage to get these deep tones and still not come up with mud?

First: Fix this fleeting impression—this image of the light of dawn on these dew-laden tulips—into your artist's eye . . . your memory. Your desire is to express this piece of poetry in paint.

Right away, picture in your head how the entire vision will look as a painting. Get a fix on how the colors relate to each other. How you are going to rapidly grade these colors for the tulips, grasses, sky, and leaves on your value scale of one (white) to ten (black)? How will you get those values of tone, grayness, brilliance of edges . . . wet . . . catching the first sun?

How? By remembering it! But you have to *want* to remember it. You only have a few moments to stare at this thing . . . to get it thought out in color before you even try to wet your brush. You will have to remember the first rays of light . . . the emotion of this sudden discovery. That's what you'll have to get into the watercolor!

Your goal is easy. . . . Just remember this first impression— But look quickly! The light is changing right now. You've had your chance. You've had your look. *That first look!*

OK, now let's analyze how this gets translated into paint. That rim of dew catching the sun has to be done by leaving a tiny separation of white paper between the edges of the blossoms and leaves. The sky is still quite gray since the sun is so low. The grasses are dull grayish greens and earth tones that run down into deep, deep green-browns mixed with blues Some areas are intensely deep, such as where ultramarine blue and alizarin crimson are mixed on the extreme left-hand side.

The yellows start out quite light, but are then grayed off with raw umber and run down into a fusion of umber-oranges and quite-deep yellow-browns. The center blossom moves into mauve and burnt sienna at its base . . . really deep color. But it will remain clear and clean if you apply your wash *quickly* and keep your sketchbook slanted at all times . . . *even while drying.* Use cool greens for the stems and leaves. After all, it's early morning and the sun isn't adding any warmth to speak of, as yet.

This is poetry. You are thinking of the music of Mahler or Sibelius. . . . Deep . . . clear . . . sonorous tones. Different . . . emotional . . . beautiful poetry.

The trick is to catch this first glimpse, lock it into your memory, and then, in a burst of emotion, paint this thing to match your first impression, even though the light and colors have changed as the clock ticks on.

USE REALISTIC COLOR

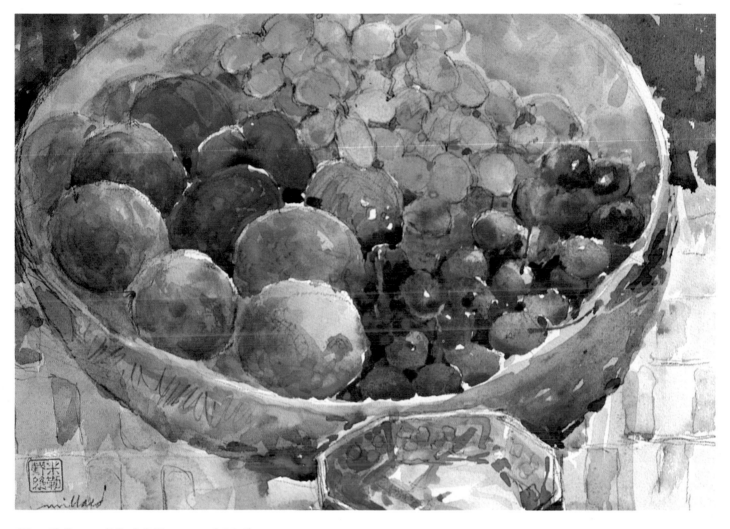

Use Color to Model Form and Light

There are no new colors here, just the same ones as in the *Three Trawlers* series. But the difficulty here is that you must model the form as you apply the color. You must also work out some problems: How to make the light travel across the bowl and then into it? How to keep the plums and deep burgundy cherries a luscious dark, and yet maintain a luminous quality? You can never equal what you see in your mind's eye, though the more you try the better you get. Here are a few suggestions.

First, take considerable care with your contour/freehand drawing . . . but draw as fast as you can push yourself. Keep a spirited line. It will reflect in your finish.

Next, look at the dark upper right-hand corner next to the light-colored back of the bowl. Do you see how the "path of light" comes from the angled green grapes, moves diagonally to the pinkish cherries, then down along the rim of the bowl into the brightly illumined inside of the multisided, small dish, then off to the right onto the "faded" checkered cloth. This path of light is an imagined thing . . . it exists only in the mind (the right side). It is not painted with a lift-out technique, but through the discipline of painting lighter tones in this imaginary path.

Finally, keep all the little sparkly bits and specks of flickering white paper (no masking allowed) as illustrated . . . to handle the edges in a "painterly" manner, making some hard and some soft—lost and found—just as you observe them.

USE COLOR PATCHES

What Are Color Patches?

There are three major color patches in this harbor scene . . . sky, land, and sea.

The Sky: This patch of white is an interesting, abstractly shaped "sky piece." Take the time to study how this simple white mass "fits" down into the interstices of the ship masts, roof pipes, and bits of buildings. There is also a special way that this patch of white relates with the "earth piece." Interlock the fingers of your two hands, squeeze them a little and try to pull them apart. Do you *feel the quality of "joining"* that is going on? Well, be on the lookout for this manner of fitting, joining, exchange of edges between sky and earth . . . it is never-ending. Remember this!

Wash clear water around the sky area . . . carefully painting around the masts and roofs and ship. Then mix a pale, juicy wash of Davy's gray, raw umber, and cobalt violet—and drop it, wet-in-wet, into the wet paper.

The Land: This piece is divided into three sections . . . foreground, middle distance, and distance. Visually, you enter this composition from the snow-covered dock on the left *foreground.* The *middle distance* contains the two trawlers. Carefully contour the exact spacing of the masts, superstructure, dory, and hulls. Mix cobalt blue and raw umber on the hulls and two dock planks and add a touch of cobalt violet into your bow mix. *The distance* consists of a cluster of commercial fish houses. They provide an example of how to find beauty in the commonplace. It is the simple, single-weight, contour line drawing that creates this beauty and allows you the freedom to design and place these subtle nuances of color patches in the buildings. Your color? A mixture of cobalt blue, raw umber, and Davy's gray. Take care when you select and place these patches, for each relates to the other. Paint with the same fondness for variations of gray you would find in a still life by Braque.

The Sea: This is a large, irregularly shaped green patch with "wave marks" created by the white of your paper.

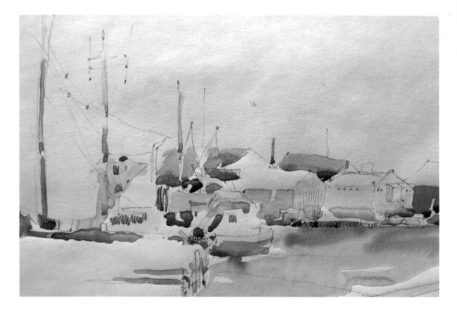

Mix cobalt green and viridian for the water. As you place this soft green wash, allow it to barely touch in several spots the wet "bubbles" of gray/blue color from your hull and fish house piers. Where the wet areas meet, small floods of the color run down into your sea . . . wet-into-wet. Are you remembering to keep your sketchbook always on a slant? Now you know why. You will create these color "bubbles" again in the next painting.

Finish the painting with touches of cadmium yellow pale and cadmium orange in the ship's masts, and add a touch of burnt sienna to the orange on the dory.

Note: There is also a very subtle interrelationship between the sky piece and the earth piece that involves the fine lines of the ship's rigging and pulleys. There is a "spacing" around the pulleys similar to the spacing you would perceive within a small flock of flying birds.

Assignment: Try this composition, varying the color scheme to suggest: 1) sunset, 2) rainy day, 3) red and brown buildings.

How Do You Find Color Patches?

By squinting your eyes. That will force you to pull all the many tonal variations and color nuances of an object into large color patches. You will also get another painterly advantage by squinting: you will see that this composition breaks down into two separate divisions—top and bottom.

The top half of the painting is made up of two dissimilar white patches. See how the large patch of white "reaches down" into the still life and interlocks with it like the sky and earth of a landscape?

The bottom half consists of a *conglomeration of color patches* of everyday life in the tropics. A hurricane lamp (cerulean blue and light red) holds the last vestiges of a large chocolate-colored candle (mauve and burnt umber). A green papaya (sap green, viridian, raw sienna) nicely fills the lower left corner and gently guides your eye back into the composition. (Leave white paper for the highlight.) The blue tablecloth in the left background is actually a mixture of several colors (mauve, burnt umber, Winsor violet, ultramarine blue), and yet it is simplified into two rather triangular patches. The wine bottle also becomes a single squinty patch, although it is made up of a multitude of greens, blues, ochres, browns, and red.

Leave a fine line of white paper between each color patch to separate them. This technique will allow you to handle

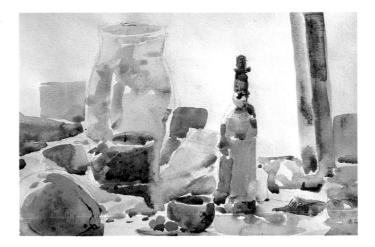

several mixtures of wet color at a time without their blending. Because of these white spaces, you should be able to complete this very fresh watercolor in half an hour if you're advanced, three-quarters of an hour if you're an intermediate, and one hour if you're a novice.

Note: All colors-values, hues, and chromas are "keyed" to the chocolate candle and earthenware teacup. The reddest of the three cherry tomatoes is the exact complement of the bright green bottle.

Direct the Eye with Negative Spaces

These white lines are the white of the sketchbook paper showing between each patch of color. Leaving white spaces permits you to work quickly, to change from one color wash to another without their running into each other, as they would if their wet edges touched. But these white lines are more than an expedient painting device. They also have the power to guide the viewer's eye throughout your composition. And they also provide the chance to simplify your composition—here, a bustling seascape—into several broad, diversified shapes.

The background sky is a broad band of lavender ochres. The buildings, middle distant and distant, are variegated strips of rich, muted blues. You have now created a deep-toned backdrop for the trawlers, against which their light yellows, greens, and oranges appear all the more brilliant.

Most brilliant of all are your exotic little lines of white. The five vertical masts seem to be a stabilizing factor for the swooping lines of the rigging, the diagonals of the rooftop on the left, and the carefully designed pilings, forecastles, and transoms of motley shapes. The white foreground water further enhances the brilliance of your color sketch because it connects visually with all the other whites. Don't overdo the water reflections or you'll lose the shimmer. Think where you want the color statement.

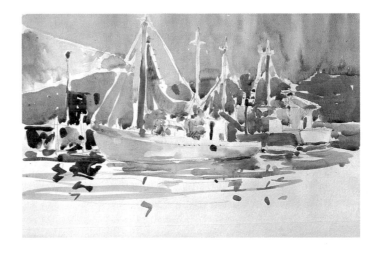

Then mix it . . . put it in, daringly . . . *once!* If you miss it, don't try to "correct" it! Just do another painting!

Assignment: Do another painting anyway, exactly as you did the first, except this time fill in the white water with a blue wash . . . and draw in the rigging instead of leaving it as white lines. See how quickly, and with so little effort, you can get back to a very ordinary watercolor? See how you have lost the brilliance?

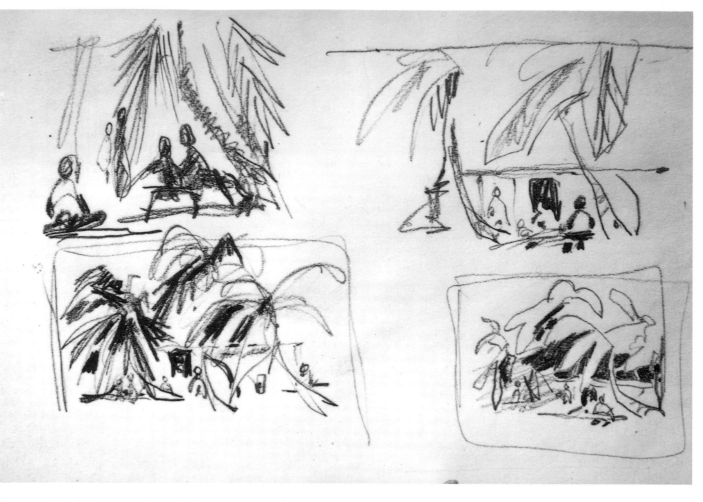

How to Find Patterns for a Painting

Find yourself a shady spot on the beach . . . near the action . . . not too conspicuous. Get on the sun oil . . . you're in the tropics! You're also in the shade to accustom your eyes to the true values of color before you. *You don't want to paint in the sun . . . Nevaah!* Painting in the sun is only for Eskimos. (They have no shade.) To put people at ease, you can paint a "dummy" watercolor first. Spend an hour with a scene looking down the beach. Just do the water and palm trees . . . and maybe a little figure or two way down the sandy shore. No one pays any attention to you after a while. Also you don't get into a conversation with *anyone*. So *now* you start your sketches for real.

Plan to place four sketches on the page. This takes the pressure off your first sketch. You like the contrast of flat beach and the flat beach chair against the upward arc of the palm tree and the delicate tracery of the fronds. Two figures are sitting back in the shade and another is sitting, lotus fashion, in the sun. Two little figures are rather obscured in the distance. That's sketch no. 1.

Second Sketch (top right): You "try" these three figures again in changed positions, but you are still entranced with the contrast of the beach chair. One palm worked so well, you try it again with two palms, one on each side, framing the actors on your stage. There's a white beach shack off to the right. You *"bring it over with your eye"* and position the white patch behind the figures. "Fake" a doorway of dark so there's a figure silhouetted in front of it. Then add the nifty flat line of the roof.

Move right along with these sketches . . . maybe ten min-

utes each, maybe less. Be excited. Don't go into detail now. There's time enough for that in the painting.

Third Sketch (lower left): Your next try takes in all the tops of the palms. Figures under the palms . . . no beach chair emphasized . . . leave the white shack over to the right where it really stands . . . The palms are fighting each other for the spotlight. Too scattered. Next. . . !

Fourth Sketch (lower right): There's something about the dark negative spots under the fronds of the right-hand palm . . . You try that thought again. This time you go back to the figures on the beach chair and locate the dark door so as to "pop" the figure out in front of it.. That's good. Now you put in dark negatives using the triangular shape of the tin roof to accent under the fronds. . . . Good action against the flat accent of the beach chair. Repeat it in the flat gutter line below the roof . . . good.

Study your sketches. Which do you like better? Should you do a composite, taking the best from each sketch? Yes, that's the thing to do. Take the juice from each except that third sketch . . . too nervous. Too twitchy.

Look at the patterns: You like the business of one figure dark against the white. You like the light figure against the dark doorway, which didn't really exist. You like the flat of the beach chair. And the flat of the gutter line. And the dark negatives of the tin roof underneath and behind the fronds of the palm.

These are patterns . . . pieces . . . studies from various angles of the same subject looking for different aspects . . . hidden messages . . . probings of how to say something in paint that will excite your viewer.

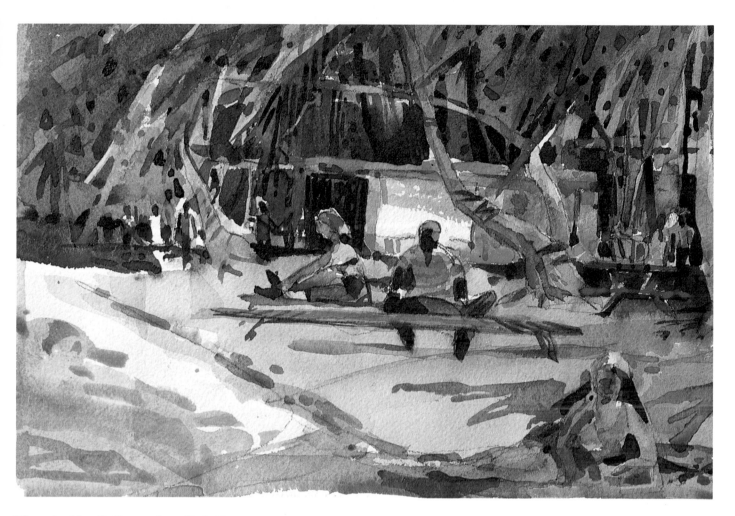

How to Use Patterns in a Painting

Turn over a fresh sheet . . . No reference material in front of you to slow you down. Quickly sketch in a full page in your sketchbook just as you quickly made your carbon sketches . . . a fast twenty-minute rough. Watch the figures moving around. A bather sees you sketching and takes a "pose" in front of you . . . that's great! This thing is growing. Now the figures "line up" at an angle. There are tiny people way back that also "line up" . . . one in stark white, the others in shadow. This thing is getting rich . . . better than any of the sketches you just made. Pull the waterline of the beach back and repeat the angle of the figures. . . . Good!

Something is happening: This composition is getting richer, more important. You feel like Gauguin. Gauguin used loads of color . . . tons of it. Let go . . . be free! Green and then turquoise on the shack beside the brightness of the white. Yes, just one piece of white. . . . Maybe the one little guy in the white toga . . . way back. That exotic S-curve of the center palm . . . hot pink. That's got the blood pumping! Hey, Gauguin . . . move over, pal.

Quickly lay in light washes of pale, but daring, colors in soft pastel pinks . . . lavenders . . . blues, many blues . . . earths and mauves. All of these are a foundation, a footing to take later washes, so these first touches go in wet-in-wet. Let them run and mingle a bit. Then let everything rest and dry.

Now, squint your eyes and start the second batch of deeper color tones. Keep these colors clear and broad in handling.

Just slightly closer to reality than the first broad washes. . . . But don't get picky. The beach wash has other colors coming into it wet-in-wet from the first wash, but this second wash has definite sharp edges: shadows of the palm on the sand . . . shadows on the foreground figure and on the figures on the beach chair . . . wave marks in the water, but not along the white froth. Let these new color patches of deeper tone run over your first light washes. They may be of the same color or they may be of contrasting color. It depends on how you "feel" . . . how you "read it."

Before you start your third washes, take a look at the illustration and study how the first washes went into place . . . then the second . . . and now the third. Not until this third wash do you start to cut in behind the bottles and objects on the magenta table . . . or those tiny figures way down the beach . . . or the long streaks of palm fronds. Now get fussy . . . get into the details more carefully by beginning to define the costume colors . . . and cut deeper color *around* the shack and tree trunks.

As you apply the last touches of definition, *you are creating a mosaic quality of color* . . . dark spots for heads, feet, pants, arms, hair, legs . . . the final dark stripes in the shadow of the shack door . . . the final and darkest palm trunks above the shack roof. You are shaping many of your brushstrokes as you would cut mosaic chips. You can lead the eye according to where and how you might align your dark spots. But don't put in too many dark touches or they'll just make for confusion.

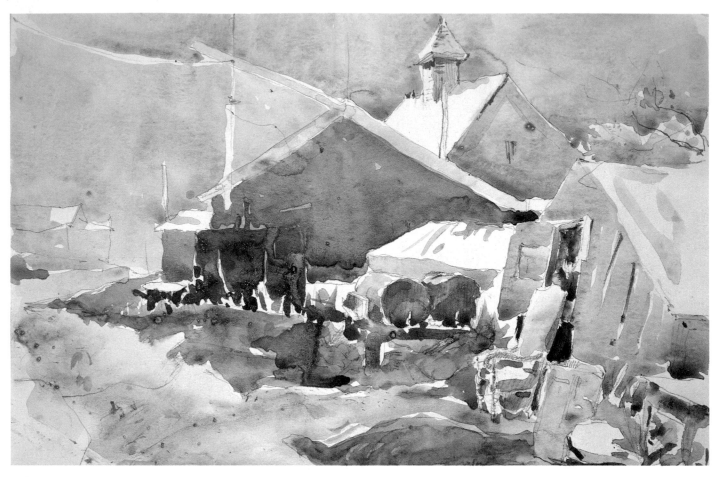

Direct the Eye with White Edges

By leaving white spaces around patches, you are actually leading the viewer into your painting with a series of white panels that work like visual stepping stones. These patches vary in shape from flat parallelograms and triangular forms to slim rectangles that tip and tilt to coax and tempt the eye. The directions keep shifting in a perpendicular manner, one from the other . . . like, left foot, right foot . . . left foot, right foot. Notice how the lines keep shifting in a rising, zigzag fashion, taking you back and up into the painting.

Use subdued color patches to accent these white lines . . . and in turn, realize that these patterns of white are actually shaping the patches of color. Notice the variations in the white spaces . . . wide pieces of white define the green house . . . fine tiny white lines are around the drums . . . there is a change of pace in the whites delineating the square tanks . . . and in the delicate white tracery along the top of the apple blossoms in the center at right. Cover the lower left white corner with your fingertip and see *how quickly you slip into a realistic painting!*

Keep the sky very cool—a mixture of cerulean blue and light red—to suggest the 40°F (4°C) temperature that existed that day. Also cover parts of the barn with it. Then add a little permanent rose used in the apple blossoms to the end of the barn previously covered with the sky wash to relate it to the blossoms and the pink chair.

The greens are olive and sap with some raw umber to tone them down. The front of the building in the right corner is Davy's gray. The oil drums and tank are a combination of mauve and burnt umber. Add a bit of ultramarine blue under the drums.

And Have You Considered . . .

1. The chair by the house on the right was a brown vinyl. Would you have painted it pink?
2. The apple tree was not yet in bloom. Would you have painted the green buds or would you have "invented" the pink blossoms?
3. The chair was located to the left of the drums. Would you have moved it to the right in order to slant your eye back to the pink blossoms?
4. The house on the right was brown shingle. Would you have made the change to light gray slanted boards?
5. The large green shed in the center was actually dark brown. Would you have made it green in order to repeat the color of the grass?

Always be thinking about what will make a better painting . . . a more unusual composition. In your excitement, don't just sit down and paint what's before your eyes. This is an example of why you should take the time to *figure out a better way to do it!*

BEGIN WITH AN ORANGE OUTLINE

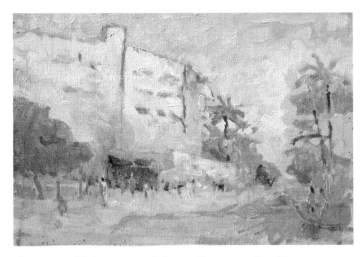

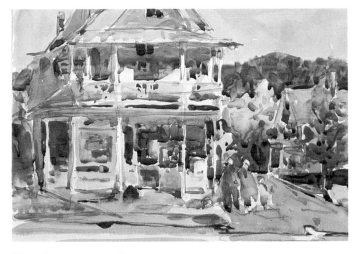

Create a Shimmer with an Orange Outline

How do you express, in color, the brilliant light of the French Riviera? There is a "strange" quality to this light, a shimmer . . . a vibration . . . like reflecting heat waves quivering. This painting looks like Debussy sounds . . . lyrical and poetic. It is hard to define, but Matisse, Renoir, Cezanne, van Gogh, Bonnard, Signac, and a host of others found its secret and expressed it in their color.

Achieving this brilliant effect has to do with the manner in which you juxtapose certain colors in combination.

Let's try it. You are in Cannes. Your subject is a corridor of white apartments facing the sun reflecting off the Mediterranean just across the street. Start your drawing in orange watercolor on your white sketchbook paper. This begins a mild vibration between the orange and the white. Notice that you never see this "color jump" when you draw with *dark* colors—earths, deep blues, deep greens, or violets.

Now, add yellow to your orange, wet-in-wet, in the reflections under the balconies and particularly on the top of the tree at the right. You are modeling the tree by using a lighter value on top but, more important, you are causing another color vibration to occur when you place yellow next to orange on a white background. Deepen your orange for darks by adding burnt sienna . . . for example, under the palm fronds and on the tree trunks. Add a bit of cadmium red to this burnt sienna where you want the deepest accents . . . such as on some heads and feet.

Substitute lavender for the usual green leaves and midtone dark streets and building shadows. Mild vibrations are occurring wherever the lavender abuts the orange. Now substitute turquoise for the green lawns and add a spot of it to the center trees. Yet another vibration is created when you bring in cobalt blue to enrich the storefront and the curb at the lower right. Close one eye and hold out your finger, blocking out these two spots of cobalt blue. Can you see how the shimmer diminishes?

Use Orange to Cheer Up a Gray Picture

Your subject is a country store in northern Vermont . . . you're cold . . . it is 40 degrees Fahrenheit . . . and you are outside! There are dull days like this when you have to "manufacture" your own direction of sunlight. Let's see what you can do with this old gray building. It has the makings of a good painting. . . . Let's dig it out!

Why did you choose orange to outline the building? Fate can play a hand if you let it. There is a "Maple Sugar for Sale" sign in the window . . . it is a deep, tawny orange. Two signs in other windows and a tin one tacked outside on the porch . . . are also orange-colored. There are a host of trees in orange foliage nearby and the building is gray and the touches of orange look so great with the gray . . . and it is a wicked day to paint.

Just try drawing this subject in orange and see how it lifts your spirits! Crop the roof to bring more power to your composition. Take your time . . . draw with the brush— carefully . . . get the structure right. It's really a neat piece of architecture. . . . It sure looks like Vermont! And the store downstairs is chock full of nifty shapes, bits and pieces of good design . . . just waiting to be captured.

As for getting great contrast, you couldn't have invented a better second-floor balcony or triangular third floor. This is getting good. Make up a lot of different gray colors . . . warm and cool . . . some rich and some pale. Gray house . . . gray sky . . . gray street and sidewalk. See how many grays you can concoct.

Use the complementary color blue in the mountains and the woman's dress. Bring in a green tree that hasn't reached its "peak" yet and put a splash of this cool green on a spot of lawn. Give the tree orange foliage . . . and put some pinks on the little girl and on the house back to the right.

Now, see how your orange sings. All because of the red-gray, violet-gray, and blue-gray contrasts. . . . Whistler would have loved it!

PAINT THE SAME PICTURE WITH DIFFERENT COLORS

Use the Primaries

Let's explore the effects of color and how it can affect mood. We will begin by making two careful drawings of the same street scene. Color your first study with the primary triad: yellow ochre . . . ultramarine blue . . . Venetian red. Mix them as illustrated . . . with a lot of very subtle color nuances . . . very quiet color combinations. Make your depth of color quite rich in the foreground . . . and quite pale as you recede visually down the street and into the mountains. The deep-toned roof and dormer help the illusion of the mountain being distant . . . because of the intense contrast of dark to pale.

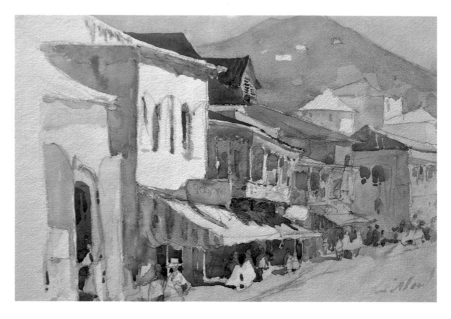

This painting differs from the previous one, the country store in Vermont, in several ways. This scene is of a tropical climate . . . St. Thomas, in fact, and you can *feel* the temperature difference. Vermont is cold and crisp . . . while St. Thomas is sultry and humid. Look closely. How have these temperatures been expressed . . . in the colors? . . . in the brushwork? . . . in the edges?

The painting of the Vermont store contains a concentrated range of deep, rich colors, while the color nuances here range from deep tones in the foreground to very pale ones in the heavy humidity in the distance. The mood of this painting is also different. It is much more subdued. The street is much quieter. There are no vibrant oranges to contrast against complementary blues and deep grays. Everything has changed.

Add Another Color

By adding just one more color to your triad, a green, and lessening the quantity of blue in this second example, you can get quite a different effect from the same subject. You are now working with a quartet of colors: yellow ochre . . . ultramarine blue . . . Venetian red . . . sap green. I chose sap green because it has a clear, luminous, bright quality, though any green could have been selected.

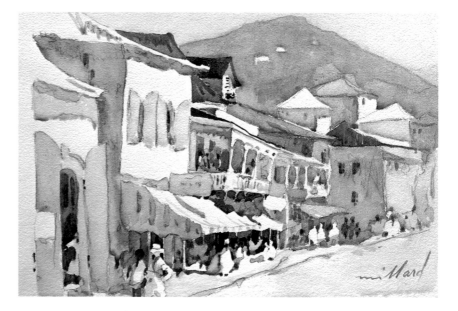

Look at the difference a change of color makes. Notice the greater luminosity that the sap green has introduced. Keeping your washes lighter and a little less intense has also increased the feeling of luminosity. It has also made the painting seem sunnier and has altered the mood. The blue tones seemed to dominate the first painting, now there are brighter green tones, and a more transparent feeling. Would you guess that just a change in the color of an awning and a balcony might result in such a marked change in the quality of the sunlight and in the mood?

Each painting is a valid statement, and you, the artist, have the final say. Don't be afraid to "work in depth" and make more than one interpretation of a single scene. Take your lead from Monet and his marvelous series of paintings . . . his cathedrals . . . his waterlilies . . . his haystacks. What an inspiring colorist to follow! Make your exploration of color a lifelong pursuit.

USE A (SEEMINGLY) LIMITED PALETTE

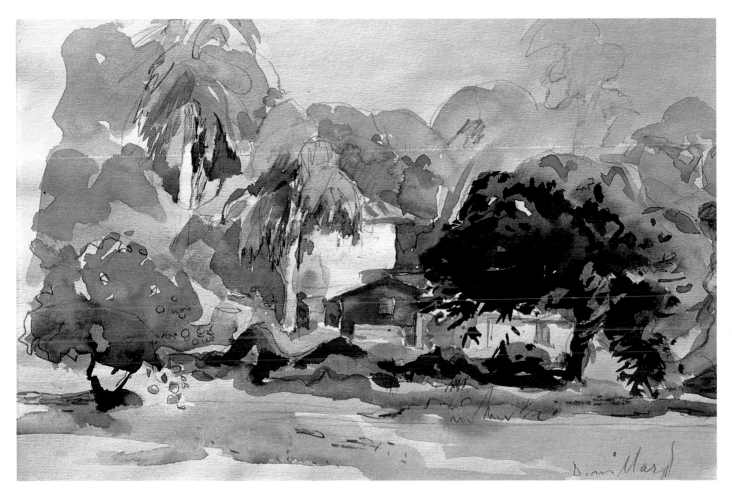

Mix as Many Different Greens as You Can

You've had a taste of green in the preceding study. We talked then about exploring. . . . Keep your explorer's hat on! Let's see what you can do now by probing into several greens . . . many, many greens! The only prerequisite is that *all the greens* must be comfortable together. You have to have a good feeling—"good vibes"—about how one green goes with the next.

You've had a taste of how colors react with each other and vibrate in the first painting in this chapter. But that was the Riviera. This time we're in Florida, under a winter sun. There are orange trees . . . palm trees . . . hedges . . . bushes . . . grasses . . . close-up greens . . . distant greens . . . yellow-greens . . . blue-greens . . . greens that are almost white . . . greens that are almost black.

See how many greens you can mix from yellows and blues, one yellow at a time mixed with all the other blues, and see if you can make them all work together. Some of your greens can come from the tube or pan. though most should be mixed—especially raw or harsh colors, like Winsor or phthalo green. And you can take a few liberties and mix some colors you *don't* see in the landscape.

Note the small tangelo tree at the bottom left, with a few fruits on the ground. Then turn the painting upside down and observe how many warm yellow-greens are on this side of the painting . . . and how many cool greens are on the opposite side. Then look again. Do you see how there is an X shape running throughout the composition that tends to organize these many varieties of green? Without it, there would be confusion.

Save the spot of red (the complement of all these greens) for the very end. It can be distracting if it's inserted too early, and you can tune in on the painting better without the vibration the red will make.

There are several other touches of pure color here, too. The top of the tangelo tree is just Indian yellow with the barest amount of green added. This pure spot of color is balanced by a touch of pure orange in the palm tree. And these warm color spots let you balance them with the lavender shape of a bush . . . which in turn allows you to use a lavender sky. Use the same hues for the blue roof, which opens the door for other touches of blue. But use restraint. Keep your touches of yellow, orange, and blue very understated. Use only the barest amount. Notice that there is only one touch of red here . . . not six!

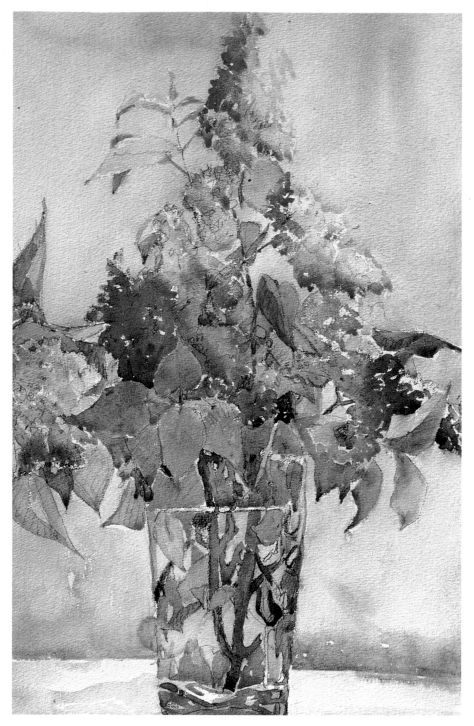

Make a Good Painting with Only Two Colors

One way to learn about what your colors can do is to work with a limited palette. Challenge yourself. Pick one or two colors at random and see what you can do with them. Here is a two-color floral . . . some spring lilacs, just begging to be painted . . . and just a bit of mauve and green to paint them with. How can you do it?

Tone the paper with a big, soupy wash of mauve . . . except where you want little white touches and the white paper to separate your wet colors and prevent them from running into each other. This wash diminishes the quality of light so you now have a soft, foggy morning effect. The bits of white paper tend to sparkle in the fog and give the feeling of a third color, white . . . as though you were actually using a tube of white paint.

After the first wash is dry, begin to design and color your way down through the bouquet of lilacs and leaves, working down from the top. Get the most out of your green: heavily pigmented leaves, tinted-water leaves, or green and mauve mixed for stems and a few dark accents. Then design the stems with great affection. Good stems can make a floral!

Turn the painting upside down and study the negative shapes around the outside of the bouquet. Note the near-parallel horizontals of the water level in the vase compared to the table top . . . and the vitreous quality of the shape of the light reflection at the base of the glass. Even on a two-color, "make-do" watercolor, good design is always important.

Make Three Colors Look Like Four

You are expanding very little when you take your previous two colors, mauve and green, and add raw umber. You have ferreted out another set of lilacs . . . this one by the sea. You also have as a subject an excellent house with well-related shapes and pieces. Look at the three sections of roof. Look at the bonanza you have discovered in these white shapes. *Study the various pieces* of white, your "fourth color," in the house: the figure stepping off of the porch . . . the white sea wall . . . ramp railings . . . the white spots in the towers of the distant town hall. How could you design it better? You likely could not, but there are always ways to enhance what you have discovered.

The gray roof is made to order from a mixture of lavender and green . . . for the most compatible, most harmonious gray you could mix for this painting! Paint the roof first . . . then the shadows . . . then the darks. Next: put in the green trees around the house and add raw umber and a touch of mauve to the green to deepen it so it is almost "spotlighting" the house. Chiaroscuro at work! Step from the darkest trees to the deep-toned hills, then to the sky. Look at the painting as a whole, feeling what the value or tone of this sky should be. Be sure to leave white spots on these towers.

Notice how carefully you are building the "tone" of the

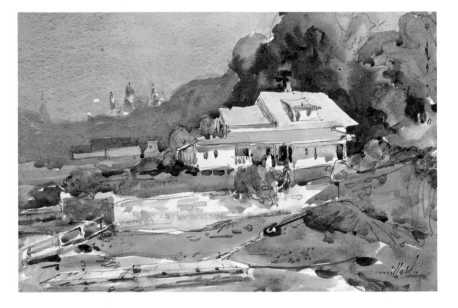

painting. I don't think you would have been able to control this tone had you started with the tidal flat and worked up. But the contrast between the light house and dark trees has set a daring pace for this watercolor.

Spring has not reached the somber grasses as yet, so your wash for the lawn is *almost* a raw umber . . . almost, but with just a breath of green in it. Then *finish* the tidal flat with your raw umber wash. Now, last, the clusters of lilacs that first attracted you to this scene. Be careful not to overwork them.

Put Color in Reflected Light

You can obtain the effect of brilliant sunshine if you keep your shadow values high in key. There is so much light reflected *from the earth up into the shadows* of the buildings and then *bouncing back down* into the street shadows that the glare almost makes you squint. To see how much brightness there is in the shadow of the nearest building, cut a hole in a square of white paper to isolate this color. See how bright it is? Yet the first building is much darker than the center building.

Be mindful of this change as you lay in your shadow wash from one house to another . . . as you proceed down the street. You might want to paint the windows first to establish the difference in values . . . dark in the foreground . . . lighter at middle distance . . . lightest far away.

Break the rules when you paint the three roofs. Paint the first and last housetops dark to light, as you did your shadows. But the middle roof is where you hang out your sign, "artistic license." This extreme dark establishes the contrast in values that makes your street scene seem so brilliant. However, you are not following the customary rule: that colors get more pale as they recede.

Your colors here are ultramarine blue, Venetian red, and raw sienna . . . the raw sienna being a warmer and sunnier color than raw umber . . . plus the white paper.

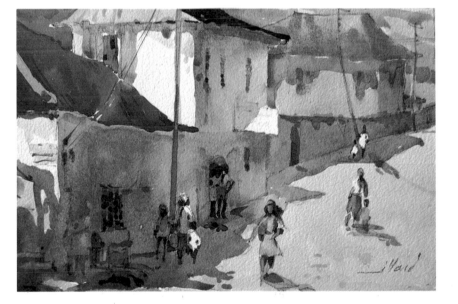

You can feel the difference between the sun in this painting and the sun in the previous one. The scene is actually 20 degrees in latitude further south.

Again, three colors looks like four in this painting, as in the last one. The white of your sketchbook paper is used here much as an oil painter would use white on the palette. Get used to planning your whites. I happen to be a "purist" in the sense that I do not use white paint in watercolor. But this is a personal decision. Try gouache or opaque white before you make up your own mind.

SKETCH FROM MEMORY

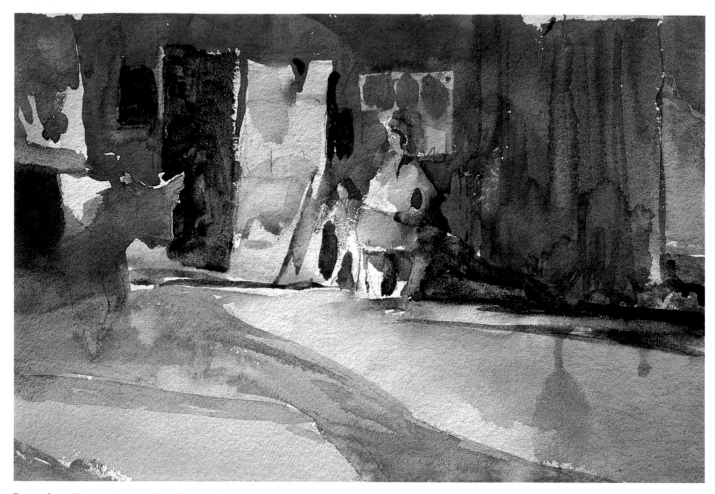

Imagine Deep-Toned Reflected Light

You are in Vermont, late afternoon . . . the cows are coming in for milking. Hence the title *First One In*. The sun is low in the sky, sending a warm raking light across the barnyard. The warm earth, in turn, is reflecting deep tones upward onto the figures of the farmer's wife and daughter. The low light is catching their legs and the barn door, rimming the cow, and skimming her white shoulder patch.

Design the shapes, the way the light falls on the earth in the foreground and tones it. These earth shapes are colorful and pleasant . . . leading the viewer's eye toward the figures and the cow. The legs of the cow blend into the earth colors in a wet-in-wet wash. The upper sections of the figures are nearly lost in the shadows except for the deep reflected light that barely defines them . . . the little girl, almost completely lost in the rich light.

Design the shapes of the architectural features of the barn too. The barn door was closed . . . open it! The windows were both the same size . . . too static . . . make the one on the left small and almost black. Likewise the upper part of the door opening . . . so it seems you are really looking through into the openings.

The intense, dark color of the reflected light makes your viewers believe they are in the barnyard actually seeing this intimate, natural scene. Your washes of deep tones must carry a load of pigment in the first application. Don't try to capture this drama with weak tinted washes. Hit the color right the first time. Keep your paper slanted all the time you're working. Make your darks deep and clear, for it is this very deep color inside the barn and around the legs of the figures that gives the impression that your shadows are filled with light . . . low in key though it is.

Turn this painting upside down to better study the abstract designs of all the bits and pieces. See how the shape of light racing across the yard and exactly up into the door is obvious. And notice that the horizontal white across the doorsill takes you right to the interesting light shapes on the legs.

Don't expect to stumble across these intimate scenes . . . with camera poised . . . models posed just so . . . including the cow . . . just the right light . . . just the right film exposure . . . the sun patiently waiting for you to get comfortable with your paintbox. No way!

Travel with your sketchbook on the ready. This one happened while I was fishing for trout in the Battenkill. I pulled the sketchbook out of my gamepocket and *reconstructed from memory* what I had seen a moment before. You can do this too. Learn to sketch from memory. It's easy . . . really easy. The painting was done the next day, a mile away . . . also from memory.

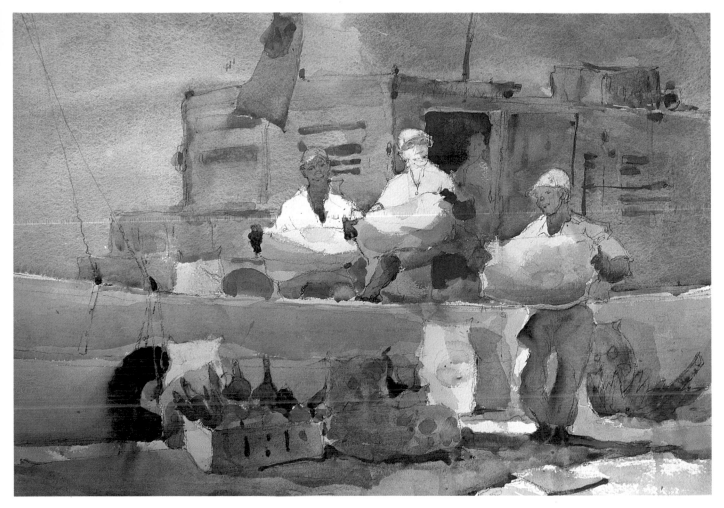

Design and Color a Moving Subject

You are watching a Down Island freighter being unloaded. There is only one stevedore unloading the vessel. There is a grace in his movement. There is a pattern shaping up here . . . something is happening. You keep watching this industrious character . . . back and forth . . . in, empty . . . out, with a piece of cargo. *The ship is the "stage setting."* Our hero comes out of the shadow into the light. It is exciting to watch.

It is like watching a breaking wave. There is a repetition in the patterns. The *Rosario Stevedore* (title) is the actor moving across the stage. It's like an opera. There is a classical quality in this composition. How do you capture it?

Sketch in the ship first for your background. That's stationary.

Next, you have decided that the most important position in this "painting" is when Jose comes out of the doorway and into the sun. You have him in the most dramatic location . . . with the dark square door opening silhouetting his white shoulders. Leave room for the cook to peer over Jose's shoulder from the shade.

Position #2: Jose is just onto the dock . . . in the sun . . . framed by the open door. His ankles and shoes create a firm, black pattern as he steps onto the canvas where he is piling the cargo.

Position #3: Jose is carrying a sugar sack from across the deck and as he moves into position where he touches the first figure. Zap . . . in he goes!

Light your "stage setting" with an overall blue wash. Change Jose out of his red and black checkered shirt and put him in a classical white shirt. Light him in his three positions with white spots. Fill in your shadows on the ship, on the cargo, and on the clothing.

Next: Your colors are umber, orange, and green for the produce . . . muted red for the British flag. A deeper tone of blue for the shadow side of the freighter.

Finally add your darks with special attention to shapes and locations. Turn this sketch upside down and study the patterns of the white. Now take a careful look at the blacks. Cover the truck tire with your finger . . . and you lose the triangular pattern of tire, ankles, and doorway.

Invent Unusual and Unexpected Color Combinations

The fisherman ties his sloop to the dock . . . tosses a bevy of beautiful tropical fish and calls, *"fish!"* From nowhere, people come scurrying to buy the daily catch.

You are making fast contour drawings of these marvelous native folk in constantly changing compositions of moving figures . . . four small sketches to the page.

This is Jose again . . . only this time it is for real. No classical composition . . . you are at your wit's end to capture as many group sketches as you can manage before all the fish are bought and your subjects have vanished. You are lucky to have come up with six sketches. Now you know why you have practiced your two-minute and five-minute figure sketches. You needed speed to catch the action today.

Now comes the fun. Your memory takes over. You had a good look at these costumes while you were capturing the gestures of the local women bending and stooping to inspect dinner. Here is where you retire to a quiet shady spot and *put on your thinking cap!*

Now you are going to invent your own color, four different color interpretations of similar subjects. Don't be afraid of color. Do a lot of experimenting in the beginning and as you go along and increase the volume, you can only get better.

Take a cue from your local color for starters: For instance, if the boat is blue, what was one of the women wearing? A pink and white striped shirt. Pink . . . white . . . blue . . . that's OK . . . how about green with that . . . seems OK . . . so there is one combination. Try a blue sky with that one.

Next try orange, yellow, yellow ochre, pink, mauve, white, and vermillion. Use an ochre sky with a little bit of mauve on it. Some ultramarine blue will bring the mauve down almost to black for richness.

Finally try a pale hot sky . . . or try a midnight scene with a bright moon. Just use your imagination and conjure up color combinations that *you like!* They'll work all right. Be clever . . . be daring . . . be classical . . . be contemporary . . . be *you!*

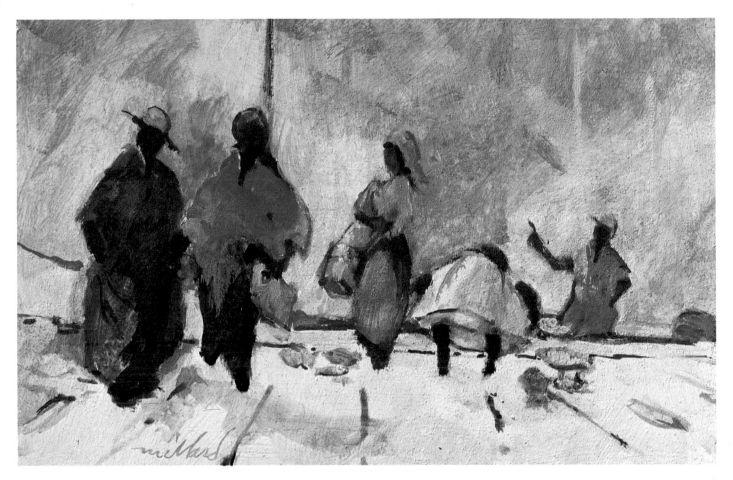

Fisherman in Orange and Pink

This is a detail of one of the preceding color experiments. I call it *A Stray Fisherman Soon Attracts His Customers at the Waterfront*. Try giving all of your sketches titles from here on. It's easy to program this into your thinking as you plan a painting . . . *before you start it*. It will help you to paint it. It will also give you a feeling of caring about your subject in a way that is different from just sitting down to whack out another landscape.

The white boat with the vermillion gunwhale is what has prompted you to put together this particular combination of colors. Oranges with pinks . . . oranges with mauves . . . neutral warm sky of ochres and palest mauve. In the sky, you see faint sails in the mist . . . subtle verticals of masts . . . some with white accents and some with dark. A yellow rigging streak for the forestay.

The fisherman is in orange and pink. This is a painting that shows the warmth of the tropics. You should feel free to use any colors you wish . . . you are the artist! You first want a painting that pleases you. . . . When you pick the right combinations of colors you'll know it . . . you'll sense it. These colors are quite contemporary . . . have a modern quality. And they feel right!

Divide your "stage" into two parts. The foreground dock is spotlighted . . . the backdrop or sky is a tone or two deeper in value and makes a quiet or intentionally dull backdrop for the figures. Imagine a few sails and masts in the mist. Can you see them?

Plan your figures like a classical composition . . . with a triangle or wedge running from the largest figure on the left to the apex or point at the hero . . . the fisherman. He in turn responds with a magnificent little gesture . . . a finger lifted in "hello" . . . that stops the action from sliding out the right side of the composition. Classic?

Your choice of large interestingly shaped darks—ultramarine blue and mauve—lend a sense of importance to the two largest figures. That's a deep color mixture and it will stay clean if you *put it on quickly* and *paint at an angle*. Mauve and cobalt violet for the first figure and on the next figure, a flattering orange-yellow-raw sienna mix in the flamboyant gesture of the jacket. The central figure is quiet . . . in gentle colors.

The lady in white has upstaged the whole show with her "mooning" gesture, but the fisherman wins Best Supporting Role. What a pose! What color! Note the motor is in the same color. The scarlet gunwhale on the white sloop is swooping your eager eye to the fish and the two figures on the right. The planks that make up the dock's surface are in a rather staged perspective . . . but it works.

Assignment: This is in warm tones. Try the next with hot colors on a neutral ground . . . and for the following one, choose colors just because you like them. Just don't fall into the easy trap of copying something that has been successful . . . again and again.

Memory Pencil Study of the Market

Your mind is like a muscle . . . the more you use it the better it responds. The more you demand of your memory . . . the more your own computer will program and store your artistic ingredients. Push it harder!

At times you'll see the "makings" of a great painting . . . but your "subjects" may not be receptive to sitting for you. As a matter of fact, when you are traveling in strange places, you will be well advised to think twice before you haul out your pad and pencil to start a sketch. You might wind up in the soup kettle! Savvy?

This is a case in point. You would have to make many a trip to the well to fill the bucket for this painting. No sketching here . . . you don't dare! First you just "float around" the market . . . looking . . . thinking . . . seeing. Then you come back for a second look and buy a banana . . . and

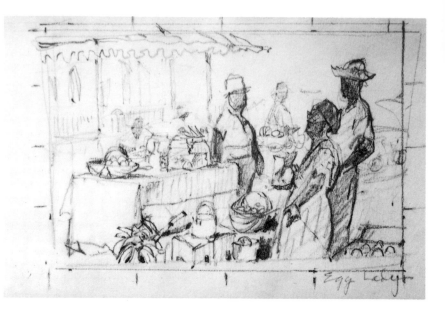

munch on it while you're "floating" again. You think you spot *"it."* From a distance you can sketch the old slave market and the church beyond. From around the corner you can sketch on your pad and *rough in your figures from memory*. You'd be surprised how inventive your mind will become.

You have a pretty good idea of the composition, and you try out a few ideas. Remember the two egg baskets? Two different shapes . . . unusual shapes. Remember the big bottles of preserved mangoes, guavas, and the dark guava berries? Remember the white tablecloth and how it hung down . . . making a perfect visual "entry" into the painting? Remember the three major figures. *The Egg Lady* (title) . . . with her little white paper bag to put the eggs in? The skivvy shirt and neat hat on the portly man? The gesture and hat on the Frenchman? Remember the two guys sitting on the counter tops . . . one in a classical pose . . . the other one watching you?

Painting from the Memory Sketch

You have a commission to do a full sheet, 22″ × 30″ (56 × 76cm) watercolor in full color at a good price. You have your sketchbook memory pencil sketch in front of you . . . and you select a good quality white sheet of 300-lb paper to work on . . . good and heavy. You may have to give this one a "beating" before you're done.

First, sketch in your subject lightly to scale. Be accurate—excited, but accurate.

Next, *wash in the background wet-in-wet.* Use distilled water . . . you never know how much chlorine is in the water. Chlorine is a *bleach*, the enemy of watercolorists! Lay in the warm-colored church . . . right across the background and over the two major figures, right onto the lower table. Paint around the two guys who are sitting in the back in the cool shade . . . no warm tones wanted here . . . no warm color on the fence.

That wash has to go on quickly, and while it's still wet . . . paint the church windows and that slanted roof. Then dilute the mixture and stroke in the windows of the distant building after your first warm wash is dry.

Your next wash is blues and lavenders . . . painted right over the Big Three! It includes the shadow side of the top table, the eggs, the box the eggs are resting in, a piece of the chair, and the frying pan. Let it dry. Then touch in the three different flesh colors . . . quickly. If you fuss too much in laying a wash over a prior dry one, you can lift

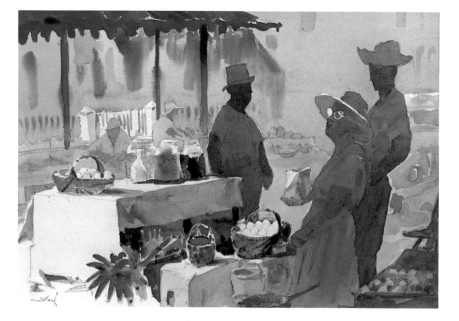

the first color and ruin the painting. So don't hesitate—do it!

Paint the stalk of bananas in sap green with a touch of burnt sienna. . . . Touch the egg basket with same green plus viridian in the deep shadow. Then let it dry.

Paint around the bottles under the table . . . note they already have their first tone of blue from your first blue wash. Did you leave the white reflection on the Egg Lady's glasses? Nice going.

LET MUSIC AND POETRY INSPIRE YOUR COLOR

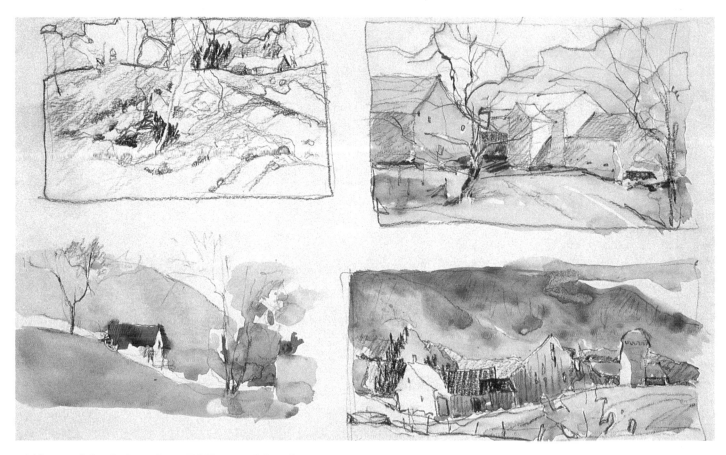

Different Music Inspires Different Moods

Sketch as you would compose music. Draw as you would write poetry. Lift yourself out of the mundane world and strive for the uncommon way of seeing things. You can learn how to "look" with the eyes of an artist. Look for the rhythms . . . the motions . . . the patterns that are all about you. This book will try to help you tune into these things.

When you are looking for a subject to paint, you are also "listening" for the tune, the shape of things . . . the color of objects or the color of the day . . . how the light is striking a group of figures . . . the undulations of the earth. All of these things are trying to speak to you . . . to tune you in. "Listen" for them.

There are similarities in a way a subject is composed with the way a composer writes his music . . . or a poet puts the words together. There is much beauty in music . . . there is much power in poetry. And *music and poetry are much like painting.* Seek to connect them, first through your drawing and then your color.

Begin by looking for the rhythms in these four landscape sketches. All four are on one sketchbook page, so you know the artist is out "looking" and "listening" for a subject to speak to the mind's eye . . . searching for fragments with which to start a painting. Let's look at these four sketches and see what was attractive about each composition.

First Sketch (top left): Look at the rolling lines of the earth, the small house tucked into the undulating crest of

a hill, set low and surrounded by interesting shapes of trees and sky. The many natural linear accents pointing to the house from left and right have definite rhythms, both light and heavy, like those of a symphony. There's poetry in these shapes.

Second Sketch (lower left): This small farmhouse, set against a great mountain, is like a tone poem . . . the small against the mighty. It's early morning. The colors are soft and lyrical, simple and gentle. The trees are also designed to fit the composition harmoniously. There's a crescendo in the strength of that dark roof. The shape of the land repeats the shape of the mountain almost exactly, like a musical repetition.

Third Sketch (top right): There's a harmony in these barns, a rhythm in their size relationship and in the way each building thrusts out from the other. There's also an excitement generated by the various sizes of the white pieces, by the positioning of the darks along the ground line, by the angles of the mountain and roofs . . . all seemingly related like full notes, half notes, and quarter notes in music.

Fourth Sketch (lower right): There's a serious mood here. The winter storm moving into the mountains behind this array of farm buildings is hovering, threatening. This complex setting is rendered in a restrained palette, the color of a Sibelius or Brahms symphony. To capture this awesome quality, you must get out into the elements and paint against the rising wind until the snow starts to hit you . . . not sit comfortably in a heated car.

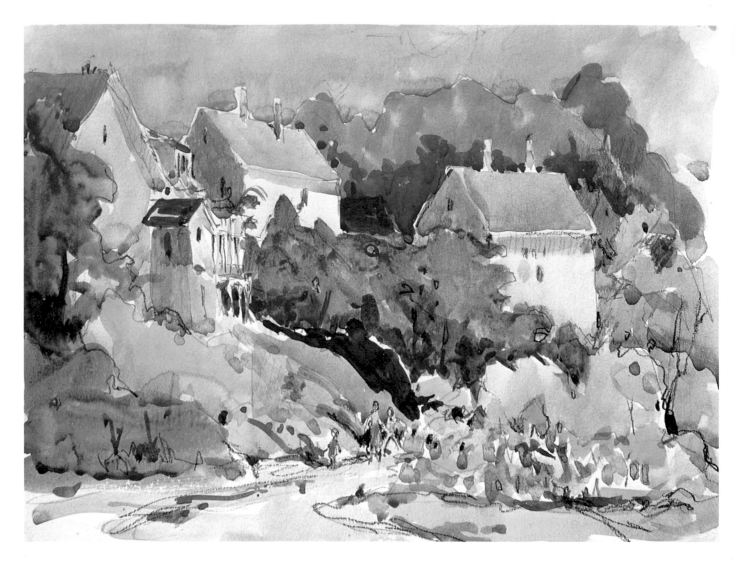

How the Music of Debussy Can Inspire a Painting

Debussy (1862–1918) composed very unusual spirited music in the same sense that Monet put together his colors in a very unusual lyrical palette. They worked and created during the same time frame. Both men were French and working at a time when the French Impressionists were creating paintings bursting with new color . . . color never experienced before. Monet was an impressionist painter and Debussy was an impressionist composer. When you listen to Debussy's "La Mer" or "Afternoon of a Faun," you are "listening" to the color of Monet . . . or Bonnard . . . or Renoir . . . or van Gogh. The color, not the technique. Each of these four painters is vastly different as far as technique is concerned. And you, too, will differ from these artists in the manner in which you "listen" to the colors on your palette. *Tune in your own "music."* But let the "music" influence the colors of your palette.

When I came upon these houses, there was something about the pattern that I liked . . . several buildings grouped together to one side . . . the other house set apart. The early morning summer light was good, the pattern was good, and I could "see" a painting. The purple loose-strife was in blossom and the combination of the reddish lavender and the various greens was an unusual combination. It made me think of some of Monet's waterlilies.

Don't always paint what you see. These houses were tan, gray, and buff . . . not enough contrast with the greens . . . not quite "right" with the pink-lavender. But I was thinking of the lightness, the brilliance, of Debussy's music. What if the houses were given more brilliance . . . and if the trees and grasses were of more unusual, different greens . . . some cool and some warm? There could also be a very deep-toned, negative shape of blue-purple to make the one white house "sing" and separate it from the house on the right, pushing it toward the viewer. And the same dark-toned blue-purple could delineate the sweeping graceful curve of the bank, arching over the little figures, and you could put a piece of this dark on the distant roof. That would give these darks an important role. It would also make the pinks and lavender of the loose strife work better . . . to be more of a surprise when related to all these different greens. Just as Debussy seemed to constantly surprise the listener with unexpected, creative, joyous interludes, we surprise the viewer with these unexpected pinks and lavenders against the cobalt greens. These colors and the unreal blue lavender roofs are really creating a fantasy for the eye, yet the viewer believes these colors because of the realistic cloak of the house and tree shapes.

What Is the Color of Music?

You are not alone when you play classical music to inspire you when you are painting. Beethoven, Brahms, Grieg, Tchaikovsky . . . you name them . . . there is a close relationship between painting and music . . . it has been thus through the ages.

Pythagoras, the 500-BC Greek mathematician and philosopher, *devised measurements of time and space . . . in music and painting . . .* which are recorded on the east frieze of the Parthenon. Piero Della Francesca took measurements of space from Pythagoras and used them to structure rhythms in his paintings . . . Puvis de Chavannes took a page from the book of Francesca . . . Vuillard from Puvis and so on. The point is that musical rhythms and spatial relationships are closely tied. . . . Art and music are married!

With this preface behind you . . . let's take a look at an insignificant pencil sketch of a harbor scene at sunset. You have the ability and the power to take this simple pencil structure or composition and devise your own personal interpretations of what you have "seen" on the right side of the brain . . . your creative side.

Take the time to think . . . to daydream a while . . . to let your thoughts incubate. Run two divergent courses *from the identical pencil sketch* . . . one cool . . . one warm. Sky, ships, and water . . . same subject. Now, *you supply the music* . . . put on the recording or insert the tape. Let your mind think about *poetic color.* . . . To "see" the color of music, make two identical pencil sketches of the harbor.

For the first sketch, put on Chopin or Grieg's "Piano Concerto." There are cool notes coming through your mind . . . grays . . . pinks . . . lavenders . . . mauves . . . some ochre. This is the first painting.

For the second, put on Stravinsky's "Firebird Suite" . . . or Tchaikovsky's "1812 Overture." There are images of hot, fire, fast, noise, bang, rockets, wow! Orange . . . yellow . . . red . . . burgundy . . . burnt sienna . . . mauve . . . purple . . . Prussian blue. This is the second painting. Beethoven's "Pastoral" was for the woman and child at milking time on page 90. Rich music . . . very rich tones. It's simple! Just try it a half dozen times.

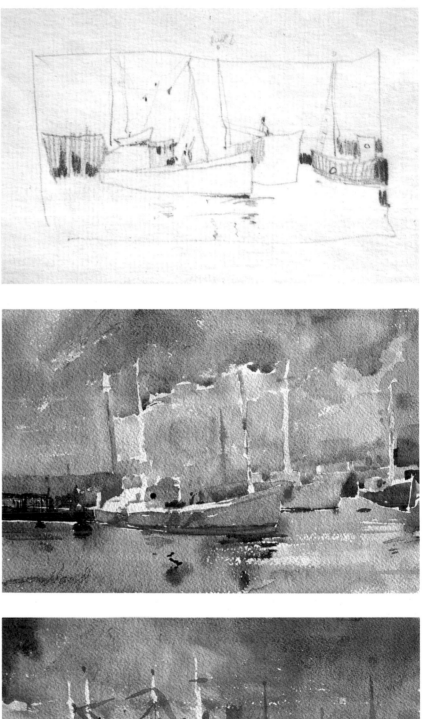

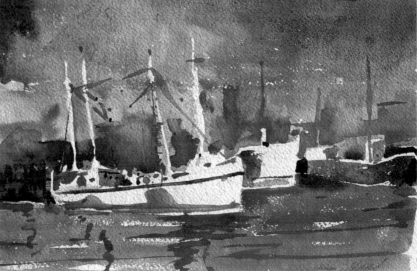

VARY THE SUBJECT

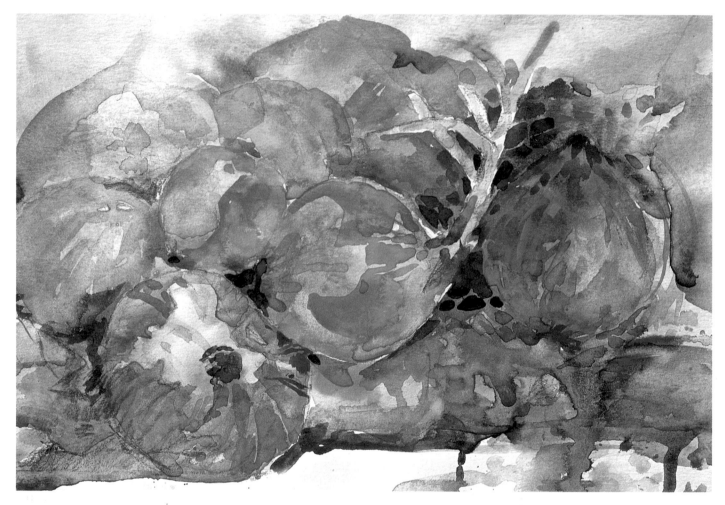

Try Unusual Colors on a Still Life

You are attracted by the orange color and round shapes of a cluster of onions. You decide to paint this subject to see what you can learn . . . by trying different colors.

Stop. . . . Study and *absorb* the visual pattern. Look for a basic abstract design. There is a small major circle, surrounded by an outside ring of onions. You shift the onion with the green sprout . . . from a flat position to an interesting diagonal. The sprout catches your eye and leads you to the small circle of three onions.

Remember to start with your black-and-white sketch . . . plan your composition and design . . . and then think . . . and then plan your color.

You keep turning the onion at the lower left until you find the broken skin . . . likewise the smaller one above it. This is where you decide to *concentrate your center of interest.* To all appearances, all of the onions are of equal value in tone and color.

Forget what you see and apply what you know! Concen-

trate your strongest color on the opaque skins of these three onions, but first lay in your palest washes on the exposed surfaces under the skins . . . pale green, pale orange, and raw umber. Next, put in the stronger colored outer skins. Finish these three onions, including the green sprout.

Next, in palest tones, apply the under-skin colors of the outer ring of onions . . . green, pink, lavender. Let it dry. Then put on slightly stronger tints of pink, lavender, umber, and greens on the outer skins. You knew this would "push back" these perimeter onions because you have already done this in landscape work, with lavender mountains and pale pink or green trees . . . all to take you visually into the background.

You knew this would work . . . all you had to do was try it! Now, place your dark accents around the sprout and put in the shadows. Leave the strip of white table-cloth for contrast with the pale tones.

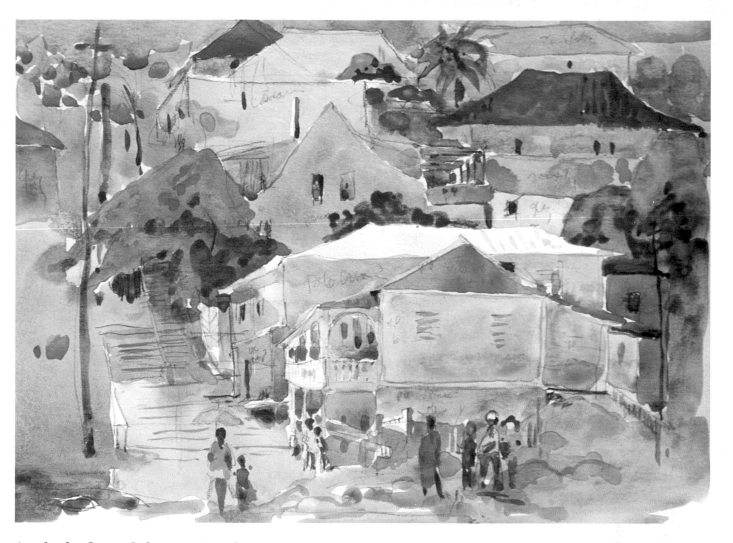

Apply the Same Colors to a Landscape

You worked out a successful color combination on the onions . . . now try the same palette on this tropical street scene. You are looking at a jumble of dull brown houses and roofs, yet the shapes are interesting.

Study the subject first, then make your freehand carbon drawing. There is a mother on the first balcony, talking to little children nearby. This house and the figures will be your *center of interest*. Use the long slim roof as a white accent to "push" the first house toward the viewer and to contrast with the pale tones you will be using.

Begin by putting in the dark green trees behind this white roof. Paint in these houses, figures, and shadows below the trees. Keep these quickly applied washes light and clear. Remember, you are working in brilliant tropical light and it is hot in the sun. Paint with this in mind.

Paint your sky lavender . . . the same color that was on

the right of the onions. Don't be afraid to try unusual colors. After all, you just used this color to make a pale setting behind the onions. Render the rest of these hill houses in the same pale tones as the pink, lavender, and green of the receding outer ring of onions. Bring this pale green down the left-hand side of the painting, covering some of the houses in the green wash, but leaving the roofs white so you can wash on a new color, cadmium scarlet, to add zest and bits of sparkling red triangles.

Lead the viewer's eye up the stairway by adding the quick dashes for the step marks. Add the elongated telephone pole, the top of which is level with the patch of tiny red roofs. Then move the eye down the roofs . . . from color to color . . . down to the cluster of carefully placed figures. Add the darkest touches to the heads and legs and to a few carefully selected windows . . . just a few. You have the same luminous quality here as in the onions.

VARY THE MOOD

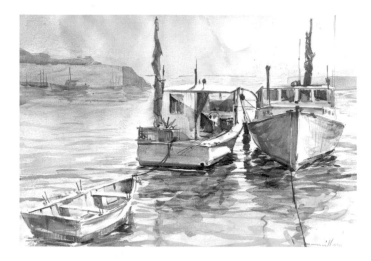

Early Morning, Spring

This is the first in a series of three seascapes using the same palette with slight changes to alter the moods. Your palette is similar to that of the last two paintings . . . with manganese blue substituted for the green.

You are out very early on a spring morning . . . the sun is just getting out of bed . . . you have already made your freehand carbon pencil sketch. The sky is blue and so is the water.

Don't copy what's there! Turn your back on the subject. Stop and think what you would like to dream up for color in order to capture this early morning mood.

Start with a pale orange sky wash around the white orb of the sun. Work quickly and bring a pale lavender on each side of the orange . . . down each side . . . forming a large X that crosses where the two boats touch. Continue the orange down the center.

Save your previously thought-out white pieces of design. Your orange and lavender intermingle in the water reflections. Whack this color on quickly in your first washes . . . you don't have to be picky. *Remember this technique* . . . to work quickly in watercolor . . . so your painting looks like a watercolor and not something that has been in labor for a month! There is always time to add detail later.

Place your heavier pigment in the detail where your two boats touch . . . at the cross of the X, your center of interest. Don't use heavy pigment to render the skiff in the foreground . . . even though the "rules" say this is what you're supposed to do. Keep the skiff delicately colored (after all, it's early morning), but be accurate in your drawing here in the foreground where your work is under scrutiny. But don't belabor your sketch . . . no erasing! Keep it fresh!

Late Afternoon, Cool Autumn

This is a similar palette to the other examples, but now your colors are taking on a grayish tone. There has been an early dusting of snow and it gives you a new avenue to explore . . . roof shapes, balconies, and masts . . . for linear patterns. You have planned to play these shapes of white against the more somber values of pinks, greens, and lavenders . . . less brilliant than before. You accomplish this by adding raw umber to your pinks, greens, and purples, graying these chromatic colors. (Achromatic colors are black, white, and grays.)

You are making a temperature change in this painting just by adding raw umber to each color. Raw umber is a "cool" earth compared to raw or burnt sienna, and you can add it to pink, green, and lavender to gray them without losing their essential color (that is, pink will stay pink, etc.)

You are also making your darks rather deep while still keeping them quite transparent. By careful scrutinizing of the scene . . . taking the time to analyze and decide on a desirable dark pattern, squinting your eyes to simplify the middle tones, you decide on a series of geometric shapes. Your darkest tones are the small square at the bow of the yellow trawler . . . the triangular roof at right center . . . small shapes around the white antennas and ship's bridge . . . and on the heads and clothes of the fishermen on the deck.

There are also transparent darks on the rectangular balconies that clearly suggest support columns. But you're less specific in describing exactly what else is there. The lack of detail and pale tones pushes these balconies back in aerial perspective.

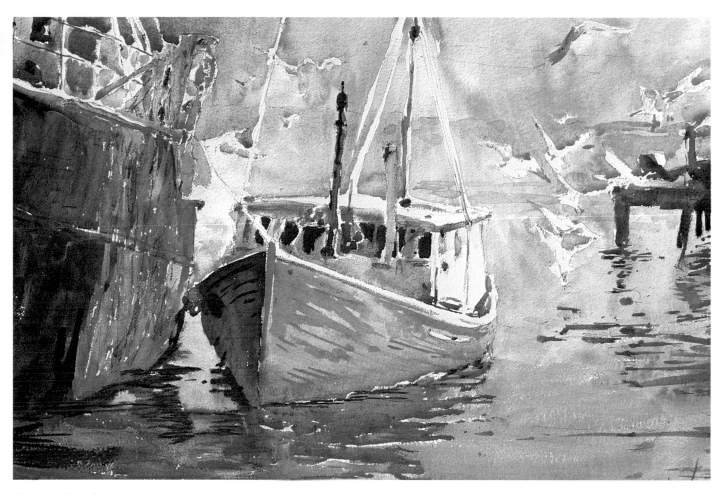

Noon, Hot Summer Light

Your palette is similar to the first painting, but the color is more intense. This time you're working in the shade of the overhanging roof of a boat shed. It is noon . . . blistering hot.

Paint it the way it feels—not the way it looks. You're looking at a dark green trawler hull, a white lobster boat . . . sitting dead in deep gray-green water . . . under a blue sky. Other artists around you are busy painting the green and the white boats . . . some out in the sun . . . at 90-degree temperatures.

What are you *going to do?* Be inventive . . . explore new color. Your impulse is to start the paint flying . . . but, stop now and think. The heat is creating a definite glare on objects . . . the heat is shimmering.

You decide to use a much more heavily pigmented set of washes, but you keep the top and side surfaces of the lobster boat pure white . . . likewise all of the rigging.

How about the gulls? Let's keep the gulls white as well, so they have a brilliance about them not dulled by their gray feathers.

Start your sky as a very wet pink wash . . . good and soupy . . . not too much of an angle to the paper. Drop in orange and let it run down through this wash . . . guiding it around the gulls and rigging. Quickly drop in a rich-colored wash of purple (phthalo blue and permanent rose) at top left and also bring this wash downward . . . around the threads of rigging, rails, and deck line. Now add the rust color (burnt sienna) to the trawler's stern. Using these three colors in varying, rich intensities, paint the balance of the trawler . . . shadow side of the lobster boat . . . water and dock . . . leaving tiny sparkling slivers of white.

After studying the water, you decide to try making the edges of the boats and reflections a very deep purple . . . but just the edges.

EXPLORE GRAYS AND MUTED COLOR

Combine Subtle Grays with Complementary Color Accents

The second painting is also based on gray, with yellow, brown, and purple accents . . . in modest amounts. The day's light is failing . . . the sun has long since set. You are still looking for another subject before you leave.

There are four figures across the street, sitting on a bench. The composition is static . . . dull. You are watching and waiting. Then one of the *Old Ones* (title) gets up and leaves. The others shift their legs and feet. Suddenly, everything is right! The light is right. The composition is perfect—unusual. The poses are so natural, so varied. Look at the negative shapes between their legs.

It is getting darker. The figure on the right is melting into the shadow . . . lost edges! The street light goes on, accenting the highlights of the shapes of design . . . an arm . . . a cheek . . . a foot. You are sketching a private moment. Remember the light . . . the quality of the light. You only have time for a rapid drawing. *You will have to paint this from memory.* The single figure leaves . . . the other two stay . . . another chance at that classic gesture . . . arm resting on a knee, one hand on the other arm, like Rodin's *Thinker.*

And Have You Considered . . . Do you sketch and paint figures? If not, start today. How else will you be ready to capture a private moment like this?

Look again at the colors. Would you have painted these three old men in this quiet, subdued gray and lavender setting? Would you have run this background wash over everything except the highlights and the space for the yellow curbstone? Would you have even included this yellow "no-parking" curb area? Or have run the figure on the right into the purple/brown shadows? Or have put the brown/pink/purple tones under the bench for warmth? Block out the yellow with a fingertip and see how you miss it.

Would you have left out the red brick wall . . . and the green pants and red checkered shirt of one of the figures? Think of what this lesson is all about!

Interplay a Shifting Gray Background Against "Positive" Color Shapes

An unusual pattern of negative shapes is created in between the many leaves and stems and flowers of these irises. These unique designs are so strong that they could easily overpower this floral still life. Therefore let's keep these shapes in a muted series of grays and yet seek a challenging variation in the background.

First paint the leaves and stems following the warmth of the light as it moves from top to bottom, striking the plants. It begins as warm green (sap green) on the upper leaf, turns cool green (viridian) at the bottom, becomes bluer (ultramarine blue), and turns to warm earth (burnt sienna) at its base. The leaves in the light are olive, and the white leaves strengthen the design.

Second, letting the left iris remain white, start your corner iris in a pale cerulean blue . . . dropping in ultramarine blue and manganese blue wet-in-wet for shading. Working toward the corner, add alizarin crimson, ivory black, viridian, and burnt sienna. Gradually paint from the dark into the light . . . working down the right-hand side in deep tones. The entire left and top two thirds are all one color, a mixture of burnt sienna and ultramarine blue in the paler tones, and pale lavender and violet is added at the base.

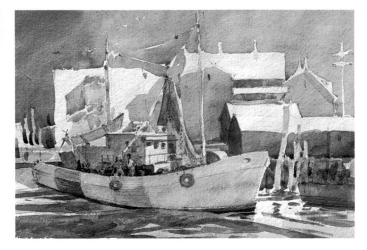

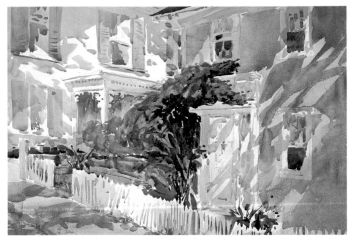

Use Grays in a Cold Setting

Winter provides a rather somber setting for your third painting. From a gray base, your composition will support a striking set of abstract shapes in white . . . prompted by the snow on the roofs. Be on the alert for these signals from nature. This roof pattern might have gone unheeded by a less observant artist, and yet *it is the key* to this very understated watercolor.

Your objective is to capture this cold, bleak day and to do it in such a way that you also capture the viewer's heart! Remember, you are painting "poetry," not just worrying about how to push paint. Braque could tie your emotions in knots with his compositions, yet he fed you mostly grays . . . a dozen different grays in a single painting.

You find an interestingly shaped house and decide to make it green . . . an orange dory helps you visualize a triangle tied in with a roof peak . . . and you finally decide on an earth brown for the fish house.

The "proper" gray for this painting is mixed from three colors . . . green, orange, and brown. Make a big soupy puddle on your palette so you don't run out of a special color. . . . It will throw you off your stride. Add a bit of blue to make your color cooler, and as you begin your painting after making a carefully thought-out sketch, add a touch more blue with a bit of alizarin crimson to make that dark squall at the top left. Let this color drain down around the pilings and serve to accent the largest building as well.

This is an example of a painting in which pattern is more important than color! Apply your color washes quickly to keep them clean. Slant your paper.

Use a wool sock to keep your hand warm on a bitter, cold day like this. Just make a hole and poke the end of the brush through it and you will have better control than a glove or mitten. (That's a welcome suggestion from Emile Gruppé in Vermont.)

Diagram of *Yellow Door* (top right).

Warm and Cool Grays as Dappled Light

Your fourth painting in this series is again based on gray . . . this time warmed by mixing in some of the color of the *Yellow Door* (title). Your grays will be both warm and cool. Don't forget to think out your method of tackling this subject . . . before you get emotionally carried away by the beauty of the scene. Work out several angles of attack. Your best vantage spot is from the middle of the street . . . but watch the cars! Make your quick sketch and paint from the *sketch* . . . not from where you're sitting!

Mix your basic gray for the house on the right with raw umber and cobalt blue. Make two large puddles of this . . . and then let them sit!

Start painting the house by adding the yellow to the first puddle. Paint the house . . . let it dry. Then use this same color for the shutters on the white house . . . and let that dry. Put in the yellow door next. Now you decide to leave out the pink rosebush since you feel this will detract from your painting of the *Yellow Door*. And you paint the sidewalk as a pink . . . not the deep asphalt you are looking at. Let it dry.

From the second puddle, apply this cool wash over everything that gets a shadow. But . . . you have already thought out your shadow pattern in your sketch. You are not following the cast shadows you see in reality. Instead, you have designed a better set . . . a set that has a planned composition. (see diagram). You are working in a parallelogram . . . triggered by the black (ultramarine blue and alizarin crimson) roof angle, paralleled by the top of the carefully designed deep-green rosebush and house shadows. Your secondary interest is the gingerbread porch column, accented in blue.

When you painted the yellow, pink, and blue, did you have the primaries in mind?

Study the diagram. It should duplicate the sketch in your sketchbook. That is where you should be doing your design testing . . . feeling your way with the shadows on the yellow house that are repeating the invented angle of the rosebush. This painting should be well-thought out . . . even before you touch your watercolor . . . and then painted rapidly! Maximum time for the advanced artist, one hour!

103

EMPHASIZE COOL OR WARM COLORS

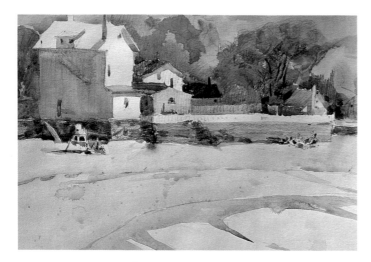

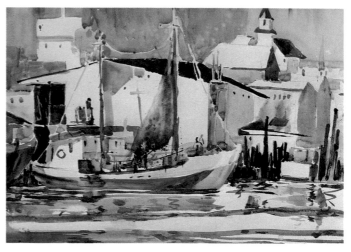

A Beach Scene, Emphasis on Cool Colors

You are perched high above the sea, sketching during lunch. The waves are coming in at an angle . . . running high up on the beach at low tide . . . making a good design . . . making different values in the gray sand between the wet and dry . . . warm and cool. This is "warm and cool" repeated in the houses . . . and in the trees. You are just sketching.

This looks like a major painting. Look at the way the public bathhouse, a large, white geometric shape . . . seems to balance the tiny cottage at the far end of the white fence . . . this looks like a classical example you'd see in a textbook on composition.

Your whites look like they were "painted" into position by a pro because they're so crisp, like accents, against all of the soft, dark shapes of the trees. This crispness is repeated in the pink fence and in the varied grays of the sea wall . . . which incidentally is also spelling out the delineation of the land forms . . . and is quite modelled.

You realize as you finish lunch that you are going to have to do your color application from memory! You make a note of the warm and cool division of the sandy beach . . . the gray sky . . . the bluishness of the trees . . . and how rich they are in tone against the whites. Note the surprise of the raw sienna in the willow trees . . . that first spring color.

Figures are drifting onto the beach as it begins to warm a touch. A cluster of people spread a blanket below that beach cottage on the right . . . and several sit at the foot of the out-of-season lifeguard stand under the bathhouse! This painting looks "planned," but you'll paint it this way anyhow. It's perfect . . . a good, simple, colored subject for your first memory painting of the season.

A Harbor Scene, Emphasis on Warm Colors

The colors of your second subject are warmer and they are multiplied! Now there are larger pieces of these blues and burgundies and yellows (raw sienna), thereby making much more interesting color areas. Where there was only a small bit of pink in a fence and a roof, you are now tempted to splash an entire pink sky across the top of your painting . . . dropping a variety of pale blues into it.

When you started sketching this morning, there was only the shape of the big blue (it was really green) trawler in the mist and the barest suggestions of rooftops just beyond. But by now you are well into your third freehand sketch and the sun has begun to burn off the fog . . . and you can't believe your eyes. There is a gorgeous seaport looming up out of the mist just like in the movies . . . beautiful blue-white fish houses by the docks . . . houses way up on the hilltops. What perspective! What a painting!

The sea that runs into the harbor is quiet and is floating long strips of light from the horizontal wake of a passing ship. Your composition is being solved before your eyes! These long horizontals are acting as a very stabilizing influence on the many verticals rising out of the sea. You think "design" as you carefully place each of your deep-colored dark pieces . . . deep burgundy for the long slim roof arching over the big fish house . . . and an intense, deep blue in the opening behind the trawler and on the church touching the top of your painting. Rich colors also go into the pilings along the dock.

The sienna shapes of masts . . . the fishnet . . . the roof eaves and water reflections are carefully planned. You are balancing . . . playing a game with just where you place the blue versus the sienna. Push yourself to keep this a very spirited watercolor . . . work for one hour!

VARY THE QUALITY OF THE DAY

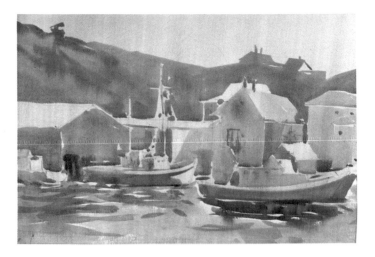

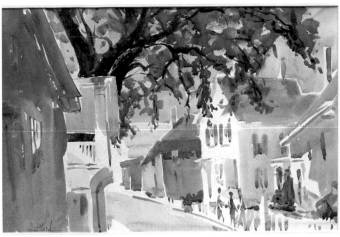

Paint a Rainy Day

You are going to have fun with this one . . . but I'm going to tell you how to paint the actual painting—not the sketch in your sketchbook, otherwise you wouldn't know how to get this rainy-day effect. Transfer your sketch to a 15" × 22" (38 × 55cm) sheet of 140-lb cold press watercolor paper . . . just clip it at the top with two 3" (7.5 cm) wide clips. (I never tape mine on four sides because it buckles.)

It has been a day of showers and the rooftops are a glistening white. You are working under a shed roof and the damp day lends itself to watercolor. But it is also staving off the drying, so leave tiny white lines of separation between wash puddles.

There are no shadows here, only a slight change of values from one side of a house to the other. So you decide to cast a "fake" shadow . . . creating a triangle of white that brings the eye diagonally down from the hilltop houses to the bridge of the blue trawler. This counters the roof angle of the big fish house on the left.

You carefully plan your whites for a good design pattern and also decide where you want them to lead the eye.

There are no really deep darks except under the green trawler in the foreground. This is a "soft day," as they say in Ireland. It is important that you use sap green, since this is the one green that stains. You are also using light red, ultramarine blue, both umbers, and burnt sienna . . . a rather "granular" lot.

First, put in the upper houses and the hillside . . . silhouetted against the barest skytone. This wet wash "sits" on top of the dockside houses. Let it dry. Then paint the balance . . . houses, water and ships . . . dropping slight color into these wet washes. Again let it sit until it's bone dry.

Now . . . brush a cup of clear water over the entire painting with a 2" (5 cm) flat brush. Keep your work at an angle and let it run, drip, and bleed. There's your rainy day!

Paint a Crisp, Sunny, Summer Day

You find it a pure delight to be setting up your easel under the big elm tree. This position should give you about an hour before you get blasted out by the midday sun. The cool sea breeze is blowing in from the cold water, creating a moist atmosphere . . . perfect conditions for a watercolor. Just enough moisture to retard the drying time . . . enough to pale the deep red house to a faded rose color . . . enough to lift dark roofs and shutters into a bright, high key. There is a constant trickle of tourists moving along the sidewalk as you sketch in your exciting composition.

What you've been watching for is suddenly taking place, right where you planned it . . . about two-thirds of the way in from the left side of your composition . . . at the golden section! Your center of interest! What luck! Two tourists stop to chat with the lady of the house who has just come out for the mail. Paint them in but keep them light in value. Accent the middle figure with a sharp shadow of burnt sienna . . . warm and quite-strong in color.

There is so much brilliance now, that all of your shadows are picking up an enormous amount of reflected light. Keep your colors pale, but don't use tinted water . . . give it some pigment. Put down each stroke exactly where you want it . . . quickly . . . don't be shy!

Let everything dry before you render that tree. You want crisp edges where the elm leaves are painted on top of the sky and roofs. You know you can't paint too many leaves or you'll lose that airy feeling of the sun filtering through . . . letting the viewer see the many well-designed negative shapes of the sky. Really lean on that tree trunk . . . use plenty of pigment. Let the sun come from the left, mist the top . . . and you've got a winner . . . fresh and clean . . . a crisp watercolor—in just an hour!

COMPOSE WITH COLOR: Floral arrangements

Design with Color and Light

These brilliant summer zinnias are arranged in an old white earthenware pitcher. They are sitting on a broad windowsill . . . far enough away from the glass so that when you focus your eyes on the flowers, the background "goes out of focus" and just becomes a light gray setting. The brightest light is hitting the very top of the pink zinnia, so you leave the white paper and begin increasing your depth of color toward the outer petals. The stem is dark between this pink and the orange of the next blossom . . . and the orange darkens into burnt sienna.

By the time you have crossed this orange zinnia, the orange has actually run into four or five petals at the top of the fuschia zinnia.

You are creating an arc when you curve upward into the two deep burgundy zinnias on the right. Since these are as high as the first pink flower, you are indicating that there has to be a narrow concentration of light on the first zinnia in order to achieve so dark a color on the right.

The rich green is a heavily pigmented wash of sap plus burnt sienna . . . duplicating the upper arc . . . and swinging your eye toward the light striking the handle of the pitcher. This path of light is made on the leaves and stems by swabbing or lifting off some spots with a damp brush.

Color relationships is what this arrangement of zinnias is all about: orange next to pink next to fuschia, moving around the color wheel . . . each color influencing the color next to it . . . which is why the fuschia zinnia contains some orange petals. The famous colorist Josef Albers spent a lifetime playing one color against another. So did Bonnard and all of the Impressionists . . . Monet, Renoir, Degas . . . the list is endless.

Cut the stems to different lengths. Don't make them all the same. Lay the blossoms out flat on a white tablecloth and shift them around, creating color designs and relationships . . . *then* cut the stems to fit your ideas and put them in the vase. Arrange the stems for good negative shapes, too.

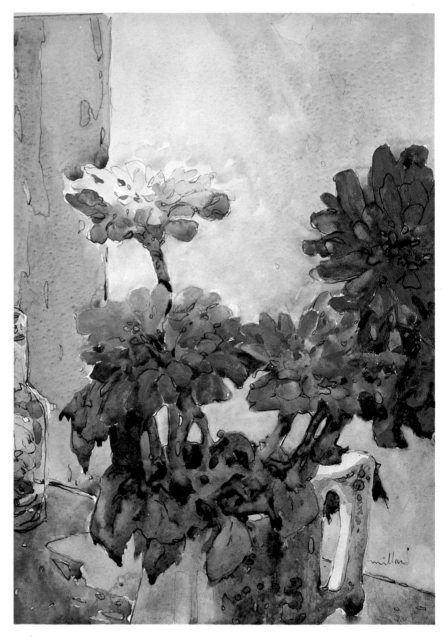

MAKE THREE PAINTINGS OF THE SAME SUBJECT

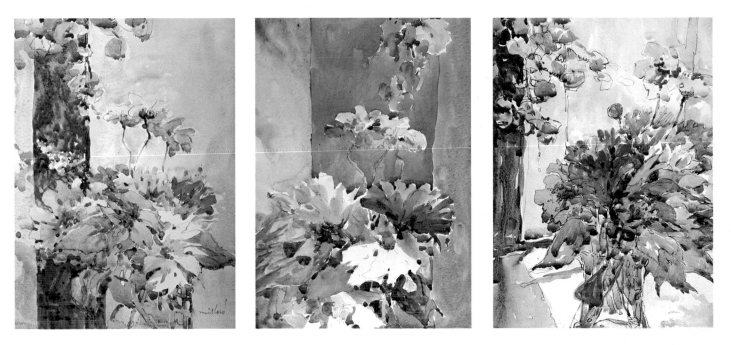

We are not just concerned with color. We are probing . . . exploring how we can compose with it. Here are three different paintings that express the delicacy of a few fragile pale pink cosmos blossoms. We have also decided to dangle some Swedish ivy above them, injecting it into the composition to imply that there is more to the top of this picture than the eye sees.

These round, green, ivy shapes are very compatible with the awkward stems of the cosmos. An awkward child has a special beauty . . . let's play on this. These will be "sensitive" floral paintings . . . in a way that a musician is sensitive to a certain theme that's running through his head . . . and bases a series of tone poems on it. Many composers have done this . . . why shouldn't we? We can get better acquainted with a problem if we tackle it with three variations on a theme.

We decide that there will be certain factors common to all three of those cosmos tone poems:

1. Each painting will feature the pink cosmos and their awkward stems as being aloof from the rest of the bouquet.
2. Each painting will present the flowers in a very different composition and with different color treatments.
3. Each painting will use a color panel to establish a hard line contrast with the delicate asymmetrical patterns of the flowers.

Compare the Paintings

In the first flora, we've moved in on the flowers and lopped off the bottom of the vase. The painting has a rather cool quality, with a light, simple background to set the stage for the delicate flowers . . . we are aiming for a "soft color relationship" between them. The flowers cast a blue-gray shadow on the wall. Note the carefully drawn negative shapes of the stems. There are also many smaller negatives within the vase and flowers. The size and position of the panel is based on the way it fits into the interstices of the carbon drawing, rather than on its actual contours in the setup. No two panel widths are the same.

In the second painting, we have zoomed in even closer to the floral setup. We are also using stronger color . . . harder edges . . . and have deeper shadows in the flowers. This time, no vase is visible. The central location of the cosmos has also predetermined the position of the panel. Note the powerful negative shapes in the cosmos and white flowers. The pink cosmos have been placed against a panel of an analogous color . . . a deeper, smoky pink. The edges of the cosmos are hard on top . . . but soft at the bottom.

In the third painting, the cosmos are very different, both in color and position. This time the negative shapes surrounding the bouquet have been emphasized . . . and the edges of the flowers are soft on top . . . and hard at the bottom. Complementaries have been stressed, with "invented" lavenders around most of the bouquet. The side panel is composed of "self-mixed" browns, browns mixed from the floral colors. The shadow on the left implies that the vase is sitting on a table top. Note the curve that sweeps from the upper right-hand corner, down through the greens, and weaves through the flowers to the leaves at the lower left.

CREATE A SERIES OF FLORAL TONE POEMS

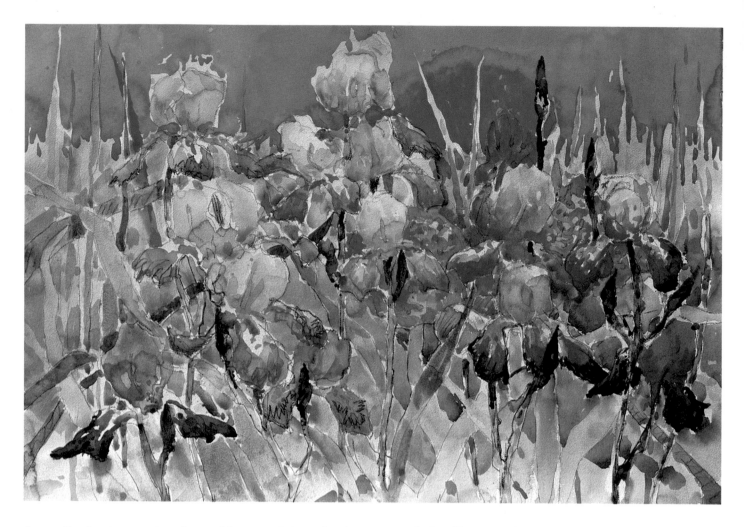

In continuing to examine the problems and thoughts involved in arranging still lifes, designing colors, and creating a mood, we will do another type of floral series. This time it will be based not on the same setup, but on our attempt to create different types of moods, another sensation, for each of these "tone poems." Let's see where they're similar . . . and where they're different.

As tone poems, their colors and moods are varied. The first painting has high-key oranges, lavenders, pinks, and greens. It makes me think of "Scheherazade" (by Rimsky-Korsakov), an exotic Oriental fantasy. The second painting is deep and sonorous, with dark earths, purple-browns, and blues. Looking at it, I think of Beethoven. The third painting is strident in its strong contrasting tones . . . both very high and very low. It has an abstract quality that makes me think of modern jazz.

Now let's look at the basic design themes. The first painting has vertical spears . . . spikes in puffy circles . . . phallic qualities. The second painting also contains many V-shapes originating from the tree trunk, but these shapes are less vertical and closer in quality to those in the third painting. The third example, on the other hand, has a

rounded effect, with its emphasis on circles and ovals . . . formed by the swirling stems.

Notice the importance and volume of the darks. In the first example, the pattern of V-shapes is continued in the dark bottom petals and their tips. In the second painting, an enormous volume of darks is interwoven between the delicate branches. The third painting has a more varied treatment of darks . . . as negative shapes in the stripes and positive forms in the shadows.

Now let's look at the picture plane. How deeply do we move into the distance . . . or stay on the surface of the paper? In the first painting, the green leaves are modest in their penetration, but the sun and sky are deep behind the iris. In the second example, you look deep into the forest in the upper half, but slabs of granite in the middle distance block the lower areas. Looking at the third painting from all four sides, we move from shallow to moderate penetration of the surface.

Looking at other features in common, notice the use of thread-like whites in each painting, to separate the colors and emphasize directional movement. Also, note the non-classical treatments here, the use of asymmetrical shapes and non-formal arrangements. Your eye is con-

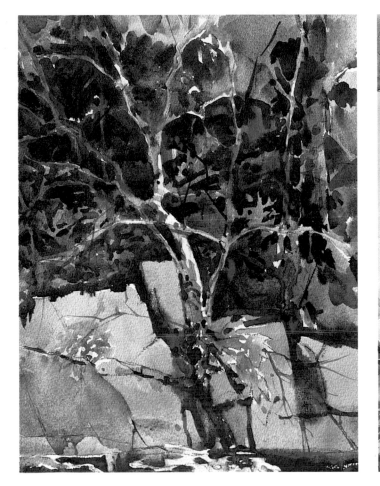

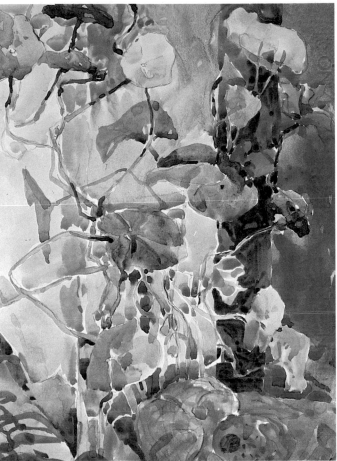

stantly drawn from positive shapes to negative ones and back again, creating a great deal of surface tension throughout the paintings. Finally, notice how the problems of landscape and still life are interchangeable. If you're having a tough time with a landscape, just pretend its a still life . . . and vice versa. The problems are similar.

Each of these paintings should take about an hour to paint. This time, after making your drawing in the sketchbook, you can work on regular sheets of watercolor paper: a full sheet, 22″ × 30″ (56 × 76cm), for the first . . . and a quarter sheet, 11″ × 15″ (28 × 38cm), for the second and third paintings. As your paintings improve, you will be working more and more frequently on good-quality paper. The sketchbook is a tool . . . not an end in itself.

11 PLAN COLOR WITH THE MIND'S EYE

How do we develop a painting from the first rude impulses that catch our attention and stop us in our tracks for a moment? How do we shift gears from reality . . . to art? We run a scene through the projector of our "mind's eye" . . . and mix a little of the real world . . . with a good measure of the colorful, poetic, dream world that exists only in our inner selves.

Each of us is a walking storehouse of experiences unique to us alone . . . that have occurred during our lifetime. *Your own personal* style of seeing . . . of painting . . . of designing, dreaming, inventing . . . comes from where *you* live . . . where *you* were born . . . the exploring and discoveries *you* are making . . . in your own environment.

Let's start our journey into the mind . . . putting aside mastery of technique . . . and search for some *instinctive responses* to these problems.

VERMONT FARM

Look at the Scene

The colorful leaves are all but gone . . . we are scouring northern Vermont . . . searching for another painting. There, way ahead of us, on the left is a huge red barn . . . an old white house . . . towering sugar maples. Put on the brakes! Stop! Why? Let's dig a little . . . just rattle off our thoughts and jot them down.

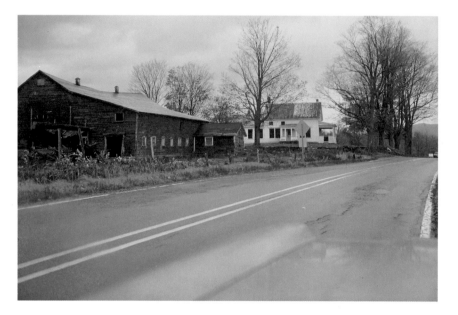

1. The pattern . . . first . . . the pattern! The pattern of the trees against the gray, simple sky . . . and the buildings.
2. The big "hole" in the end of the barn . . . a negative hole.
3. The shape of the old colonial house . . . a large house . . . dwarfed by these huge trees . . . the side porch . . . we can see a patch of sky through the roof and the railing. Another negative.
4. The entire foreground is black asphalt with two yellow lines. Your instinctive response to that is . . . "terrible." Listen to your inner voices . . . if you don't like it don't paint it!
5. That piece of mountain is great . . . block it out with your fingertip and you could be on the plains. Leave it in and you're back in the mountains.

How do you translate this "so-so" scene into a painting? Get out your sketchbook and try some rapid contour-freehand drawings from several different positions. Watch out for the traffic . . . those lumber trucks coming over the hill . . . they really travel! Mincemeat!

On the scene, it is ice cold . . . you can just manage a few sketches . . . no chance to paint. You'll take it home and work on it later.

First Interpretation

Confronted with several good-looking sketches, you plan a painting. Let's put this on *good* paper . . . ¼ sheet, 11" × 15" (28 × 38 cm). This shows you feel it is more important than to color sketchbook drawing. Let's try for an unusual interpretation.

It's going to be a sunny day . . . an early snowfall. The wind is blowing the snow in swirls . . . covering the edge of the barn . . . losing the corner of the house. A "mood" is being created in the mind . . . and problems are also being created at the same time . . . how to paint the swirling snow? A welcome challenge.

Move the road . . . show a small amount of it, where the plows can't reach out here on this dirt road . . . and put in a fence . . . some thin poles . . . positioned to suggest perspective . . . and a clump of grass in the foreground road.

Carry a warm brownish pink throughout: sky, trees, barn, grass. This is a warm, sunny interpretation of the scene.

Let's continue the warmer color, with raw sienna in the leaves and grasses . . . in the bushes near the house and for the cattle tracks leading to the barn. This seems to "feel" sunny.

Look at the whites. All of the snow . . . the highlights on the house . . . the lightest areas of the sky are the white of your paper. It is certainly pulling everything together.

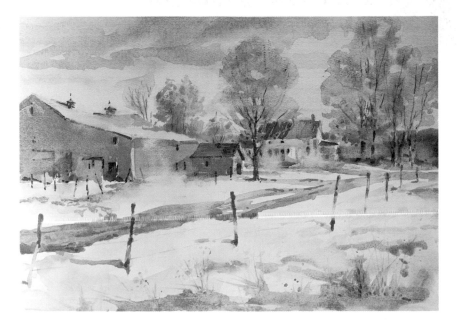

Keep Searching and Probing a Subject

This close-up of the house and trees also comes from one of those sketches done on that raw fall day. It, too, will be painted on good paper.

The wind has picked up. The snow is really blowing, packing against the windward side of those great dark trees. Your feeling is to make this a cool version of the scene. Follow your instinctive responses. You also want to create a dark "belt" across the painting with the roof and the five big trees. And you add a dark road to give perspective, pushing the house and trees back.

Lay in the sky first . . . let it dry. Then indicate the foliage—small branch area—with a blue-lavender overwash . . . and let it dry. Make a diagonal swipe from top right across the four trees with a damp sponge . . . picking up on the angle of the shadows on the right side of the house . . . wiping out some color . . . and let it dry. Lightly suggest the slanting sun's rays with raw sienna. Tie these randomly spaced trees and house together with a background wash for the bushes . . . a purplish-brown-pink. Then lay a cerulean blue wash across the distant mountains.

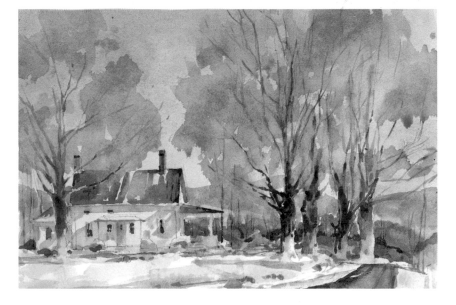

BLACK DOG

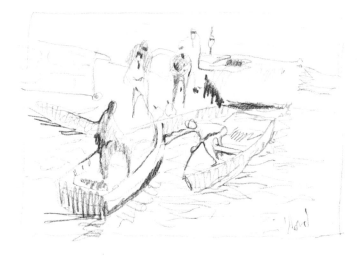

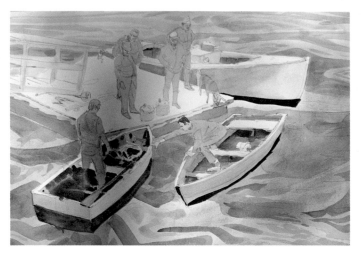

Getting Ideas for a Painting

Our sketchbook is always at hand when we are out "looking" for the next painting subject. You have no preconceived composition planned for today . . . just keep an open and fertile mind "on the ready."

We are sitting . . . waiting. Pigeon Cove is quiet. Not much doing. A dinghy starts its trip from a distant lobster boat . . . heading for the float . . . a black labradore starts down the ramp. That must be his master coming for gas. See the red tanks? Your eyes are not the only ones watching the black dog. Figures start moving toward the ramp. . . .

Here comes a painting! That's the first feeling. Your creative juices have sent up a red flare. Your mind is working; you're itching. Make that carbon pencil fly!

Set the stage. It's going to happen around the float. Decide. . . . Design where and what size . . . angle . . . shape? Next, the ramp railing . . . what angle? Make that small lobster boat part of a single unit: ramp, float, boat . . . one unit . . . the stage!

The black dog has picked his spot . . . quickly, nail him down. Now the two guys . . . first the one in the maroon jacket and out of his shoulder grows the guy with the black cap. Done!

The dinghy reaches the float and you sketch it as the gas cans are unloaded. A second skiff comes up and the guy on it grabs for the dinghy. Get him and these boats in quickly. Next put in the two tourists by the gas cans . . . join them as one shape.

That sketch feels like a good composition . . . it just flew off the pencil. *The mind's eye* was drawing that arrangement of "objects."

First Washes

You are working now on a full sheet of watercolor paper, 22″ × 30″ (56 × 76cm) . . . time limit, one hour. You are also working from memory . . . because everybody has gone home. No figures to hold that pose for you. No wonderful black dog to stand still for a careful animal study. Wouldn't that be nice, to sit back in your easy chair and make a spiritless drawing!

Now your "mind's eye" really takes over. This, I think, is the right side of the brain doing the work . . . 'cause the left side doesn't have reality sitting out there on the float ready to be copied.

How are we going to "see" this thing? This is exciting. There is a distinct feeling that this painting is going to get done by that "walking storehouse" . . . personal creativity. That's a challenge . . . this is where the first decision is made. Put in the three dark accents of the boats.

As soon as the first brushful of colored juice goes onto the paper, the tension is lifted and we are underway. Let's make this a controlled watercolor. The sketch is loose . . . let's understate it and use a restrained palette of grays and blues.

After the darks are located to set up a "rotating motion" for the viewer's eye, the gray-blue washes are established . . . rapidly stroked on but with thoughts of design . . . creating shapes from nothing.

Warm tones of raw umber are also carefully placed . . . as carefully as the darks. Be fussy about this kind of creative planning of locations for your black-and-white design pattern. On the other hand, the time *not* to be fussy is when you are applying your washes. Watercolor is a scintillating medium. Maybe this thought will help to keep your washes clean and crisp. This should be part of your *instinctive responsiveness*.

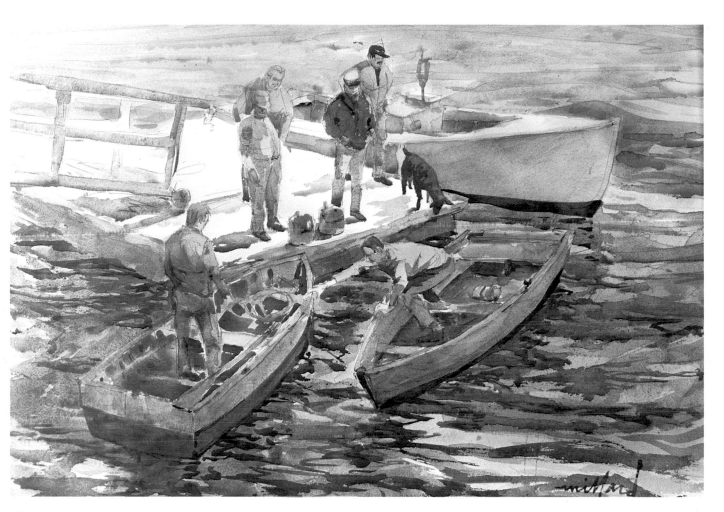

Finishing the Painting

Reality is what you're looking at . . . what you see . . . what the camera sees before the lens. In this case, the water is as dark at the top of your painting as it is at the bottom. But you don't paint it that way!

Creativity is what you see in your "mind's eye" . . . what you think you want to see. You can imagine an image . . . dream a plan for a painting in your head and "see" it. This is part of how to see as an artist.

You are looking at a dark green lobster boat tied to the end of the float. You can see that this green boat blends into the dark green water . . . but in your mind's eye, you visualize the water being pale at the top of the painting and also picture this boat in pale tones.

You are also looking at a brown float . . . but you know in your mind that it will be a better design if you make it white and *create some excitement* with the negative shapes around the legs of the black dog and also the men. Where some of the first pale blue-gray wash bled onto the damp surface of the float, you can lay a new wash of clear water and blot up or use a clean brush to get back to white.

Bring the color into the gas cans, jackets, skiffs, and float edge. Let the color become a little stronger than understated.

Lay in the second wash on the water, keeping the white highlights. By making your brushstrokes in the water run in wavy curves across the action of the two skiffs, you are able to create the *illusion* that there is a tide running toward the viewer. Pick your design pattern into the darks in the water as reflections that zigzag with the direction of the wavelets. Don't overdo it with too many darks or you'll lose the feeling of liquidity . . . lose the sparkle.

BOAT IN THE FOG

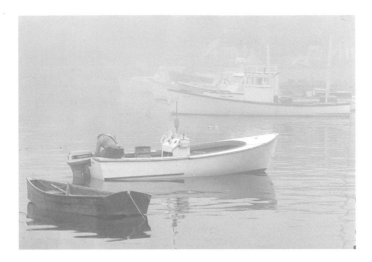

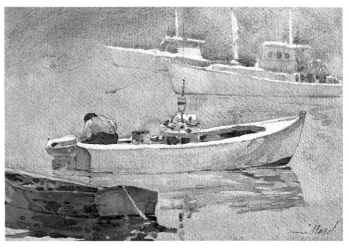

Looking for a Painting

You might pass this scene by as too dull . . . too indistinct . . . lackluster . . . out of focus. No composition that's discernable. No action. But you're looking at this subject as a photographer . . . as a realist . . . from the left side, the realist side, of your think box. *There's a painting here.* Let's give it to the creative side, the right side of the brain, and put our intuitive enthusiasm to work. I bet the first thing you'll want to attack is the weakness . . . the lack of apparent interest. But let's see.

Making a Painting Out of Reality

Just as in the painting of the Vermont farm at the beginning of this chapter, let's get our creative flow moving by making several freehand contour sketches to "see" in our mind's eye where we'll bring up the artillery. Out of your many sketches, the best one seems to pick up on a Z-shaped composition: red rowboat points left . . . motorboat with the guy in the pink shirt points right . . . two big lobster boats (not the six in the photo) point left again.

Your mind's eye is saying, "Give me some dominance! I need stronger interest!" So we create a fog that has quiet strength . . . a uniqueness in design and a stronger fog color than the reality. Mix a big puddle of cerulean blue and light red for the fog—a touch of ultramarine blue goes into this wash only at the top quarter, as far as the boat decks—and lay this wash over everything . . . except the white upper surfaces of the boats and the three masts. Diminish the strength as you come down past the halfway point. Save the whites on the motorboat.

After this wash is dry, pick up the gunwhale in blue . . . darken the innards, hat, pants, and waterline . . . all on the motorboat. Then add its reflections . . . don't overdo them . . . just once and that's it! Then hit the red skiff . . . don't paint over the mooring line aft.

Note how the mind's eye has created more emphasis in all the boats. This happens in the head . . . you can "visualize it" before you paint it. This painting was designed, made up, created . . . yet it doesn't look faked or false. Remember you must have some believability when you draw the boats. Those "in the know" will *hang you* if your boats are wrong.

BARN AND WAGON WHEELS AT JEFF

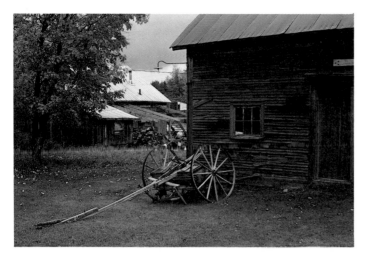

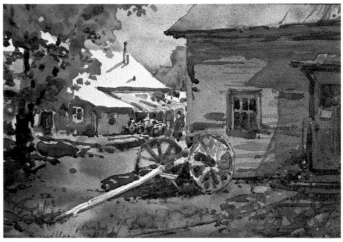

What Was Seen . . .

The dramatic pattern stopped me here. It was raining hard and the tin roofs were picking up a bright glare . . . almost white. These odd roof shapes . . . pointing toward me from the distant house . . . were working as a counter action against the directions of the tongue of the wagon wheels and the slope of the barn roof . . . creating a zigzag like a lightning bolt.

First I did a quick freehand contour sketch of the whole composition . . . working in the station wagon. Then at the end of that heavy shower, I stepped out to take a color shot. *This is my common procedure.* First, the sketch . . . always, then the photo. The reason for this order, at least in my mind, is that *an intuitive sketch is created from the mind's eye* and is a personal and emotional response to what stopped me . . . called to me . . . in the first instance. After . . . repeat, *after* . . . this sketch is completed . . . only then will I take the mechanical recording on film. Only *on rare occasions* . . . such as on a bus, racing at high speed through the Italian alps . . . will I be shooting photos first . . . with a zoom lens, capturing distant mountain villages. Then, from prints of these shots I will make *freehand sketches.* Or I will sketch from slides projected onto a screen.

But normally, my sketch always comes first . . . to get the benefit of my own intuitive response to a subject. This is a good habit!

What Was Painted . . .

While we have the details in front of us, let's do the watercolor. We are comfortable in the car . . . there are intermittant showers . . . we open and near close the windows as we work to keep the steam from blocking our view. I have painted literally hundreds of watercolors in the sketchbook and quarter sheet sizes in my car and still there are no sloppy color splashes. It's just as easy to be neat and keep color stains off a passenger's dress at a future date as it is to be careless and sloppy. The water jug hangs from the radio knob . . . brushes go into the open ash tray. Or rig it your own way.

Plan the white roof pattern with care . . . this is what stopped us. Several sketches are quickly made to search out the format . . . to decide the size of the barn. You pick up the angle of that long tongue of the wheels and repeat or continue that same angle in the shadow on the barn.

Improvise. Invent your own colors. Don't always follow what's in front of you, either in color or in the arrangement of objects. Explore . . . be inventive. It is a gray, rainy day, but let's go for color. Mix a gray-pink sky of lavender and raw umber . . . and use it on the barn, only richer . . . and on the distant house. Add cobalt violet to it for the barn and grass shadows.

Then use oranges and cobalt violet for the maple tree. And drop in a diluted sap green and raw umber combination into it, wet-in-wet. Keep this green dull. Make the tree trunk a mixture of ultramarine blue and alizarin crimson. Spot the branches in carefully between the mass of leaves. Give some thought to the size and position of these dark spots of branches moving up from the trunk. Then let the trunk bleed pale at the base.

Now put in the accents. Use cadmium red for some selected leaves . . . for the plant at the foot of the barn door . . . and for the girl's shirt. Then color the woman's dress manganese blue. These two figures are the center of interest. Finish by making the grass a mix of raw umber and palest green. Keep the color dull . . . it's October!

These colors are all invented in the mind's eye. No black barns here!

CAPE ANN FISH HOUSE

Why a Photograph Can Be Misleading

You are excited seeing the pattern of the house by the water . . . in a "stage setting" of summer greenery . . . a pleasant group of figures frolicking, enjoying the hot day. This time you are taking the photo before you make your sketch. But this is giving you a mechanical recording instead of an emotional response to what you are seeing with your mind's eye.

You like what you see in the camera's view-finder, including the dog in the fore-ground. The scene composes well in the camera . . . it makes a good photograph. But you are looking at *reality.*

What you see is wrong! You have divided your compositional interest in half horizon-tally. You are about to paint a "post-card" . . . too much material. The dog, rocks, and figures on the rocks are detract-ing from your main subject matter . . . the fish house and its immediate surround-ings.

Trust your mind's eye, your intuition, for your compositions . . . not your camera.

How to "Use" the Photo

The procedure of advanced color planning can be summarized in the way this old fish house was painted. It had a good shape . . . a good pattern . . . not in its dull, lackluster reality, but in the mind's eye. In each of the four previous exercises, you have been improvising . . . invent-ing . . . exploring color. Now sit on your creative rock and start dreaming . . . dream color!

As you are sketching, think about the col-ors. Open your mind. And while you're at it, open that closed fish house door, too. Pretend you can see two lobstermen inside, talking about their catch for the day. Then run a brilliant mixture of burnt sienna and cobalt violet on the roof . . . then substitute cadmium orange for the burnt sienna as you paint the shadow side of the house. Cascade this color over the two figures in the picnic group, leaving the girl in white out in the full sunshine.

Where did the figures come from? And the idea that they were having a picnic? They came from your imagination. In your mind's eye you could see these people sit-ting there . . . in the center of interest. Think poetry . . . then paint. And im-provise your own colors!

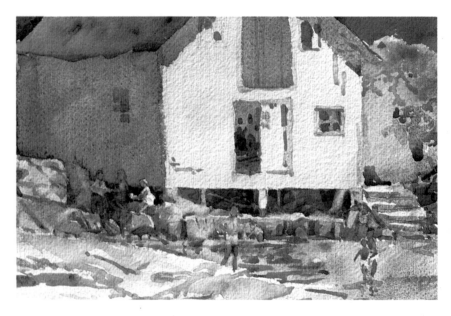

116

VERMONT SUGAR BUCKETS

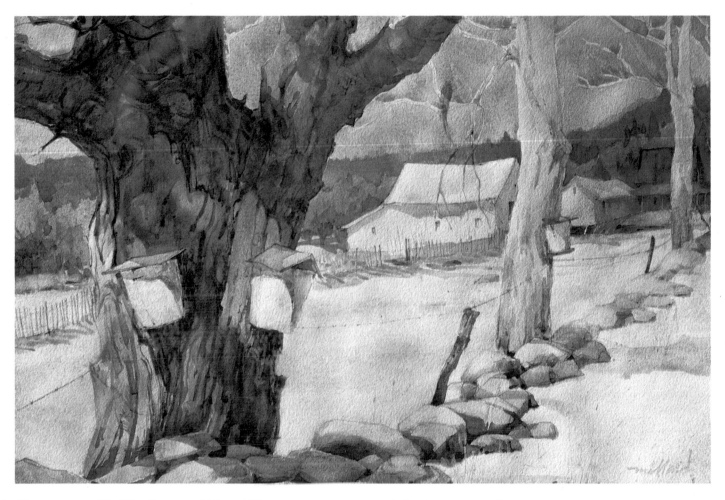

Compose with Rhythm and Repetition

Vermont Sugar Buckets gives us a good opportunity to see what we mean by *rhythm in a painting*. There is a rhythm in the great sugar maple itself . . . in the way the branches are designed in size and shape and in the spacing of the three negative "holes" in-between the branches. There is also a rhythm in the number of buckets . . . not one, not three (too crowded), but two . . . and their position—tipped to follow the angle of the tree trunk. Furthermore, there is a planned difference in the caps on these two buckets and in the way the sunlight and shadow shows their form.

There is rhythm in the manner in which the three trees are placed . . . the way the color is only on the first tree and the way there is only one bucket on the second tree and none on the third. Look at the rhythm in similar shapes of the sky negatives. There is also a rhythm:

1. In the converging perspective lines of the snow fields . . . in front of the stone wall . . . behind the stone wall . . . and behind the snow fence.
2. In the converging line of the strand of barbed wire.
3. In the lines of the snow fence.
4. In the long row of plum-colored trees.
5. In the purple mountain range.
6. In the stone wall.
7. In the shapes of the farm buildings.

You know by now that these things were not all as you see them here. You know that *the farm buildings were across the street*, and the *snow fence was just behind the stone wall*. You know that you must take the time to study this subject *before* you start to sketch and paint. This studio painting, on 22″ × 30″ (56 × 76cm), 300-lb cold press paper, took more than one day.

12 COMPOSE WITH GEOMETRY

COMPOSE WITH SHAPES: A series of three florals

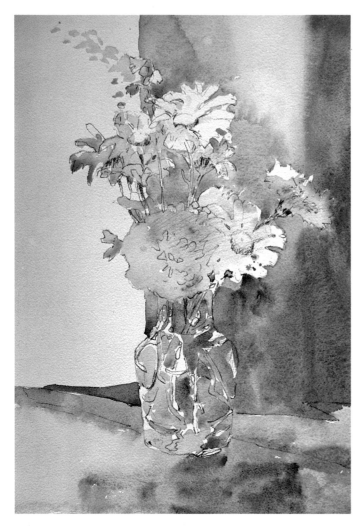

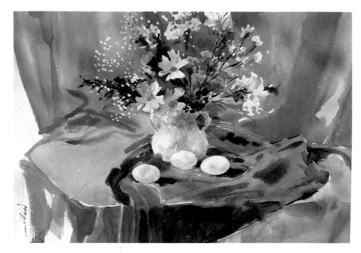

Compose with Triangles

These are just ordinary wildflowers from the field, "stuck" into a common glass jar. In keeping with the simplicity of this floral, we'll also understate the color. Let's see how beautiful a watercolor you can create from these humble beginnings.

As you arrange the flowers, think out your composition of accents and angles first. Don't get too stiff or "organized." Be subtle. Only *you* should know where these geometric shapes occur. Take the time to move or rotate the vase, looking at it from all angles with an eye to selecting the best "pose." Also think about where you want to place your white shapes . . . and plan your light direction before you put in your first wash.

This floral has a very simple mood, but it is dramatic because of the triangles and diagonals: a major triangle, the main group of flowers . . . a major rectangle, the white panel at the top left . . . and several small "supporting" triangles. This "invisible structure" allows you to cut loose with a zingy, free wash.

Compose with Circles

This floral is moving into color. You're working at a full-sheet size, but keep it very simple with a limited palette . . . just browns, blues, and greens.

You can create an excitement with shapes . . . just as you can with brilliant colors. In this floral, you are using a series of circular shapes: center of the flower . . . rim of the flower . . . the entire bouquet is a circle . . . also pitcher, pitcher handle, eggs, and the dots for the baby's breath. (Here is a case where it is desirable to use masking fluid, because of the varied wet-in-wet wash behind the dots.)

Although this floral is set on a square bridge table, you can create more visual excitement by changing the square to a triangular wedge for the top. This in turn encourages your mind's eye to "see" or invent other wedges or triangles into the weave of the composition.

There is a considerable amount of visual motion created by the S sweep of the backdrop cloth . . . across the table top . . . and down toward the base. This gives a definite feeling of "space" behind and around the flowers. The various triangles (indicated in the diagram) serve to give contrast to all of the circles . . . as well as direct the eye.

Block out the white shape on the left-hand side with your fingertip where light seems to be entering. Do you like it as a more classic composition, without this white. This is an intuitive choice, to be made by you alone.

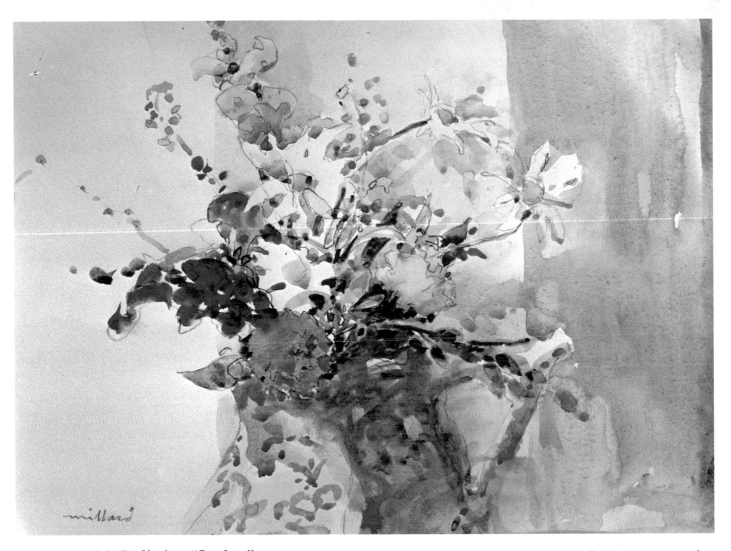

Compose with Radiating "Spokes"

This floral is moving into more color, with small pieces of pinks, reds, yellow, and green in the blossoms. They present a loose appearance . . . haphazard or straggly at first glance . . . but, in fact, quite controlled when the underlying geometry is disclosed. You are working on a quarter sheet of hot press paper.

As shown in the diagram, the rich blue tones on the pitcher serve as a dark central core for the discharge of color out in various directions like the spokes of a wagon wheel. Even the handle of the pitcher seems to duplicate this radiation of the colored blossoms.

This asymmetrical splay of flowers is complemented and steadied by the three rectangular panels of the background . . . which, in turn, are graded in tonal value from light on the left to darkest on the right side . . . indicating the direction or source of illumination.

These same graded tones of the rectangles present a strong contrast to the delicate flowers . . . not by strength of color, but by the difference in shape. So you can be composing with shapes *within* the florals and at the same time composing with shapes *surrounding* the subject.

Composing with shapes need not be a constant discipline in the use of geometrics, but it should arouse in you a quality of awareness. Always be on the lookout for any visual device that will make your painting better and thereby make you a better artist.

Speaking of discipline, there were ten or so of these marvelous miniature wildflower bouquets on the breakfast table for each of seven mornings at a charming country inn. Permission granted, I borrowed two of these little florals and painted them before breakfast each morning, which gave me fourteen delightful quarter sheets. This story has to do with self-motivation . . . a discipline of sorts.

COMPOSE WITH PANELS AND BANDS: Four florals

Horizontal Bands

I liked the way the brilliant colors with their bloopy stems were on one side of this bouquet and the four white daisies were on the other. This made an unusual vertical division of color. I also liked the "Lazy S" form of the flowers. Against this combination, it seemed natural to use horizontal bands at the base, where the wired bottle sat on a shelf of multi-browns, reds, and lavenders . . . and at the top, where it seemed most appropriate to use the midnight blue band against that yellow panel.

This blue band was painted in *after* the floral was completed, working first around the white daisy and then around the imaginary small floral shapes and the red and pink flowers, to make very interesting negative design shapes.

When you do this exercise, follow the same order. Do the floral first and complete the painting without this blue band. Then live with the painting propped up where you can see it for a week. After that you can brush in the blue if you still think the painting needs it. Make it very deep and rich and paint it in a single wash.

The reason for living without the panel for a week . . . and then adding the panel . . . is so that you can develop some emotional response to what is happening. There is a great deal of difference between these two versions . . . in their impact . . . or their softness. *Which one do you like?*

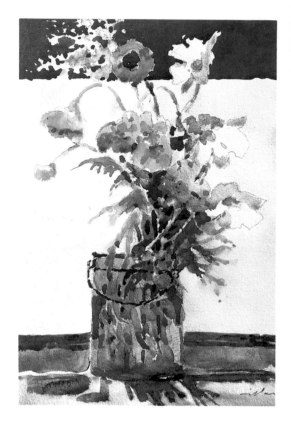

A Vertical Band

This cluster of country flowers was set into a long-necked white vase resting on a brown table. The blossoms consisted of daisies, cosmos, a marigold, and a bachelor's button. This still life needed more enthusiasm, so imagination was called upon to help raise this painting from the ordinary. You can't paint what you plop into a jar.

Again, treat still lifes like landscapes! In fact, still lifes are even easier to shift around and recompose than houses, fields, and trees. *Take your inspiration* from Redon. This great French pastelist was good with color and composition, and he was not above inventing blossoms that existed only in his mind's eye . . . and that's what's going on here: The top two daisies start white in the piece of light and then turn pale blue. The next several daisies below it become pink and the next several to the left, a stronger blue. These colors are invented. Also invented are the pine-needlelike sprigs fanning out from the top of the vase. These pine needles were not painted in the first session, but were added later . . . after the floral was finished (or so I thought). The white table was invented.

When the flowers were completed in the first session, I set the sketch aside for a couple of weeks . . . studying the thing from time to time. Then I decided to try a vertical panel to give the flowers some punch . . . they seemed too weak. I thought I'd also try some "fake" pine needles and paint the panel "behind" the edge of the flowers and paint in several dozen negative shapes and see what happened. And it worked!

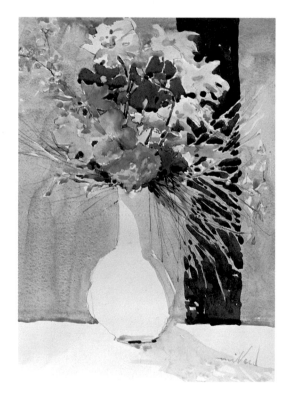

Two-Color Vertical Band

Pink Tigers and Rose is a full sheet watercolor painted in the studio from several sketchbook studies. Each sketch was made from the same large bouquet . . . working as it was turned to several different "profiles." As the vase was rotated, the arrangements of flowers appeared to change. Make this "rotating" a standard practice!

This floral was completed and placed in a location for daily study. It looked all right and might well have been sold as it was. But I wanted to wait and watch it for a while.

There is often an intimate feeling for a painting which you have just finished . . . when you have just put down the brush, to the point where your own judgment is "off." You have just had such an exciting time pushing the paint around and delighted in solving the problems at hand and in the sheer beauty of putting together a great batch of colors that look right and feel right. And your vision is "colored" by these happy feelings.

If you want an opinion of your painting, don't ask a dear friend. Prop it up and keep it "in limbo" and study it. What do *you* think? You are the one to decide. This one sat for about three months . . . and I looked at it periodically between painting trips and at odd moments.

Then one morning I decided to try placing a panel behind the flowers to create a myriad of negative shapes, threading them vertically through the shadowed flowers on the left-hand side, including a portion of the vase.

What kind of panel? I selected one with an Oriental brocade of deepest blue-purple, with a faded or antique-appearing rose-colored border. The panel gave it a good deal of authority . . . a sense of importance that it did not possess on first attempt.

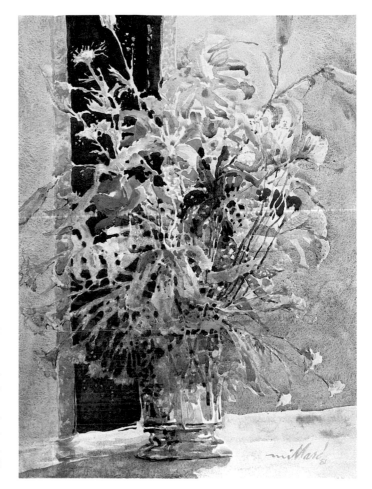

Three Panels

These three panels, themselves quiet in color, support a multicolor riot. They also divide the background into three vertical pieces. The left-hand panel is a light warm gray with casual, slim stripes of pale emerald green alternating with light streaks of drybrushed cadmium yellow pale. The center panel is a very light, clear yellow with a tint of a greenish gray cast. This color unifies the variegated colors of all the flowers and stems. The right-hand panel is a combined wash of lavender, pink, and blue. The narrow borders at the left, right, and base are brushed on variations of gray, green, and yellow.

The composition is based on an X format, with the deep colors of the burgundies and red purples at the extremeties. These darker colors—and their shapes—tend to push the eye back into the center, almost like arrows.

The bouquet is a kaleidoscope of carefully related colors. There are light, middle, and deep hues of yellows, yellow-oranges, oranges, orange-reds, blue-reds, pinks, and lavenders above the vase . . . and below, an equally complex and pleasant relationship of more than a dozen green mixtures and nearly as many blue combinations. (The white is the paper itself.)

This is no casual game of croquet. Your very best thinking is called for here. Painting is a learning process. Yes, it is *fun*, but the basis of painting is learning . . . no matter how many years you've been doing it.

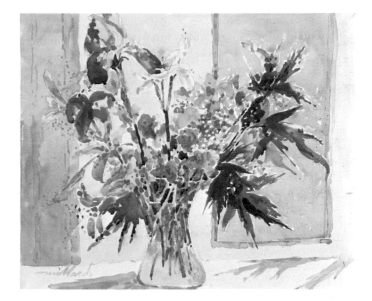

THREE INTERPRETATIONS OF THE SAME SCENE

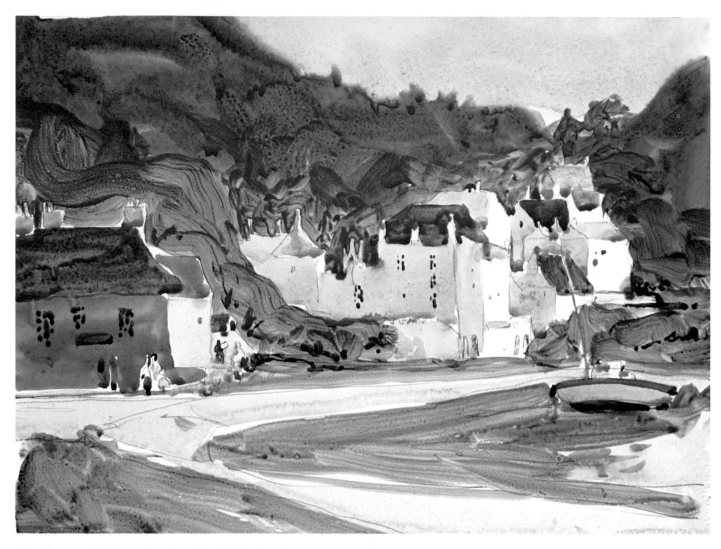

Heather and Gorse by the Sea in Ireland

This handsome Irish village was located at the base of the mountains, near the beach. I began the sketch at the center of the composition, with the village, and worked outward from that point. The village was drawn as a series of *inlines*—between the *outlines* of the mountains and the beach.

The eye is drawn in a sweeping concave curve from the tops of the mountains to this jewel-like village by the sea. The curve is again repeated in the lines of the buildings . . . at the bottom left side of the main group of buildings and in the upper right of the roof of the Red Inn. A second set of convex curves sweeps in from the sea on the road and beach. Note the additional curves in the convex deck and concave keel of the boat.

I used the same palette for all three seascapes—they were all completed in a morning from the same spot. The purple is a combination of mauve, burnt sienna, burnt umber, and ultramarine blue. The brown is raw sienna, with a touch of sap green. And the green is sap green with a touch of raw sienna.

While the sky wash was still moist, I stroked in the

mountains with very heavy pigment, allowing the edges to bleed into the sky . . . wet-in-wet. The mountains and gorse were painted around the drawing of the village . . . wet on dry. Then I painted the shadow sides of the buildings, and the roofs and windows. . . . and I was done.

The second and third paintings in this series represent two different versions of the same view. I did the first one to get a feel of the sea as it turned sienna and emerald at high tide. Then, as the light changed and the tide dropped, I did the second painting to feel the power and the closeness of the great sea boulders . . . with just one cliff and no foreground between me and the sea. Both paintings are valid. It's not a question of which is better, but of the emotional differences that inspired them. Do you ever think of things like this when you paint?

This composition is based on a large S-curve. The top or mountain edge of this S is drawn in segments of lines . . . and the bottom section of the S is made up of smaller bits and pieces of lines. Thus the S-curve itself is made up of many straight lines.

I chose 140-lb hot press paper because I could push heavily pigmented washes around on its smooth surface. This was not the type of painting for light washes of tinted water. The rugged quality of the land called for a special technique . . . using heavily pigmented washes.

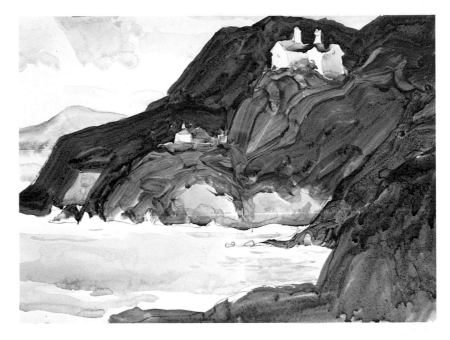

Lines and curves are repeated throughout this painting. Lines form the shape of the clouds . . . the edge of the mountain . . . the houses on the cliff . . . and the vertical faces of the big rocks.

Curves are ever present in the brushstrokes of heather and gorse cascading down the mountainside. The heavily pigmented brushstrokes show the myriad curved tops of these bushes. In contrast to the thickly painted foliage, the huge sea rocks are painted with clean, clear washes of standard pigmentation.

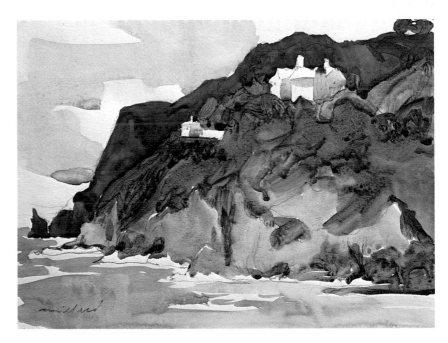

COMPOSE WITH LINES AND CURVES

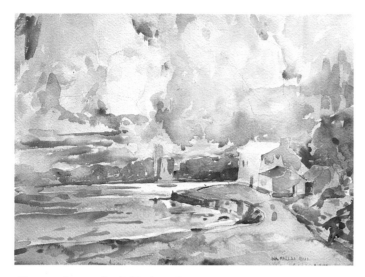

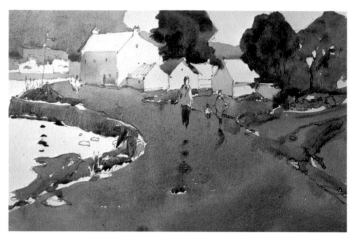

Capturing a Soft Rainy Scene

Ireland has its share of showers and I'm sure this is a blessing in a variety of ways. It gives the artist a chance to try to capture the soft radiant light, and because it is a northern country, in August I could actually paint until ten o'clock at night. The frequent rain provided a further chance to paint reflections and puddles . . . and best of all, for the watercolorist, there was the dampness. Watercolor thrives under soft, moist, and slow-drying conditions. It makes your edges less brittle . . . a bit softer, you might say.

This painting is made up of a series of lines and curves. The solid forms of the houses present vertical and horizontal lines . . . and the road sweeps into a curve by a tidal estuary. These forms flatter each other in the open countryside. Note how the curve of the road, as it ends, changes easily to the line of the sea wall and then into a linear jetty . . . in a continuous rhythm.

The light is fast failing in eventide and this is a quick fifteen-minute sketch . . . a first impression . . . painted in the car after a shower. Even the sky is dripping water from the clouds . . . a soupy wash. Sometimes you can catch the feeling of a specific condition . . . a time of day. You could set your watch by this one.

This is the same scene as on page 34, but this one was done in the colors and spirit of Turner.

Capture a Sunny Mist

This is the same site on the following morning. Notice how the road not only extends across the entire bottom of the painting, but is made to seem even wider by coming up above the corners as it starts its broad *sweeping curve* to end in a more generous setting for the cluster of houses. Note that the distant cove on the left now makes a more powerful curve coming into the side of the road. A softer curve finds its way off to the right. The sun is burning through the misty day so that there is a definite shadow pattern on the buildings, making a pattern of *lots of delicate lines* . . . vertical, horizontal, and angular at the eaves. These multiple lines that define the houses and the line of the right-hand side of the road are *inlines* and this inline of the road is broken by the three small figures. This pushes them toward you in space.

The road is executed in a very wet wash that is flooded on . . . and the changes in its color are made wet-in-wet. The shadow reflections are applied after the road washes are dry. The trees are painted in a very hearty, well-pigmented green variation of these grays, and the one roof is a much restrained red.

Assignment: The bright white reflections of the white houses were there in the glistening road. Would you have painted them in? Invest thirty minutes in this learning process and try a second watercolor using these white reflections to see how it suits you. . . . You might prefer it this way. I can only say that my decision was to keep the strong deep-colored shape of the road all the way to the houses . . . to preserve the design of this curve . . . and to carry the curve back to touch the mass of delicate lines.

Note the distortion of the houses in the preceding sketch. Do you think it's more poetic? This painting with the trees seemed to require more realistic houses. Do you agree?

PLACEMENT AND EMPHASIS: Seaport elm tree series

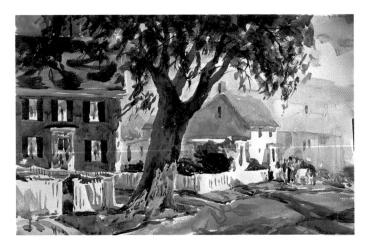

Elm and House as a Unit

In this series of paintings of a Rockport, Massachusetts, scene, the elm and surrounding houses shift in value and color as the light of the sky and center of interest change. Let's see how this works.

In this first example, the elm is painted in deep, rich tones and the graceful angle of its silhouette, together with the open gate guides the eye to the tan house beyond. The "conversation group" down the street is a secondary interest.

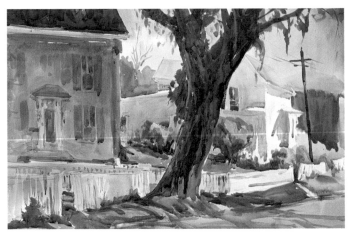

Elm as "Hero"

The weather is changing and the fog rolling in from the sea has nearly obliterated the distant rooftops, mellowing the red house. The elm, while still dark, contains reflected light from the sun-filled earth, and the white house beyond it seems even whiter by contrast. In the glare of the morning light, you can't even see the windows. The tan house is no longer a focal point. Details and contrasts there are underplayed.

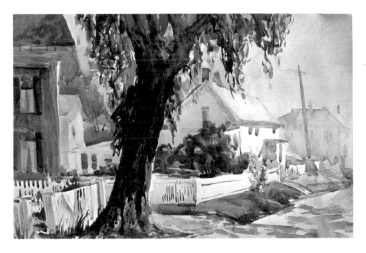

Focus on the White House and Fence

The fog is rolling in even more here, with the illusion of distance intensified by using washes of "tinted water" to paint the telephone pole and red house. The elm has been simplified, and the attention is drawn to the white house and picket fence. If you want to imply a bright light, don't get "picket happy" . . . just leave it as a white shape, with a minimum of detail. This visually implies that there is so much light that you can't see details.

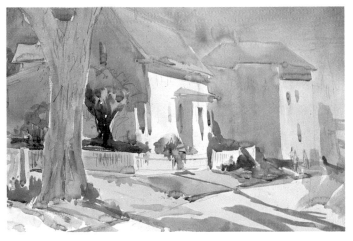

The Fog as Subject

By this time the fog has completely taken over, and the painting is now a monochromatic study of white abstract shapes. The placement of the major objects has also shifted. The only bright color is on the trees and lawns, with a touch of light brown to separate the elm from the nearby path. The foreground shadows break up the white road (use any color but asphalt) and indicate details on the houses and fence. The darkest value is on the small tree and nearby lawn.

CROPPING FOR EMPHASIS: Four ways to see

The Initial Sketch

If you work in a sketchbook, recording, sketching, composing hundreds of subjects, drawing only what attracts you, then look over these intuitive responses in your sketchbook years later, you'll be able to see where you're going as an artist.

Let's look at an example of my intuitive responses to a farm in Vermont. I had seen this big barn and silo through the brush and was excited by its possibility as a painting. Before I climbed the fence, I quickly sketched what I thought I'd paint.

This closeup cropping in the sketch was prompted by the fact that the fence was right at my chest. I felt close to the subject and that's what "said" to me: just draw the top of the fence . . . crop out the top of the tree . . . and place the barn at the third point of a triangle. The placement of the three dark accents reinforces these three main points: fence, tree, and barn.

I had captured my excitement on paper and that could have been the end of it. . . . Why go on through the brambles? The next two paintings are examples of why I climb fences!

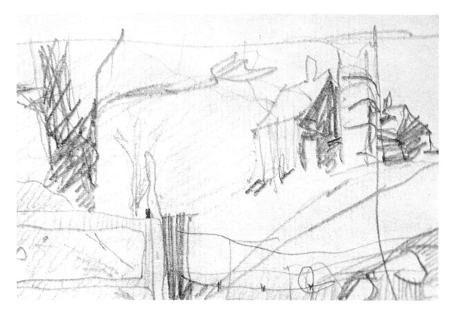

Distant Setting

After climbing the fence . . . what said to crop out that well-designed sugar maple? It had to be my intuition. I liked the stark, sharp, lonely, and powerful design of just the barn, silo, and the dead elm . . . all perched on the hilltop.

It had just rained, which made the tin roofs sparkle . . . put them into sharp focus . . . made them crisper looking because of the mist in the distance.

Note how the white pattern carries in this distant setting . . . it "makes" the painting. And the dark accents under the barn . . . their shapes and dark value . . . also give importance to the barn. Control of your values is essential.

Note also the careful planning of the color relationships . . . red barn against green grass, muted blue/lavenders in the distance . . . muted because of all the moisture in the air. (I thought the watercolor would never dry!)

Remember these three important points: design . . . value . . . color . . . in that order!

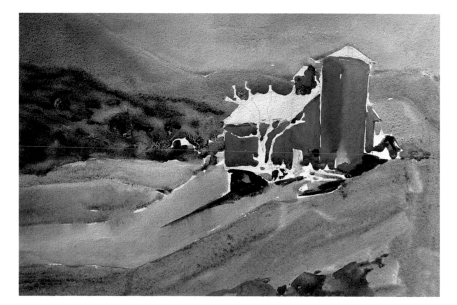

Middle Distance

What prompted the cropping of this painting? It had started to rain again. I headed for the barn. Why? I could have gone back to the station wagon. No way! I was here to paint, so paint I would! That's self-motivation. Cultivate it. It's tough in the beginning, but comes naturally the better you get as a painter.

On the way to the barn . . . I saw this composition in my mind's eye, and marked the exact spot with two stones and a crossed stick. . . . I wanted that spot! Why *that* spot? Intuition, I guess. I can only comment that the more spots you pick through the years, the better they'll get.

After the rain, the sun came out, making the foreground even sharper. There was an intuitive feeling that from the spot I had picked . . . that view indeed was the painting. *The cropping was right . . . felt right!* Note the power of the shapes, patterns, and strong diagonal.

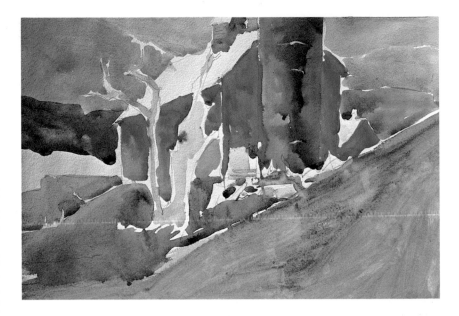

Crop to Abstract Patterns

This is actually a fragment of the first painting. It has possibilities as an abstract painting, that is, if you're into abstract painting.

I am always asked, "How do you make an abstract?" "Where do you find a subject?" "How do you start?" Well, here is a good way . . . by cropping a realistic subject artistically, and as an extreme closeup. You can turn this painting on any of its four sides and it will look good, though for me, this format is the correct one. . . . I like the balance as it is.

Note: The pigment resists and forms rivulets as one fresh wash works its way through a previous wash that is *still damp* but has lost its glisten on the paper. This odd granulation has an abstract quality and texture of its own . . . likewise the white pattern . . . the change of color in the reds . . . the depth of the green and its shape.

In this sketch the first wash is viridian with a touch of ultramarine blue. The second wash—cerulean blue and light red with a touch of permanent rose—is dropped into the damp first wash and is breaking through in rivulets. Don't forget to keep the paper at a slant.

WORK OUT IDEAS FOR COMPOSITIONS

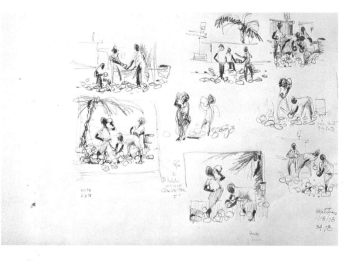

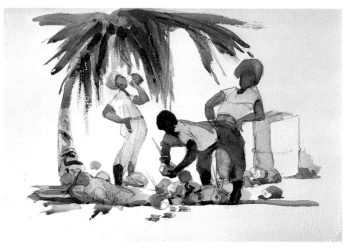

Fresh Coconut Milk: Sketches

You have a feeling now about *your* sketchbook. It is no longer a sketchpad sitting on the shelf in an art store . . . it has become a part of you. You have ideas and plans for yourself as to how you're going to go about becoming a better artist.

The sketchbook is a personal record of *your* growth and visions, and changes with what (and how) you see. It is a place where you can store and nurture plans for most of your future paintings. It's a place to plant seeds. It's a traveling laboratory.

Perhaps by going a little deeper into how a sketchbook might be used, getting a more intimate view as to how I have used my sketchbooks to help me probe . . . search . . . play games with a subject . . . to "dig it out," will make it easier for *you.*

Let's see how the sketchbook helps a painting. You're on location . . . you have a spot in the shade . . . out of the way, so to speak (any person, in any country, is wary of someone with a camera, but a sketchpad is different) . . . you see some activity and you start to work. Observing and sketching. Again and again.

You can see from the number of drawings on this page that I'm holed up here for a while . . . that I'm on the track of a painting. I start at the top left, and hope to get a few pieces I can work on later. Study the results. There are eight paintings here . . . not just one!

From Idea to Painting

How do you decide what colors you want to use? The scene is on a dockside by the turquoise sea. The characters "on stage" are wearing clothing of all colors . . . blues, reds, brilliant fuschia, greens, purple. I feel that if I stay with the colors I see, the local color, that the scene would have an atmosphere that is so festive that I'd forget the real reason for painting it.

Because of the striking negative shapes in the areas of white, around the figures, the composition reminds me of Utamaro, the early Japanese print master. If I were to use only understated or subdued colors, then the viewer could concentrate on just the delight of the *activity itself.*

And there was a lot of activity. First the guy capping the coconut with a razor sharp machette, holding the nut in his bare hand. (That's self-confidence, man!) Then the fellow drinking the sweet, quenching liquid, his arched back a counterpoint to the arch of the palm tree . . . the split arch of the palm fronds repeating the arch of the legs below. And the third guy leaning on the oil drum in a classic pose. See how his gesture is needed to assist the circles "hidden" in this composition? How many circles can you find here? The old masters used structures like this to reveal the inner relationship of figures.

Assignment: Try painting the other seven "coconut" sketches. You should plan to use a completely new combination of colors for each one. This is a good way to learn color from your sketchbook black and white drawings.

Practice Coordinating Color and Design

This is a page from one of a dozen of my St. Thomas sketchbooks. It is typical of my larger size paper, 11″×14″ (28×36cm), a yellow-covered Aquabee CO-MO pad. Its larger size is handy for accumulating material in quantity, when you want a lot of variations on a theme on a single page. The paper is a bit thinner than the Super Aquabee red-covered pad, and it's not as portable. Four of the sketches on this page have already wound up as finished paintings . . . mostly watercolors. (Put your sketches to work!)

Most of your sketches will be prompted by some visual impulse while you were out "browsing" around on your sketchbook "rambles." It can be a certain combination of colors that strikes you . . . if so, jot them down in the margin to remind you in later years. It can be an unusual shape . . . or the way one object meets another . . . or the negative shapes around objects. Again, what you're looking for is . . . design . . . value . . . color . . . in that order.

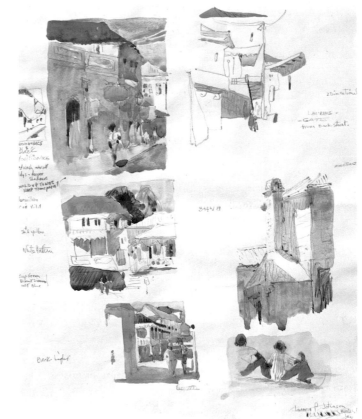

Make Notations to Retain Information

The abstract shapes of the white patterns is what attracted me to this scene, and I have made marginal notes on the colors. About the shadows, I've commented, "build up tones, keep transparent." Next to the red roof I've written "vermillion, cobalt violet." I've noted the yellow rectangle as "Indian yellow." To remind me of my interest, I've written, "white pattern." Finally, the colors under the balcony are noted as "sap green, burnt sienna, ultramarine blue." Can you see what a sketch with these comments does to stir your imagination? How it can spark enthusiasm a month or even years later?

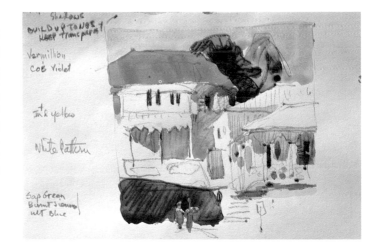

Work Up Painting Ideas

You are beginning to see a change in how the sketchbook is being used. Instead of a single sketch or two, we are now getting into multiple thoughts about a subject that are being interpreted visually . . . recorded so that you can expand on an idea.

You have been through the series of paintings that have grown out of eight sketches . . . probing *Coconut Milk.* You have also seen multiple sketches on a page . . . each fragment tending to search out a different subject possibility. Now you will see how to solve a particular painting problem . . . to decide the shape . . . size . . . composition . . . lighting . . . mood . . . and medium.

The subject has been nailed down to a single theme . . . *The Gate.* The sketchbook notations begin at the top left with a carbon pencil study of the gate itself and its setting . . . the buildings. The study below is a refinement in composition showing less of the building on the right . . . beside it, a small detail of figures by the gate. The first sketch showed a boy with a skateboard, but that was nixed for the figures with baskets on their heads.

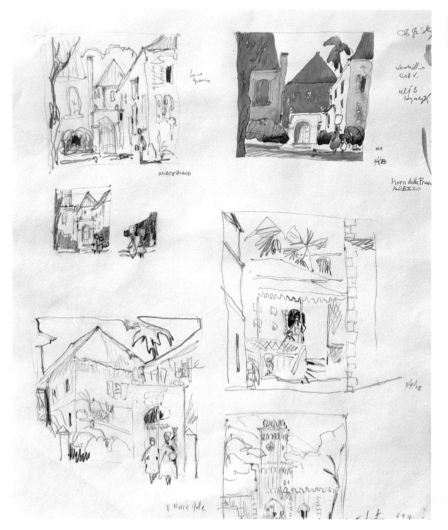

Detail

This is an enlarged detail taken from the previous sketch page. You can see how I have been fussing, not so much with the gate as with the figure selection and arrangement or composition next to the gate. The blue house takes on a good deal of importance behind that gate.

This composition was later painted in watercolor as a quarter sheet, pretty much as you see it . . . though squared up a bit so the buildings weren't leaning . . . and sold into a private collection.

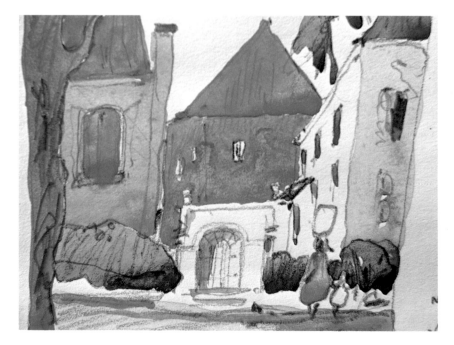

130

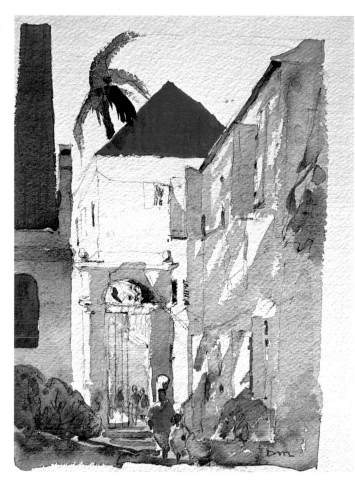

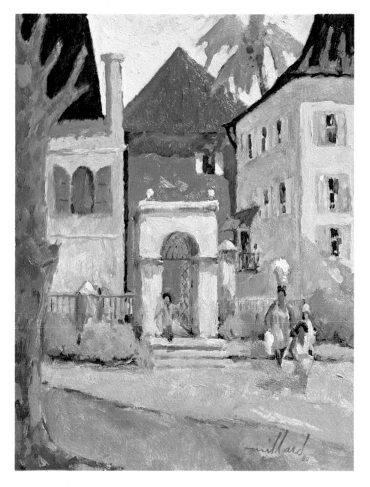

Another Version

Many of our great artists . . . old masters or contemporary . . . have painted variations on a theme. It is also done in music . . . by Beethoven, Chopin, Mozart, Gershwin, The Beatles. It is the expansion of an idea. Think about this.

Our "gate" is growing taller. It is in a different setting . . . and in a more decorative "style" . . . and again in watercolor. The title is now *The Lutheran Gate*, as it is properly called by the local gentry. The foreground has been changed so that you are visually meeting the figures as soon as they step out of the gate. Notice that the "blue" house is just as effective in white . . . or even more so. The color of the roof also has more power . . . impact. Look at how the palm tree gets into the new mood of this interpretation.

There is a dramatic change in the perspective of the house on the right. The line of the eave . . . the angle of the shadows . . . the open shutters . . . all are contributing to this. All of this, to me, is a natural way to grow . . . from the sketchbook, where you can comfortably explore an idea through sketching . . . into the paintings, which are easy to slip into because you already have drawn the roadmap to guide you. It's fun and it's easy!

An Interpretation in Oil

Another variation of *The Gate* . . . but much has been changed.

1. The title is now *The Blue House*.
2. The format is vertical.
3. The gate is much more detailed and higher.
4. The gate is open so you can see the blue house through it.
5. The color of the church and roof have been drastically changed.
6. The entire foreground has been opened up and enlarged.
7. Color relationships are also much changed. . . . Look at that yellow sky.
8. It is an *oil* painting now.

Do you see how these changes are evolving automatically from the original use of the sketchbook? This is a natural expansion to me . . . it has been a very comfortable way to grow . . . from pencil to watercolor . . . to oil.

SUMMARY OF BASIC PAINTING AND DRAWING LESSONS

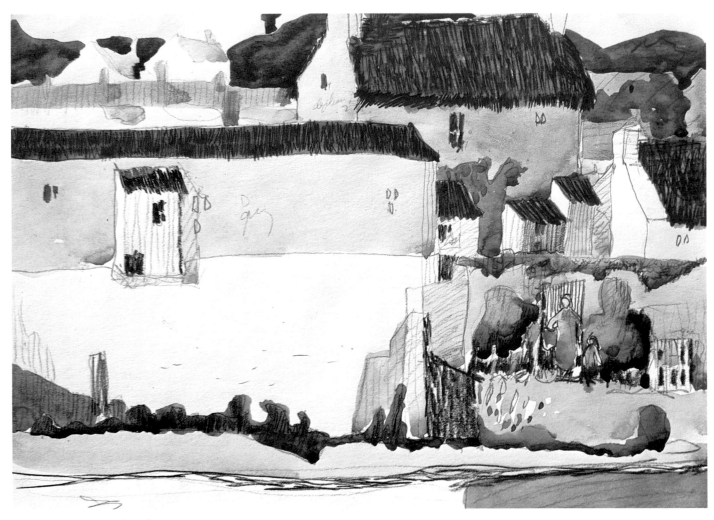

Ennistymon, Ireland
Carefully design the location as well as the dark patterns or pieces.

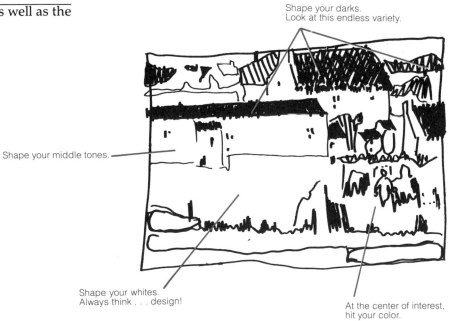

Shape your darks.
Look at this endless variety.

Shape your middle tones.

Shape your whites.
Always think . . . design!

At the center of interest, hit your color.

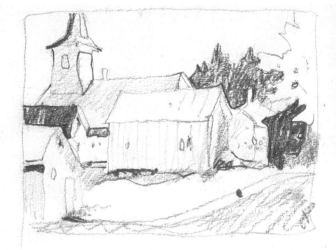

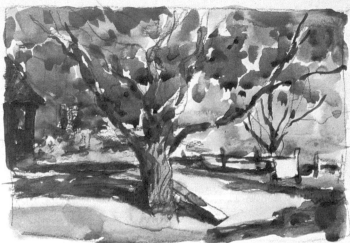

Waterville, Vermont

Position darks . . . study earth lines . . .
plan negatives.

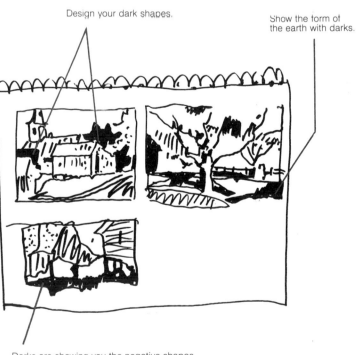

Design your dark shapes.

Show the form of
the earth with darks.

Darks are showing you the negative shapes.
Look for them everywhere. Don't put in darks without first thinking "design."

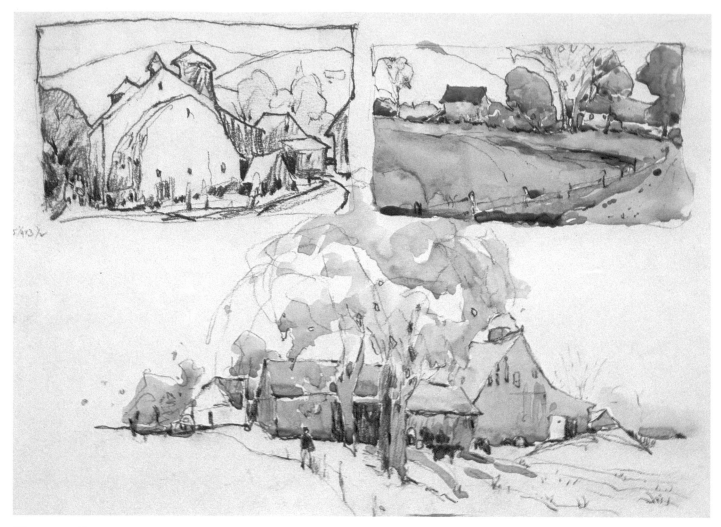

Vermont Farm

Compose the page. Note the importance of the sky pattern and ground line.

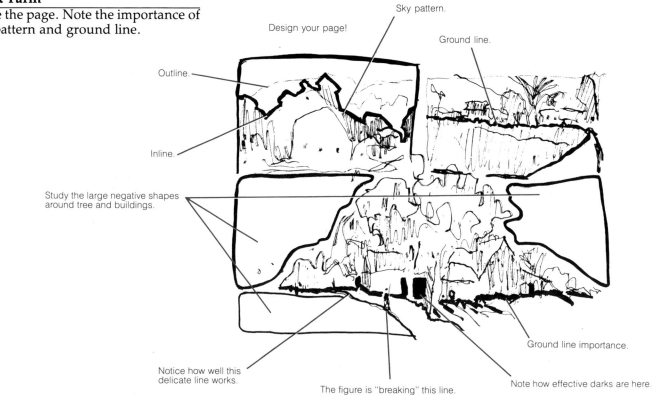

Design your page!

Sky pattern.

Ground line.

Outline.

Inline.

Study the large negative shapes around tree and buildings.

Notice how well this delicate line works.

The figure is "breaking" this line.

Ground line importance.

Note how effective darks are here.

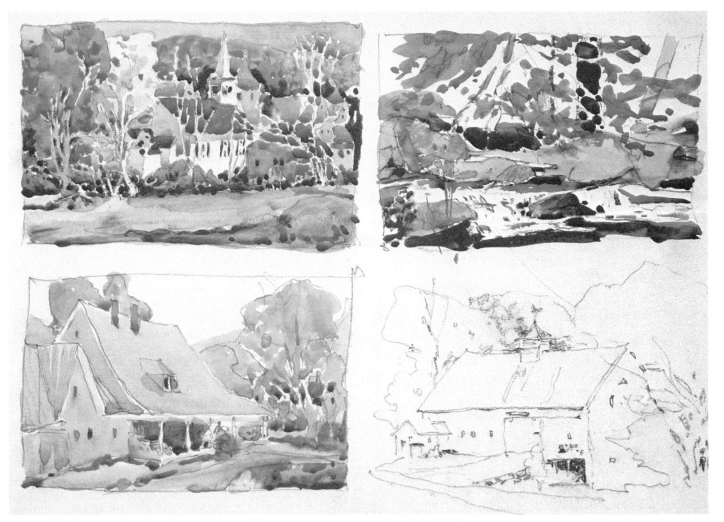

Jackson Village, New Hampshire
Remember: pattern . . . value . . . color . . . and design! Design! Design!

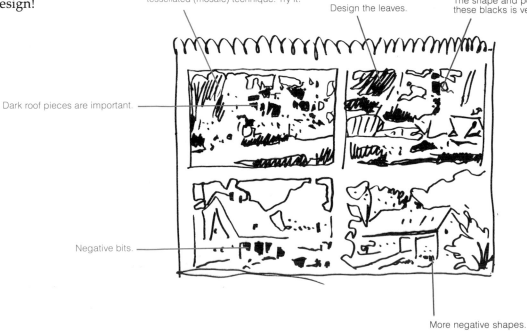

This sketch is drawn in a tessellated (mosaic) technique. Try it!

Design the leaves.

The shape and position of these blacks is very important.

Dark roof pieces are important.

Negative bits.

More negative shapes.

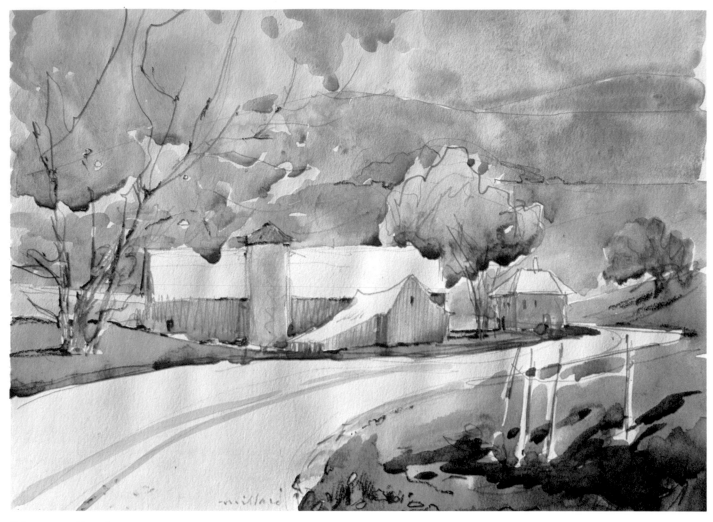

Vermont Road

See patterns better by planning your whites. You can do your sketchbook rambling from your car. Get your sketch! You can always add color from memory.

The landscape is painted "around" these white shapes.

The surrounding colors are "setting up" this blue house.

You can see the patterns here better by planning your whites first.

The wet highway is reflecting the white glare of the sky.

Try this painting, saving the yellow lines for last!

Note the deep tones in the foreground.

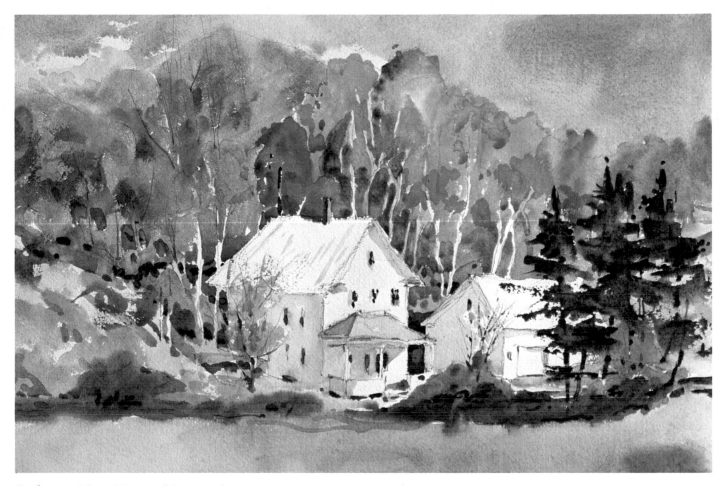

Jackson, New Hampshire

High key. Paint the landscape around the white house. Note the negative between the house and barn . . . and the ground line. This is handled like a still life.

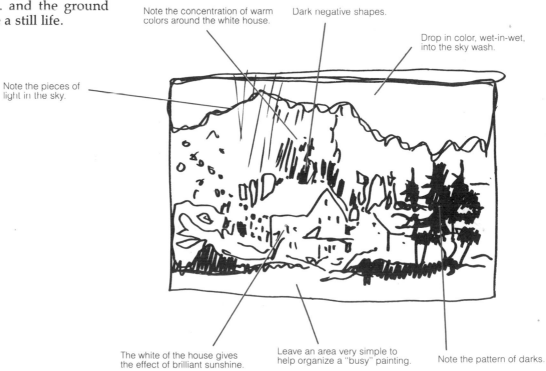

Note the concentration of warm colors around the white house.

Dark negative shapes.

Drop in color, wet-in-wet, into the sky wash.

Note the pieces of light in the sky.

The white of the house gives the effect of brilliant sunshine.

Leave an area very simple to help organize a "busy" painting.

Note the pattern of darks.

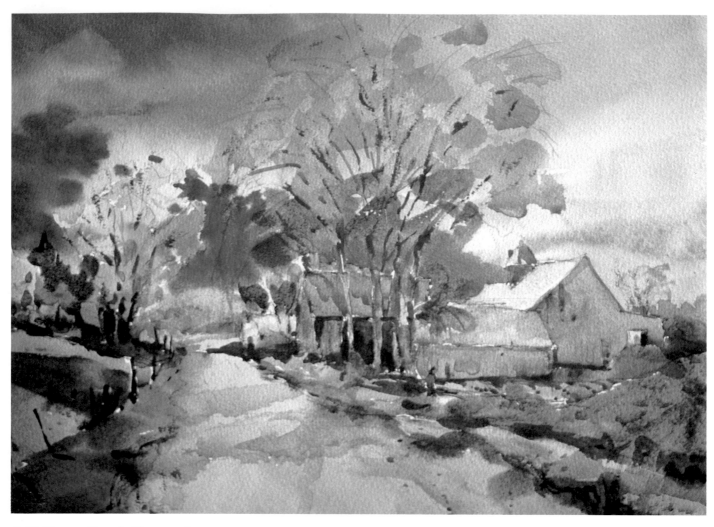

Jeff Upper Road, Vermont

Middle key. Sky and barn are the same wash. Mood: snow squalls in the distance . . . soft, warm, sunny foreground. Ground-line accent. Gray barn is lost into sky. Note the dark negative shapes at base between trees.

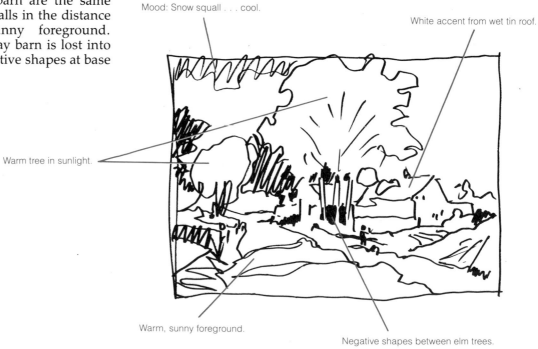

Mood: Snow squall . . . cool.

White accent from wet tin roof.

Warm tree in sunlight.

Warm, sunny foreground.

Negative shapes between elm trees.

138

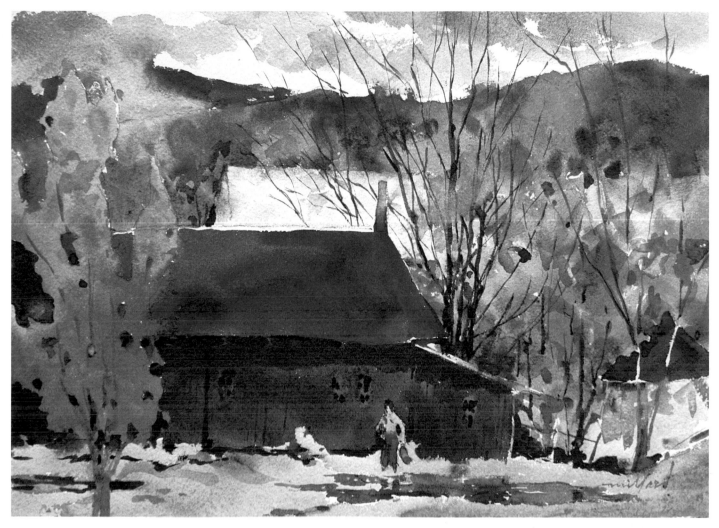

Vermont: Opposite Smuggler's Notch Inn

Rich colors, low in key. Mood: The intense, cold blue mountain shadows . . . almost black . . . of a passing snow squall contrasts with the varied foliage. Look at the shapes and locations of the darks. Note how the ground line is broken by the figure. Don't just copy from nature . . . the foreground building was tan with a green roof.

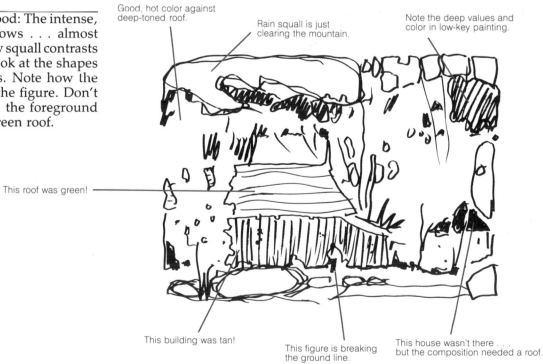

Good, hot color against deep-toned roof.

Rain squall is just clearing the mountain.

Note the deep values and color in low-key painting.

This roof was green!

This building was tan!

This figure is breaking the ground line.

This house wasn't there . . . but the composition needed a roof.

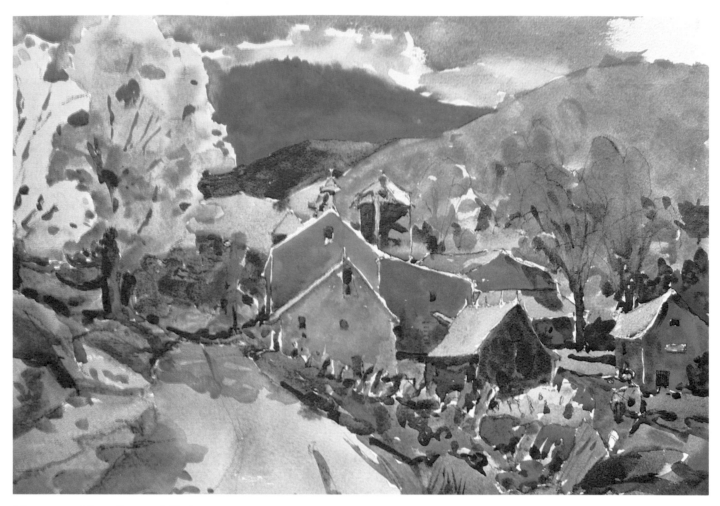

Vermont, Near Reynold's Barn

Rich, low in key . . . with many, many reds. Switch to ¼ sheet . . . do a carbon sketch as in your sketchbook, then run watercolors over it. Easy! Note the use of the sky outline.

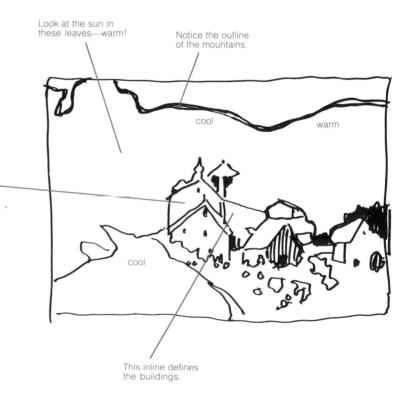

Look at the sun in these leaves—warm!

Notice the outline of the mountains.

cool

warm

I used 15 different reds on this trip . . . a new one each day!

cool

This inline defines the buildings.

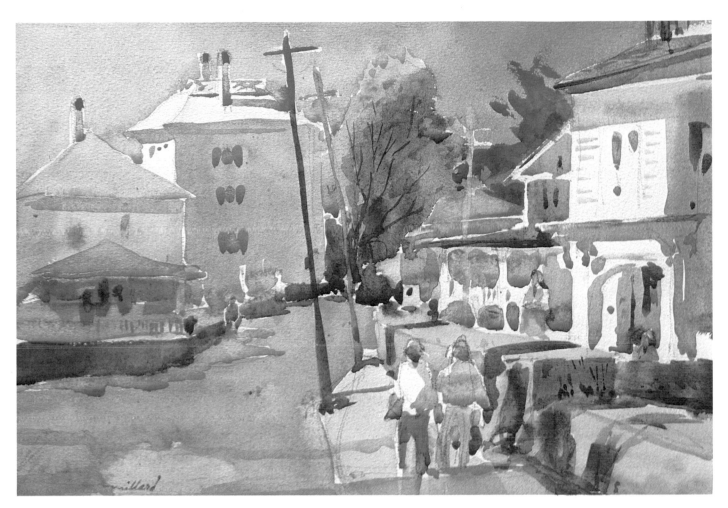

Martha's Vineyard Side Street

Emphasis on speed . . . but keep the same free style of your sketchbook. Work on ¼ sheet . . . quickly.

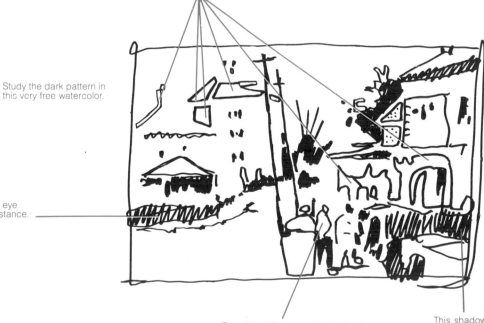

Note the variety in all these white shapes.

Study the dark pattern in this very free watercolor.

This dark path helps the eye to move back into the distance.

The white shirt helps attract attention to the center of interest.

This shadow "shapes" the hedge.

LIST OF ARTISTS

Albers	Color juxtapositions, one color next to another.
Bonnard	First "modern" colorist, unique cropping techniques.
Braque	Cubist, exquisite shapes of blacks and whites and grays.
Cassatt	Exceptional mother and child compositions.
Cézanne	Forerunner of contemporary color and paint application.
Corot	Composition and subtle grays.
Degas	Drawing, figure positioning, pastellist.
Flint	Unsurpassed as a watercolorist, clean washes, good composition.
Gauguin	Brilliant colorist, excellent figure compositions.
Hawthorne	Taught color patch idea, "one color coming next to another color." Exhilarating words.
Hopper	Sureness of pattern, intensity of color.
Matisse	Originator of the "color over color" used today.
Morandi	Power-packed simplicity, with tender color.
Monet	Colorist, subtle color combinations.
Picasso	Broad range of creativity in his pink, blue, and last period.
Rembrandt	Grouping of figures, mood with light.
Renoir	Flesh tones, color, compositions.
Rodin	Fast, spontaneous first washes of figures.
Sargent	Clarity of color, fresh as a breeze.
Ucello	White patterns and compositions.
Utamaro	Negative spaces in endless variety.
Van Gogh	Combinations of color and texture variations.
Vermeer	Handling of light, and a master of composition.
Vuillard	Color juxtaposition in matte finish, composition.
Whistler	Master of gray variations, nocturnal scenes.

Learn from this list of 25 masters. Study them one at a time . . . a week at a time. This is where you will find your greatest nourishment. This is also where you will begin to find your own direction. so look at the art that interests you and don't waste time on techniques *you* don't like. Also, try not to be unduly influenced by any one instructor or artist, but learn from contemporary painters as well as the old masters.

Look at their work to learn, not to imitate. Imitation can smother your own creativity and prevent it from maturing. Follow the intuitions that spark your excitement . . . be it thick paint or thin paint . . . not enough color or too much color . . . too much drawing or not enough drawing. Just keep painting. You'll surface!

SUGGESTED READING

The following books are important in terms of adding to your basic knowledge as an artist. They deal with color, drawing, painting techniques, and aesthetic and teaching philosophy.

Color

Bonnard dans sa Lumière (Saint-Paul, France: Fondation Maeght), with 225 illustrations. "Bonnard" in the *Masters of Color* series (New York, Tudor Publishing and Paris: Braun & Cie). These two books on Bonnard are superb, but out of print or hard to come by. Perhaps you know of someone going to the French Riviera who can pick up a copy for you?

Fine Art Reproductions of Old and Modern Masters (Greenwich, Conn.: New York Graphic Society). This is one of the best investments for art students, a catalog illustrated in excellent color, containing nearly 500 pages with four to eight paintings per page. It is particularly helpful to those not near a large city museum. The book may be out of print, but perhaps you can still find a copy in a bookstore or library.

Wildenstein, Daniel. *Monet's Years at Giverny: Beyond Impressionism* (New York: Metropolitan Museum of Art and Harry N. Abrams, 1978, paperback).

Drawing

Goldstein, Nathan. *The Art of Responsive Drawing*, second edition (Englewood Cliffs, N.J.: Prentice-Hall, 1977). This is an exceptional book on contemporary drawing concepts, with old master drawings included.

Nicolaides, Kimon. *The Natural Way to Draw: A Working Plan for Art Study* (Boston: Houghton Mifflin, 1975, paperback). This book, now also in paperback, gives the exact course Nicolaides taught at the Art Students League of New York. A classic!

Painting Techniques

Carlson, John. Carlson's *Guide to Landscape Painting*, revised edition (New York: Dover, 1973, paperback). This is the landscape painter's "bible," an absolute must for the novice and intermediate watercolorist. However, I don't agree with his premise that one must paint in oils first. Watercolor is its own ballgame!

Dunstan, Bernard. *Learning to Paint* (New York: Watson-Guptill, 1978, paperback). This one will really give you a handle on what painting is all about and how to do it.

Painting Advice from Teachers

Hawthorne, Charles W. *Hawthorne on Painting* (New York: Dover, 1938, paperback). You are fortunate indeed to still be able to get this book. It costs only a few dollars, but this book is "canned inspiration." It contains such a wealth of wisdom on painting that your copy will be moth-eaten and underlined to death in just a few months! Hawthorne was one of the truly great teachers.

Henri, Robert. *The Art Spirit*, edited by Margery A. Ryerson (New York: Harper and Row, 1960, paperback). The other "great," a super teacher, is Robert Henri. His book deals with seeing and inventing and can stir your blood with words. A must!

INDEX

David Lyle Millard received his B.F.A. from Colgate University and then continued his studies in art at the Art Students League in New York and at the Massachusetts Institute of Technology. A past member of the New York Art Directors Club and the American Society of Interior Design, Millard now spends his time painting and teaching in Needham, Massachusetts, and St. Thomas, U.S. Virgin Islands. He has taught workshops throughout the United States and in France and Italy for 15 years.

Millard's work has won top awards from the National Academy, American Watercolor Society, New England Watercolor Society, New Britain Museum of American Art, Rockport Art Association, and North Shore Arts Association. His work has been exhibited in 36 art museums and major art complexes, as well as in 275 national and regional shows in the United States. His paintings also hang in many corporate and private collections. His watercolors were featured in *American Artist* magazine in 1978 and 1985.

Millard is the author of *Impasto,* a book on oils, also published by Watson-Guptill. A major show of his work is scheduled for the Centre National d'Art et de Culture Georges Pompidou in Paris.